EVERYBODY HURTS

"*Everybody Hurts* will make you laugh—or if you're *really* emo, cry—out loud." —*Revolver*

"An absolutely hilarious reference book." —*Nylon*

"Think of *Everybody Hurts* the way you do the Bible. Every so often, when you're feeling emo-lost, pick it up and be reassured. . . . If one mark of a good book is to make you plumb your pop-culture soul, then *Everybody Hurts* is important." —*Village Voice*

"[E]qual parts insight, lampoon, and celebration . . . a loving tribute that's essentially a portrait of the kind of unfettered commitment to culture that seems to sincerely spring from the unlatched hearts of teenagers." —Associated Press

"[D]estined to become a staple in emo music lover's book collection (shelve it next to *The Perks of Being a Wallflower*). Growing up can be hard if you're emo, but this book will help you get it right—and maybe laugh through your tears." —MySpace.com

"[A]ll you ever needed to know about the subculture of asymmetrical haircuts, hunched shoulders, and too-tight T-shirts. . . . Even if you already consider yourself as a member of the emo clan, you're sure to pick up a few bits of information."

—Flip.com

"*Everybody Hurts* is the ultimate emo handbook . . . an enjoyable read full of Rob Dobi's spot-on illustrations . . . [and] witty and incredibly funny insight into a culture that has been berated for too long." —venuszine.com

"If someone was to ask me, 'What is emo?' I would hand them a copy of *Everybody Hurts*." —Matt Rubano, Taking Back Sunday

"If there was ever a duo who perfectly captured the zeitgeist of this culture, it would be Leslie Simon and Trevor Kelley. *Everybody Hurts* is the essential book for anyone who fancies themselves emo, or who just wants some side-splitting humor poking fun at anyone who already is."

—Sarah "Ultragrrl" Lewitinn, author of *The Pocket DJ*

EVERYBODY HURTS

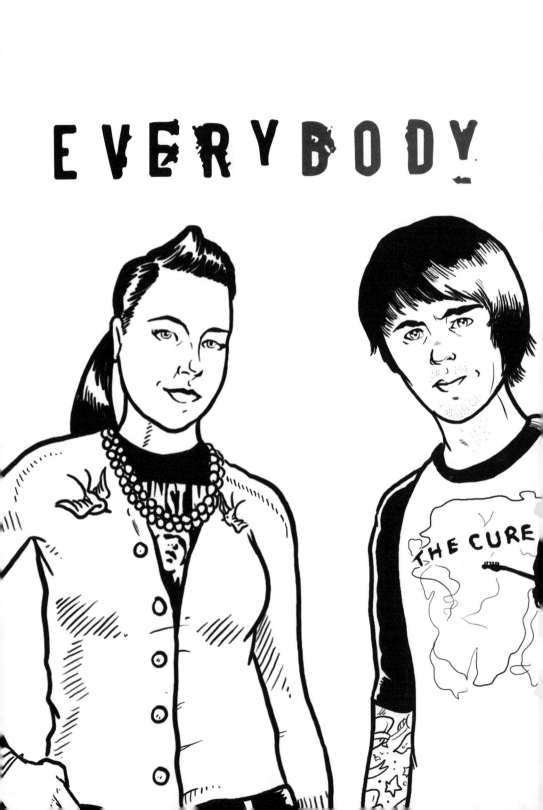

HURTS

An Essential Guide
to Emo Culture

Leslie Simon & Trevor Kelley

HARPER ENTERTAINMENT

NEW YORK • LONDON • TORONTO • SYDNEY

HARPER ● ENTERTAINMENT

E-mail courtesy of Pete Wentz.

HarperCollins books may be purchased for educational, business, or sales promotional use. For information please write: Special Markets Department, HarperCollins Publishers, 10 East 53rd Street, New York, NY 10022.

FIRST EDITION

Designed by Justin Dodd

Library of Congress Cataloging-in-Publication Data
Simon, Leslie.
Everybody hurts : an essential guide to emo culture / Leslie Simon and Trevor Kelley.—1st HarperEntertainment ed.
p. cm.
ISBN: 978-0-06-119539-6
ISBN-10: 0-06-119539-1
1. Emo (Music)—History and criticism. I. Kelley, Trevor. II. Title.
ML3534.S562 2007
781.66—dc22 200641286

07 08 09 10 11 ❖/RRD 10 9 8 7 6 5 4

For the guys who wear eyeliner—
and the girls who love them.

contents

The first time I heard the word "emo" I laughed.

It was probably sometime in 1997—I know, late to the party—and I was visiting my friend Chris, who was then a college student studying in Boston. Up until that time we had been inseparable both musically and socially: Together we forced our indie-rock buddies to listen to Biggie Smalls in between their steady diet of Archers of Loaf, and we spent countless hours scouring the import bins for obscure singles by soon-to-be-forgotten Brit-pop acts like Kenickie and Tiger. But on one fateful visit to his apartment, Chris pulled out a new CD he had been listening to. The cover featured a candy-colored carnival boarded up for the winter. The artist was the Promise Ring. The album was called *Nothing Feels Good.* And the music sounded like a bunch of untalented strivers with extra thumbs fronted by a sensitive yowler who seemed primarily concerned with having his feelings hurt by girls who couldn't understand him.

I was shocked. These Promise Ring guys didn't wear Ben Sherman suits, drop E, or hang out in Camden town—and they certainly didn't sip Cristal and gangbang, either. They scrimped on meals and stood awkwardly against the walls at parties. They wrote songs about *Delaware*, for chrissakes!

Where was the showmanship? Where was the escapism? The Promise Ring didn't take me away from me—they *were* me, and I couldn't handle it. I made fun of the song Chris put on the stereo, and when he told me what kind of music it was—*emo*—I laughed.

And that was that. Chris and I remained close friends, but for a time our musical preferences shifted. He delved deeper into the scene and listened to bands like Mineral and Jimmy Eat World, who would help define what would later be referred to as emo's second wave. While he hung out with guys who had beards and decorated their shoulder bags with tiny pins, I wrote pages of fiction inspired by Belle and Sebastian songs and bought drum and bass albums because I still wanted music that offered an escape. Besides, listening to something called "emo" just sounded like walking around wearing a giant target around your neck.

Little did I know just how popular the genre would become. At the end of the nineties, as pop music took another turn for the gargantuan, glitzy, and grotesque, Ethernet cables began snaking out of the suburban sprawl, drawing young people's tastes, style, and culture closer and closer together. Suddenly the personal could become popular—or, if not popular, then at least it could become available to those usually excluded from punk's unfortunate insular regionalism. Teenagers, as always, were frantic for music to align themselves with and for new heroes to relate to and admire. Who better to serve as these heros than a bunch of guys barely out of high school themselves who wrestled with decidedly high school problems— heartbreak, friendship, Delaware—over approachable hooks? Emo's moment had arrived, which was surprising for a number of reasons, not the least of which being that it was still technically undefined and still tended to inspire unwanted smirks, laughter, or derision.

Fast-forward five years from that first illicit chuckle in Boston. The unthinkable had happened: I found myself not only listening to emo but writing about it and—here was the real kicker—*enjoying* it. While researching my book *Nothing Feels Good: Punk Rock, Teenagers, and Emo*, I found myself in what at first seemed to be the strangest of strange lands: a world where suddenly the preppiest of preps

could be punk*ish*, where lacrosse jocks could sing along to weepy acoustic anthems, and where random Long Island dudes could keep journals, cry in front of girls, and write the word *art* with a capital *A*.

It was strange, but with a few years' worth of distance I could finally experience it through the ears of the young fans and understand what it felt like to hear one's innermost thoughts and feelings revealed in a crashing chorus or a vicious verse. I saw my own love of music reflected and magnified in the culty stares directed at Dashboard Confessional's Chris Carrabba. More important, many of the bands I encountered—from Dashboard to Thursday—were made up of genuinely decent and humble guys who had had their own lives turned around thanks to the support of an open-minded punk scene, and who were now attempting to return the favor on a national scale.

By this point the bands were coming fast and furious, each one younger and rawer than the next—and they all seemed to both flaunt and flout emo stereotypes faster than mainstream haters could dream them up. The Get Up Kids begat Saves the Day and Saves the Day begat Fall Out Boy and Fall Out Boy begat Cartel and so on. Emo has come a long way since Davey von Bohlen of the Promise Ring transformed singing with a lisp into an enviable display of nonthreatening machismo—in fact, that lisp itself had already made an impressive journey from the D.C. hardcore battlefields in the mid-eighties—and these days everything seems more sped-up than ever.

As I write this, Panic! at the Disco is packing arenas around the country and have a platinum album less than a year after forming. By the time you read these words, it's very possible that an emo band called Tears That Fall in February (notable for their architecturally impressive hair as well as their energetic keytar player) will get signed straight from a middle-school talent show and within weeks their MySpace-distributed ringtone will serve as an alert for incoming text messages from Memphis to Mumbai. But no matter how big the stakes or the sales get, as long as someone, somewhere, finds what he or she is looking for in TTFIF's

songs, then the spirit of emo—that ineffable bond between a band and a young fan looking to connect his or her life with something *bigger*—remains intact.

Whether you play in a band, work at Hot Topic, write bad poetry, or just spend far too much time on MySpace, to be emo is to tap into something sweetly innocent: an unjaded desire for romance and comfort, a nostalgia for things that haven't happened yet, or an ache for things that barely were. The music—and all the fashion and *Tiger Beat*-ish drama that comes with it—is the messenger, but not the message. All devotees have their own definition of emo, and for thousands if not millions of people all over the world, this is a way of life no matter what it dresses like or sounds like.

Which brings us to the book you have in your hands. In a world lousy with quick, clueless cash-ins, Leslie Simon and Trevor Kelley are O.G. emophiliacs, smart and savvy writers who know this tumultuous, hilarious and overdramatic world inside and out. And what they've accomplished here isn't so much a guidebook for outsiders as it is a celebration for insiders. They may have Pete Wentz's cell phone number, but they also have xScene4Lifex's LiveJournal bookmarked. They've seen the view from the stage *and* from the mosh pit. They've spent time on tour buses and online. In other words: They get it.

So, for all those who have ever cried at a concert or IM'd their life's story to a total stranger; for any boy who has ever painted his nails or any girl who has ever worn a tie; for any thirtysomething who cried when Lifetime broke up, or any young buck who sobbed when they reformed; for all those, anywhere, who have ever sung along to their favorite song like their life depended on it, this is your story and your book.

Oh, and it's okay to laugh. No, really.

Andy Greenwald
July 2007

EVERYBODY HURTS

ide•ol•o•gy *n* a body of ideas and social needs that separates you from your parents, the pep squad, and Dave Matthews Band fans.

So, what exactly is emo? Over time emo has been defined as a tuneful strain of punk rock with a lyrical emphasis on matters of the heart, but these days it means much more than that to its many fans. Emo is still a kind of music, sure, but more than anything it's a state of mind. It's a place where people who don't fit in—but who long to fit in with *other* people who don't fit in—come to find solace, and its resident ideology is something that those within the scene take very seriously.

How seriously? Well, it seems safe to say that the emo ideology affects nearly every aspect of emo fans' lives. It affects how they wear their hair and what bands they choose to listen to. It affects the way they eat and the way that they look at the history of the world. But it also affects their understanding of who they are and, more important, who they are not, which is what this first chapter is all about.

The emo ideology is what defines being emo. Even if the wrong person did one day wake up,

head directly to Diesel, pick up some black fingernail polish along the way, and then buy the entire Saves the Day catalog online upon getting home, that wouldn't ever truly allow them to differentiate between that which is emo and that which is totally lame. See, emo-ness is something that you are born with, and even if emo fans do think exactly like every one of their friends, that's what makes them different. Well, at least compared to the rest of the world . . .

EMO VALUE SYSTEM

True emo-ites are born—not made—and they embody certain patterns of behavior and thought that serve to bond and unite. Not sure if you meet the criteria? Uneasy whether that prospective love interest you met on MySpace who wears a Thrice T-shirt but lists *Independence Day* as one of the best movies ever is *really* the one for you? This checklist of ideals will help clear all of this up.

CORE EMO VALUES

- *Depression*: More dramatic than simply being sad, depression is the foundation of the entire emo ethos. Depression serves as a bonding mechanism for those with a similar outlook on life and love. Like magnets, depressed people attract one another because moping alone is, well, pathetic. But throwing yourself a pity party? That's emo.
- *Effort(lessness)*: Being emo is all about trying really hard to look like you don't really care. Being indifferent isn't as easy as it looks. It requires *effort*. Why spend two hours slathering your hair with pomade, taking a straightening iron to the bangs and the back, then shaking the whole mess out and matting it to your forehead to look like you just took a nap, haphazardly slept on your 'do, suddenly rolled out of bed, and bolted out the door? Because merely sleeping on your coif would be too easy and wouldn't look natural enough. When you're emo, you're

constantly looking to invent unnecessary obstacles so that you can overcome them.

- *Empathy*: Feeling other people's pain is crucial to being part of the emo community. Whether you're a vegan and you feel animals should be loved, not eaten, or you're a member of the Overcast Kids* because Pete Wentz's lyrics are just like the poetry you write on your blog, it's imperative to be able to transfer your feelings or emotions onto another person or object.
- *Faith*: When emo followers believe in something, they believe in it 110 percent. Anything is possible: A girl named Holly Hox really *did* inspire the Saves the Day song "Holly Hox, Forget Me Nots." Morrissey really *does* have his own MySpace account. Your prom date really *isn't* someone you're related to. And so, through struggle, strife, and tragedy, true emo types carry on. In the end, being emo is all about having the kind of unwavering conviction that allows one to face the challenges of a new day (and blog about them later in the evening).
- *Insecurity*: There's always someone out there who's smarter, funnier, and better-looking than you. They probably have a better record collection, wardrobe, and car than you, too. We'd even bet they never go to a dance without a date and will probably have sex with at least three people by the time they turn twenty-one. But screw them: Insecurity is a fundamental value taught at an early age to emo youngsters so they can prepare for a life of middle-class averageness.
- *Non-athleticism*: Sporting events and organized athletic activities are like emo kryptonite. Because most emo activities revolve around computers, chairs, television sets, couches, MP3 players, and beds, there is no reason—regardless of what your parents or gym teacher say—to partake in any activity that causes you to abandon any or all of these coveted objects.

* *n* Obsessive flock of Fall Out Boy fans known for wearing Clandestine Industries hooded sweatshirts and homemade TEAM NAKED PICS T-shirts seven days a week. Also, they are known to attend middle school.

IDEOLOGY

What if you incur tennis elbow while "hitting the ball around" with good ol' dad? Who's going to update the photos on your Flickr account? Definitely not worth the risk.

EMO ANCESTORS

Emo fans may be born with a certain sense of ideology, but this can also be learned from those who came before them. For example, many consider the following historical figures to be influential on the emo scene as it is known today.

WILLIAM SHAKESPEARE

Make no mistake about it: William Shakespeare was emo to the core. Sensitive and sexually ambiguous, Shakespeare was also extremely prolific, writing thirty-eight plays and scores of sonnets and poems about both men *and* women. Not only did those works inspire a million basement poets to pick up a quill, a pen, or a keyboard, but we're pretty sure he was at the forefront of the men-wearing-women's-clothing movement. Just check out those frilly-collar shirts he's always depicted in. It's no coincidence that the members of Panic! at the Disco look like they're about to star in a performance of *Hamlet*.

JANE EYRE

Penned by Charlotte Brontë in 1847, *Jane Eyre* quickly became lauded as one of the best novels—and most celebrated emo rags-to-riches tales—of all time. It's not enough that Jane grew up an orphan, but years later, just as she was about to tie the knot, she found out that the man she was about to marry was *already* married. When first published, Brontë released *Jane Eyre* under the

genderless pseudonym Currer Bell as a sort of middle finger to the pervasive idea at the time that women couldn't be successful novelists. This paved the way for emo-approved author JT LeRoy* to do the same thing two hundred years later. Well, sort of.

EMILY DICKINSON

Considered one of the greatest American poets of the nineteenth century, Emily Dickinson was recognized for her unconventional capitalization and grammar—two highly emo literary devices. Some said she was an agoraphobic recluse. Others insisted her romantic poetry was melodramatic. Both the words *recluse* and *melodramatic* may sound like insults, but in emo they are welcomed wholly.

HOLDEN CAULFIELD

Nut jobs like Mark David Chapman may have earned *The Catcher in the Rye* a bad rep, but Holden Caulfield, the teenage protagonist in J.D. Salinger's coming-of-age classic, is an undisputed emo icon. From his middle-class upbringing to his signature red cap to his fruitless efforts to cash in the V-card,† Caulfield is a poster boy for depression and insecurity. It was only a matter of time (sixty years, to be exact) until a melodic hard-core band from West Virginia adopted the moniker.

* Novelist who rose to notoriety in the late nineties for writing about his adventures as a former teenage prostitute. At the time, the picture he released of himself to the press suggested that he looked sort of like a cross between Andy Warhol and Beck. He, it turned out, was not even a "he" at all. Instead, the hipster figurehead was a middle-aged lady. Confused? See the Literature chapter for further details.

† *n* A piece of physical evidence given to those who have yet to lose their virginity. Many believe, incorrectly, that this is a mere figure of speech. But it's true. All virgins really carry around cards that say, "Please, somebody, *anybody*, sleep with me" in their back pockets.

BUDDY HOLLY

Buddy Holly is best known for his signature specs, inspiring the Beatles, and, unfortunately, dying prematurely in a plane crash (immortalized by the Don McLean sing-along "American Pie"). But Buddy Holly's emo legacy lives on through boy-meets-girl classics like "Peggy Sue" and "That'll Be the Day," the use of hiccupy inflection (*ahem*, Daryl Palumbo), and the fashion aesthetic of Rivers Cuomo.

DOBIE GILLIS

Unless you're a Nick at Nite nut, *The Many Loves of Dobie Gillis* might be an obscure emo reference, but Gillis marks the first time America was exposed to an emo youth on the small screen. The sitcom (which originally aired from 1959 to 1963) followed the trials and tribulations of Gillis as he tried to woo the heart of his uninterested crush, Thalia. And, though you do have to wonder who would name their kid *Dobie*, his romantic struggles were emo all the same.

CAMERON CROWE

Becoming a contributing editor at *Rolling Stone* and the now-defunct *Creem Magazine* at the tender age of fifteen proved that Cameron Crowe not only loved writing, but that he had an undying passion for music—two musts for anyone calling themselves emo. Famous for making the uncool cool, Crowe is also responsible for writing, producing, and directing emo's cinematic pièce de résistance, *Say Anything*. That alone earns Crowe a solid place in emo's history.

MOLLY RINGWALD

Being an emo muse to famed director John Hughes can be hard work. Over the course of two years, Ringwald made three must-see emo movies with Hughes (*Sixteen Candles*, *The Breakfast Club*, *Pretty in Pink*) and managed not only to redefine the standards

of beauty but to take the idea of geek chic to a whole new level. Working at a record store became cool. Landing the most popular guy in school became possible. Little did Ringwald know at the time, but in twenty years she would influence millions of female MySpace users to list "Able to apply lip gloss with my cleavage" in their "About Me" sections.

EMO FACT VS. EMO FICTION

As the popularity of the emo scene grows, many from outside the scene have begun developing a slew of misconceptions about emo fans. "They all cry," such voyeurs will say. "They all spend way too much time on the Internet," others may add. And while they may be kind of correct, here we will shed further light on some of the more common emo truths and falsities.

BEING EMO MEANS YOU DON'T HAVE ANY FRIENDS

FALSE. Being emo *doesn't* mean you don't have any friends. Actually, it's quite the opposite. Misery loves company—and so does your average emo enthusiast. In fact, a person's emo-ness often correlates with the number of friends that person has on MySpace. A true emo-ite might not have anyone to walk home with after school, but they sure have a maxed-out AIM Buddy List and ten friend requests awaiting approval on MySpace. Trust.

EMO REFERS TO A GENRE OF MUSIC—NOT A LIFESTYLE

FALSE. While, yes, the term *emo* stems from the label "emotional" music that was often attributed to mid-nineties bands like Sunny Day Real Estate and Jimmy Eat World, the word also fittingly describes the audience at large that listens to emo music. Just as punk music inspired the term *punk* to describe its audience, without the specific genre of emo we would have to call the fans who follow it Those

Who Wear Too Much Eyeliner, Listen to Depressing Music About Depressing Topics Like Depression, and Are Big Balls of Insecurity Who Would Rather Jump out a Window Than Attempt to Talk to the Opposite Sex.

And, let's be honest, TWWTMELTDMADTLDAAB-BOIWWRJOOAWTATTTTOS is a *really* crappy acronym.

BEING CALLED EMO IS AN INSULT

FALSE. Although it *was* an insult. During emo's early days, in fact, it was nearly impossible to find any band that would take being called emo lying down. But these days most emo bands—and fans—have decided that such debates are kind of exhausting and, really, you might just be better off spending your free time watching the third season of *Arrested Development* on DVD instead.

IF YOU'RE EMO, THEN YOU CRY ALL THE TIME

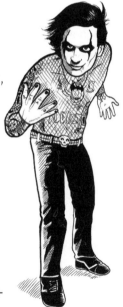

FALSE. If only it were that easy. While, yes, no well-prepared emo-er would go anywhere without a Kleenex travel pack, no, crying is not a continuous activity. Although from the tear-dripped black eyeliner sported by certain emo frontmen (i.e., Good Charlotte's Benji Madden and Aiden's wiL), one would think that emo followers had tear-duct-enlargement reconstructive surgery. Not so. Everything in moderation. After all, a person has to sleep, eat Morningstar Farms Chik Patties, and pick up a Circa Survive Jeep hat from Hot Topic. How can they do that if they can't see through the tears?

DEVOUT EMO FOLLOWERS ARE CELIBATE

FALSE. With all apologies to Morrissey, sex is something that is often coveted by the emo masses but, out of circumstance, rarely ever experienced. If they are lucky, *er*, mature enough to have sex, it's not something emo fans talk about unless they are from Long Island. Then it's as if they can't talk about it enough. Most emo kids throughout the rest of the country settle for spooning,* which makes sense—it's far more intimate and emotional.

IF YOU'RE EMO, YOU'RE STRAIGHT EDGE

FALSE. Experimentation is expected, but if you drink alcohol and do drugs on a consistent basis, be prepared to be called out on it. Speaking of, let's take a moment to reflect on the profound loss of the Edge Break List on Howsyouredge .com—where emo celebrities like the dude from Hot Hot Heat were outed when they began drinking. Man, that was a great Web site.

MANNERISMS AND ETIQUETTE

Emo types, as outlined elsewhere in this book, dress alike, read alike, and certainly act alike—especially when they are at a show. In such an environment, your typical emo kid's behavior is pretty standard. Here we provide a small guide to how most emo types should—or more likely *will*—act at the next emo show they attend.

GET THERE EARLY

Arriving at an emo show involves some degree of ceremony. To start, emo fans will carefully select music for the ride in. Listening to the latest CD by the band you are about to see is often considered to be in poor taste, but for some reason listening to that

* *v* An embrace or snuggle in which two people—usually fully clothed—lie back-to-chest, thus avoiding eye contact and actual sexual intercourse.

< 1 0 >

same CD on your return home is slightly more acceptable. Once most emo kids arrive at the venue, their prime objective is to find a spot to watch the show—the closer the better. Watching, not talking, is the goal here. Obviously this rules out any major-label A&R guy* from ever being truly emo.

ESCAPE IN THE MOMENT

Once they're settled in, most emo fans will spend a great deal of time staring directly at the stage. This is not exclusively because they're watching their favorite band perform on it. Even when there is just a paunchy roadie inhabitating the stage, it serves as a magnet for emo fans' attention because it allows them to avoid a number of awkward social situations. The more they stare anxiously, the less they have to engage with other human beings. Additional forms of escape for emo fans include text-messaging their friends or, for those who have driven in from a slightly more affluent suburb, hiding behind their Sidekicks.

PARTICIPATE IN THE ANTI-INTRODUCTION

Now, for those rare-yet-ambitious emo kids who choose to participate in social interaction, the following series of events is likely to occur. It starts with what we'll call the Anti-Introduction: a defeated greeting that often feels more like an apology. After approaching a prospective group of familiar faces, an emo fan will employ the Anti-Introduction and then extend a limp handshake. Small talk about bridge traffic (or freeway traffic, depending on where you are in the country) may follow. Miraculously, emo fans will maintain friendships *for years* based on this decidedly introverted pattern of behavior.

INTERACT WITH THE CROWD

By the time the night's headlining band takes the stage, most emo fans will assume one of two stances. The first is the re-

* *n* Anyone over thirty-two at an emo show who is on his or her BlackBerry half the time or, interchangeably, yelling out, "Hey, this round is on me."

spectful nod-and-bop commonly employed by the kind of emo fans who are also really into boring indie-rock bands. The second is the out-of-my-mind sing-along, which usually occurs when a band plays something off its first record. Why this will cause even the most introverted emo fan to begin wildly jumping up and down is not easily explained. But it seems fair to say that there are moments in life to look pensive, and there are moments in life when you grab the total stranger next to you, blurt out, "Holy crap, they haven't played this since 2002!" and hug awkwardly.

SAY GOOD-BYE—AND BE SURE TO BUY STUFF

Once the night's final band is through performing, there's one last destination: the merch table. Emo kids are consumers, and much of their appreciation is shown in overt behavior like wearing one of the seventeen T-shirt designs that a band has for sale. Many emo fans will maintain correspondence with each other in the time that elapses between shows. This will occur via Instant Messenger or by sending notes to one another on MySpace. But as for actual conversations, those are few and far between. The general basis of an emo fan's behavior is to reveal as little of yourself as you can socially, and as much as you can privately. Think about it: If they had talked about themselves at the show, what would they blog about afterward?

TIMELINE

For most emo types, understanding themselves means understanding emo's history, and there are literally hundreds—even thousands—of years' worth of historical events that are generally acknowledged as part of emo's ancestry. Remember, part of being emo is knowing where this culture has been.

3000 BC: The first form of nail polish is invented in China. Presumably it is worn by women (and maybe men) who would've looked

great singing along to the chorus of My Chemical Romance's "I'm Not Okay (I Promise)" into an air microphone.

2000 BC: The first traces of Hinduism appear, including the introduction of the vegan diet. While such a practice is quite socially advanced, at the time the Hindus were still several thousands of years away from experiencing the tofu riblet. Bummer.

THE LATE 1280s: The first pair of eyeglasses is invented in northern Italy. This remains significant for people who have trouble seeing and for emo fans who want to *appear* as if they're having trouble seeing.

MARCH 30, 1853: Postimpressionistic painter Vincent van Gogh is born. Van Gogh will later become mythologized for the unquestionably emo act of cutting off part of his ear and sending it to a woman who had rejected him. Interestingly enough, this loving deed of dismemberment proved inspirational for Boys Night Out and their song "I Got Punched in the Nose for Sticking My Face in Other Peoples Business," with lyrics like, "Watch me bruise and bleed for you." We can only imagine the impact if van Gogh had sent the woman his spleen.

1905: C. J. Walker develops the first hair-straightener. One hundred years later, the members of From First to Last will be stoked.

EARLY 1917: Marquis M. Converse, founder of the Converse Rubber Shoe Company in Malden, Massachusetts, develops what will become his most popular shoe: the All-Star. Six years later, he will rename the shoe after one of his employees, Chuck Taylor. Good thing his name wasn't Jamal Theodore Granholm.

EARLY 1950s: An early version of the famed messenger bag is created as a telephone lineman's bag. It will turn out that these are also good for carrying your vinyl copies of the first two Saves the Day LPs.

FEBRUARY 7. 1956: Actor and comedian Emo Philips is born. Legend has it that some three decades later, an incredulous heckler at a show for the D.C. proto-emo band Embrace will yell out, "You guys are like Emo Philips. What is this, 'Emo-core?'" Suddenly a new genre will find its name.

JANUARY 15. 1974: *Happy Days* airs for the first time. By the mid-nineties, the teenage members of the Get Up Kids will look suspiciously like lead character Richie Cunningham in their first press photos.

FALL 1978: Diesel Jeans is founded in Movena, Italy. Many European men get the first glimpse at what, years later, suburban teenagers will be paying hundreds of dollars for.

MAY 18. 1980: Deborah Curtis discovers her husband's body hanging from a noose in their living room. Joy Division singer Ian Curtis's life as a working-class romantic has just ended, sadly leaving the music masses with only two albums of the band's original material.

MAY 4. 1984: *Sixteen Candles* is released in theaters, thus marking John Cusack's first *memorable* appearance on the big screen—unless you happened to see him in 1983's *Class*, in which Rob Lowe

IDEOLOGY

<14>

has an affair with his college roommate's mother, Jacqueline Bisset. Yeah, we didn't think so.

SUMMER 1985: Many local punk bands in Washington, D.C. decide to turn their backs on punk rock's loud-and-fast rules and begin writing melodic rock songs about crying. One band, Rites of Spring, writes a song called "Theme (If I Started Crying)" and becomes universally agreed upon as the first real emo band because of it.

JUNE 16. 1986: The landmark emo record *The Queen Is Dead* is released by Manchester indie band the Smiths. Their singer, Morrissey, announces that he's taken a vow of celibacy. He spends this day, like many others, without having sex.

MARCH 1992: A new rock club opens in Austin, Texas. It's called Emo's, and it somehow does not seem like mere coincidence that every nascent emo band will play there over the next fifteen years.

FALL 1994: Rivers Cuomo begins his first semester at Harvard and starts writing what will become one of emo's defining records, *Pinkerton*. In addition, he also begins growing a beard and, presumably, starts hitting on nearly all of his female Asian classmates.

JANUARY 16. 1995: After just one season, *My So-Called Life* airs its final episode. Obsessed viewers are left with two burning questions: Would Angela Chase and Brian Krakow ever build a life together, and why didn't Jared Leto include an emo-infused rendition of "Red" on the self-titled debut album of his prog-emo band, 30 Seconds to Mars? Guess we'll never know—but we're pretty sure Rayanne Graff is fairly disappointed.

APRIL 17. 1995: Morrissey is totally enjoying the mid-nineties, so he decides to . . . go another day without having sex.

SPRING 1995: Cap'n Jazz records their version of the theme song to *Beverly Hills, 90210* in singer Tim Kinsella's mom's basement. This serves as the first tangible connection between emo and Fox teen programming. If the show were still around today, we're positive that Reggie and the Full Effect would have made a guest appearance at the Peach Pit After Dark and, who knows, maybe David Silver could've filled in on keys.

AUGUST 9. 1995: The very first Warped Tour begins in Salt Lake City. This is notable because it allows emo fans to enjoy for the first—and apparently last—time a performance by the post-hardcore band Quicksand while simultaneously climbing an artificial rock wall.

FEBURARY 28. 1997: Toni Braxton releases the single "Unbreak My Heart," which, even by R&B standards, is completely overdramatic, insufferably sappy, and, thus, totally emo. Eight years later, Weezer records their version of it as a B-side—which isn't the only connection between the band and the R&B diva. Braxton came out as a born-again virgin soon after the single's release, championing celibacy much like a certain Weezer frontman. Coincidence? We think not.

FEBRUARY 18. 1999: The Cure's Robert Smith makes a guest appearance on the hysterical adult cartoon *South Park*, marking the only time Smith is seen—by his fans *and* his family—without makeup. It is also the first time that someone who could be considered an emo icon appears in animated form. Turns out it won't be the last.

FEBUARY 23. 1999: Incognito emo fave Eminem releases the track "'97 Bonnie & Clyde," in which he takes the agony of a bad breakup to the extreme, killing his ex-girlfriend in the song's lyrics. This will later prove influential to a lot of emo metal bands from Long

Island who will also write a lot of songs about wanting to kill their girlfriends. Figuratively, of course.

MARCH 1999: A Web site for online diary entries called LiveJournal is launched by a nineteen-year-old computer programmer named Brad Fitzpatrick. The only drawback? Unlike a diary, it's pretty much impossible to shove a computer monitor under your pillow.

JULY 27, 1999: *Nowcore: The Punk Rock Revolution*, a surprisingly good collection of late nineties emo bands, is released by K-tel, the same label that brought us TV-advertised compilations like *Hooked on Country* and *The Greatest Hits of Christmas*. Who knows where the comp would've been today if the label had distributed it in Flying Jet Travel Plazas and Petro Truck Stops.

MARCH 2003: Jonathan Abrams develops a Web site called Friendster—a place on the Internet where you can make friends without actually having to meet people. Emo kids log on in droves and collecting friends becomes more time-consuming and intense than collecting *Star Wars* figurines.

MAY 19, 2003: Future afternoon salvation for emo fans arrives as a new video channel called Fuse premieres. Unfortunately it stumbles out of the gate: The first video it airs is by the rap-rock band Linkin Park. Damn you, Chester Bennington!

JULY 2003: After the success of Friendster, Tom Anderson and Chris DeWolfe develop the social-networking site MySpace.com. It's an instant success. Minds are blown. Digital camera sales multiply. Another argument is given for not leaving the house.

SEPTEMBER 2, 2003: During a self-induced state of seclusion at his home in the Hollywood Hills, Morrissey decides the world

misses him and he should mount a comeback. But first he decides to go another day without having sex.

OCTOBER 8. 2003: Web designer Jason Oda relaunches the site Emogame.com. Fans from across the country are encouraged to fight off evildoers (Gene Simmons, the cast of *Friends*) as the singers of their favorite emo bands battle for supremacy.

NOVEMBER 2003: American Apparel opens its flagship store in Miami Beach, Florida. The fashion aesthetic of those who have always longed to dress like a 1970s phys ed instructor is forever changed.

AUGUST 29. 2004: Yellowcard wins a Moonman at the 2004 MTV Video Music Awards. During the band's acceptance speech, singer/guitarist Ryan Key begins to cry. Good thing Key wasn't wearing black eyeliner at the time, or he would've looked like Good Charlotte's tear-stained Benji Madden circa 2002. Thank God for small victories.

APRIL 21. 2005: Death Cab for Cutie, after months of being name-checked on the show, perform live at the Bait Shop on *The O.C.* Seth Cohen—as well as people who look like Seth Cohen—collectively bro-hug.*

MAY 10. 2005: A company in Pittsfield, Massachusetts, begins manufacturing a new product called Emo Kid Gum. On the candy's packaging, below a photo of a teenage boy in requisite black-framed glasses, it reads, "Specially formulated for those with sensitive souls." Emo Mints said to be in the works. A tentative tagline is "Curiously strong for the curiously insecure."

* *n* A light embrace that involves only a limited amount of physical contact. Performed by overzealous—and oversensitive—dudes.

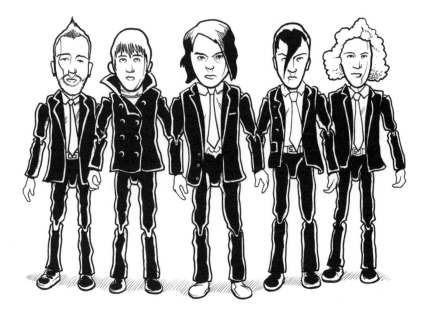

FALL 2005: Emo goes Mattel when My Chemical Romance announces that they have been chosen to produce their own line of action figures. Gerard Way "playing with himself" takes on a whole different meaning and, somewhere, the members of Coheed and Cambria seethe with jealousy.

FEBRUARY 8. 2006: In one incredibly anticlimactic night, emo's first Grammy nominees—to Fall Out Boy for Best New Artist and Death Cab for Cutie for Alternative Rock Album of the Year—are defeated by an R&B crooner and a fake brother-and-sister alt-blues act. And you thought your last breakup sucked.

APRIL 4. 2006: Morrissey releases his latest solo album, *Ringleader of the Tormentors*, which includes the song "Dear God, Please Help Me." In it he sings, "I have explosive kegs between my legs," and then, later, "Now I am spreading your legs, with mine in between." Hearts are broken and the world stands still at the very thought that the old fart finally got laid.

DIFFERENT SCHOOLS
OF THOUGHT

Many of your typical emo characteristics are a given. Antisocial?
Check. Throws like a girl? Absolutely. A snug T-shirt with a screen-
printed image of the Used's lead singer saying BERT IS MY HOMEBOY
across the front? Duh. But what about those emo kids who deviate
ever so slightly from the typical emo form? What follows is a brief
run-through of those emo fans who have generated subsets of their
own.

TRUSTAFARIAN EMO
Often found in more liberal-leaning environs like
Portland, Oregon, or Burlington, Vermont, the
trustafarian emo-type represents the increasing
number of former hippies who have gravitated
toward the scene in recent years. While most
cite the indie-rock band Modest Mouse for
kick-starting this phenomenon, in emo
circles the trustafarian personality type
is a sensitive guy or girl who wears com-
plicated North Face windbreakers even
in the summer and insists on eating
bland vegan food despite not technically
being vegan.

ON THEIR iPOD
Built to Spill
Broken Social Scene
The Flaming Lips
My Morning Jacket

IDEOLOGY

< 2 0 >

INDIE EMO

Just like John Cusack's music-obsessed character in *High Fidelity*, an indie emo fan is an overtly intellectual music connoisseur who will probably finger-quote the word *art* too much in casual conversation. They will also pledge their allegiance to just about any emo band whose members claim to be influenced by either Radiohead or Can. Your typical member of this sect can usually be found in the back of the club, arms crossed, while the night's blog-approved opening band plays its brand of heady melodic rock to a whopping crowd of seven.

ON THEIR iPOD
Muse
Death Cab for Cutie
Bloc Party
Sigur Rós

CHRISTIAN EMO

This particular emo set is made up of some of the most devout fans around, many of whom continue to be huge proponents of even the most obscure bands on the Christian indie label Tooth & Nail. By and large, the Christian emo set is mostly a plainclothes bunch who don't dress—or often act—like many of their nonreligious counterparts. For example, Christian emo fans do not drink. Only with rare exception do they flatiron their hair. And, perhaps most alarming of all, their love for the modern-rock band Switchfoot is not at all ironic.

ON THEIR iIPOD
Underoath
Further Seems Forever
Pedro the Lion
Zao

IDEOLOGY

<22>

EIGHTIES EMO

Known for their asymmetrical hair-
cuts and an affinity for neon-colored
clothing, the eighties emo set is not
to be confused with fans of emo mu-
sic from the eighties, as there are
completely separate terms used
to describe such people. ("Old"
is the first one that comes to
mind.) In this much younger
set, stylistic cues are pulled
from the new-wave culture
most of the eighties emo
set wasn't alive to see
firsthand—think check-
ered Vans, inch-wide
leather ties, and a love
for contemporary East
Coast indie-rock bands who
sing in fake British accents.

ON THEIR iPOD
Cobra Starship
Head Automatica
Men, Women & Children
Nightmare of You

FRAT EMO

Shortly after the 2001 mainstream success of the vaguely athletic-looking emo band Jimmy Eat World, frat emo types became an undeniable part of the scene's landscape. Often decked out in Abercrombie & Fitch or an oversized hooded sweatshirt bearing their universities' names, your run-of-the-mill frat emo fans can be easily spotted at the next show you attend based on the fact that they will either (a) be there with a traditionally "hot" girl or (b) look extremely bored when the band veers into a song off their first record.

ON THEIR iPOD
Taking Back Sunday
Yellowcard
The All-American Rejects
Jimmy Eat World

IDEOLOGY

GOTH EMO

Known for gravitating toward the "darker sides of life" despite the fact that they're always hanging out in front of Starbucks, emo goths are the easiest to spot of this bunch. Typically they're the ones who are dressed entirely in black (with maybe a bit of red for dramatic flair) and who look like they watched the "Helena" video by My Chemical Romance the night before and thought to themselves, "Dude, I'm *so* gonna rock that shade of eye shadow." If your friends are constantly making vampire jokes when you're around, this probably means you.

ON THEIR iPOD
The Misfits
From First to Last
Aiden
Suits-on-stage-era Alkaline Trio

MACHISMO EMO

Machismo emo is kind of like regular emo in reverse. Instead of being an over-sensitive bookworm who complains about never getting the girl, the machismo emo is often an overconfident former jock who gets laid all the time and occasionally, as in the case of former Midtown singer Gabe Saporta, writes searing punk-rock anthems about it. Surprisingly, your typical machismo emo types cocksure attitude isn't hampered by the fact that he's in his mid-twenties and still lives with his parents.

ON THEIR iPOD
From Autumn to Ashes
Midtown
Glassjaw
Senses Fail

IDEOLOGY

PROG EMO

In between comic conventions, the prog emo set has recently garnered its fair share of attention, as bands like Coheed and Cambria and the Mars Volta have begun releasing high-profile concept records that virtually no one—fans, band members, middle-aged jour-nalists—can accurately make sense of. Typified by a group of frumpy-looking gaming geeks and failed cartoon art-ists, prog emo devotees aren't as concerned with getting the girl as much as they are with saving the universe, and if that means sitting through a four-minute flute solo to do so, well, then, so be it.

ON THEIR iPOD
Circa Survive
The Receiving End of Sirens
Chiodos
Coheed and Cambria

EX-HARDCORE EMO

Though nowadays they mostly seem to be found in the white-collar suburbs outside of Chicago, ex-hardcore emo types have been a part of the scene's genetic makeup ever since hardcore pioneer and ex–Minor Threat screamer Ian MacKaye formed the melodic punk band Embrace. Today ex-hardcore emo fans are even more sensitive than they were back then, and have developed their own set of easy-to-spot characteristics: regrettable straight-edge tattoos, a hoodie-and-jeans fashion sense, and the ability to talk at great length about what it was like "back in the day."

ON THEIR iPOD
Silverstein
Set Your Goals
Rise Against
early Thursday

ALT-COUNTRY EMO

Though he is probably best known for his constant adornment of flannel, denim, and occasionally unkempt facial hair, your typical male alt-country emo fan will often look like a young Gram Parsons despite the fact that he has no idea who Gram Parsons is. Women, on the other hand, are usually sassy in that Southern belle sort of way—and, if you're lucky, they also will look a bit like indie-country siren Neko Case. Despite their sex, both genders will typically bond over the following: Uncle Tupelo (or its spin-off acts Wilco and Son Volt), Rolling Rock beer, and sentimental lyrics about touring in a van.

ON THEIR iPOD
Limbeck
Ryan Adams
Drive-by Truckers
Wilco

"EMO" vs. "SO NOT EMO"

There are many complexities to the emo ideology: values, mannerisms, religious beliefs, etc. But if we've learned anything, it's that emo is definitely hard to define but easy to spot. However, sometimes the people, places, and things you'd *expect* to be emo are in fact poseurs.* But don't be fooled by imitations. All emo is not created equal.

KEY:

☺ = EMO (Complacent, happy and, above all, emo.)

☹ = SO NOT EMO (Unhappy, un-emo and probably trying too hard.)

☺ = DECIDEDLY UNDECIDED (On the fence with their emo-ness.)

ASHLEE SIMPSON ☹

Before her infamous lip-syncing incident on *Saturday Night Live*, Ashlee probably would have been considered emo. She had star tattoos on her wrist, an asymmetrical hairdo and a badass collection of Chuck Taylors. These days, though, Ash' has undergone a serious Hollywood makeover and, let's face it, anyone within the direct bloodline of Jessica Simpson can never be considered emo.

$$E = MO^2$$

- Friendship with New Found Glory's Chad Gilbert = +5 emo points

* *n* For those in the emo know, imposters easily detected by their lack of sleeve tattoos and shallow knowledge of the Promise Ring's back catalog.

- Supposed affinity for plastic surgery = −3,003 emo points
- Rumors of supposed tryst with Fall Out Boy's Pete Wentz = +15 emo points
- Former relationship with Ryan "I Wish I Was Seacrest" Cabrera = −20 emo points
- Relation to Jessica Simpson = −500 emo points

TOTAL = −3,503 emo points

RULING = SO NOT EMO

JOHN MAYER ☹

Much like Maroon 5's Adam Levine and Matchbox Twenty's Rob Thomas, Mayer floats in the purgatory of emo-ness. He's a mainstream pop star, yet he writes sappy songs about girls and his lack of athletic ability. So doesn't that *automatically* make him emo? Unfortunately, no. Having both the endorsement of VH1 and Kappa Sigma fraternity brothers overpowers the sad and lovelorn lyrics Mayer sings on songs like "Your Body Is a Wonderland." Yes, the ladies love Mayer, and, sure, his love and affection for the female species is admirable, but most male emo-ites have no idea what to do with a woman's genitalia, therefore making it impossible to sing about them.

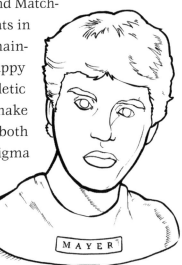

$$E = MO^2$$

- Dropping out of college to follow his dreams of singer-songwriter greatness = +30 emo points
- Dating Jennifer Love Hewitt = −50 emo points
- Guest starring on *The Dave Chappelle Show* and being surprisingly funny = +27 emo points

- Writing about heartbreak from a third-person perspective = −1,560 emo points

TOTAL = −1,553 emo points

RULING = SO NOT EMO

KELLY CLARKSON ☺

The case of Kelly Clarkson is tricky. Kelly herself is definitely not emo. She wears half shirts, is proudly from Texas, and has participated in choreographed dance numbers en masse without any of the required shame. However, when she released the hugely anthemic single "Since U Been Gone," Clarkson's past as a contestant on a crummy TV show quickly deteriorated. "Since U Been Gone" garnered the unexpected admiration of indie rocker Ted Leo, who recorded his own acoustic version of it, and Yellowcard's Ryan Key even turned up singing drunken karaoke with the former *American Idol* winner in a highly disseminated YouTube clip. The real smoking gun evidence in the case of Clarkson's alleged emo-ness, however, is this that the two middle-aged Swedish men who wrote "Since U Been Gone"—Max Martin and Lukasz "Dr. Luke" Gottwald—were listening to emo bands during the song's conception.

Now, we should probably take into consideration that Clarkson didn't even write the anthem that got her this kind of love—and if she ever hits her Faith Hill years, this book will *definitely* need a revision—but for now Kelly is one of us.

$$E = MO^2$$

- Performing a screamo*-infused rendition of "Since U Been Gone" at the 2005 MTV Video Music Awards = +50 emo points
- Being asked to perform at Bamboozle in 2007 = +100 emo points

* *n* A new strain of emo that emerged in 2002 and comprised a lot of emo bands who wore Diesel jeans and screamed all the time. However, the term *screamo* is now considered passé by most emo fans, probably because it sounds like the name of a breakfast cereal—i.e., "Scream-Os, they're *delicious*!"

IDEOLOGY

- Dating human Chia Pet Justin Guarini = −175 emo points
- Never *publicly* admitting to dating human Chia Pet Justin Guarini = +200 emo points
- Not taking (enough) acting lessons before starring in *From Justin, to Kelly* = −75 emo points

TOTAL = +100 emo points

RULING = EMO

JARED LETO ☺

Jared Leto has gone through numerous emo and non-emo phases. Playing greasy-haired aspiring rocker and leaning aficionado Jordan Catalano on *My So-Called Life?* Emo. Dating Cameron Diaz? Not so emo. Taking a hiatus from acting in the early 2000s so that 30 Seconds to Mars could go on tour with Nickelback? Not emo. Headlining on Taste of Chaos in 2007 alongside the Used, Senses Fail, and Chiodos? Emo. Dating Lindsay Lohan? Not emo. Gaining sixty pounds to play John Lennon's murderer, Mark David Chapman, in *Chapter 27*? Very emo. While Leto's ever-fluctuating state admittedly leaves him on the brink of looking like a total poseur, it also makes him seem like a confused teenager. And what could be more emo than that?

$$E = MO^2$$

- Costarring on the short-lived, emo-approved TV series *My So-Called Life* as Jordan Catalano, swoon-worthy slacker with a heart of gold = +35 emo points
- Dating Cameron Diaz = −200 emo points
- 30 Seconds to Mars performing with My Chemical Romance and Aiden = +50 emo points
- Dating Lindsay Lohan = −500 emo points
- Never *publicly* admitting to dating Lindsay Lohan = +200 emo points
- Still hasn't "found" himself = +1,000 emo points

TOTAL = +585 emo points

RULING = EMO

BILLY CORGAN ☹

The major problem here is that Billy is bald, and obviously it's hard to be completely emo without the requisite hairdo. There are, of course, exceptions to this rule (i.e., the Bald Dude from Mae, the Bald Dude from Simple Plan, the Bald Dude from the Jealous Sound), but Billy's lack of locks further hinders his emo potential. Billy is also a sports nut and is obsessed with professional wrestling. Odd . . . and definitely un-emo.

But on the other hand, just about every recent emo band has cited *Siamese Dream* as an influence—which somewhat serendipitously corresponded with Corgan blogging about how screwed up his childhood was on his official Web site. When you pair this with the fact that Corgan also released a book of poetry called *Blinking with Fists*, a title so deliberately precious and esoteric it might as well be a Matchbook Romance B-side, you might think that the former Smashing Pumpkin is straight-up Teflon emo. But the thing is, Corgan hasn't released a decent album in years, and his constant whining about the music industry isn't emo. It's just plain lame.

$$E = MO^2$$

- Having a cosmetic skin condition that translates into avoiding sunlight at all costs = +12 emo points
- Obsession with wrestling and other organized sporting events = −8 emo points
- Releasing a book of poetry = +25 emo points
- Being old, whiney, *and* musically inconsistent = −50 emo points

TOTAL = −21 emo points
RULING = SO NOT EMO

MORRISSEY ☺

This is a no-brainer. Plus, his sexual ambiguity, antisocial nature, and insistence on a vegetarian diet definitely overrules the fact that he's, like, really old now. While he might be unaware of his massive influence on the emo set, Stephen Patrick Morrissey is credited as being one of emo's founding fathers, and without him song titles would be less than four words long, *brood* would be another term for a group of young animals born and reared together, and Brand New would have had to rip off Robert Smith instead.

$$E = MO^2$$

- Sexually ambiguous = +1,000 emo points
- Influence on future blazer-wearing emo generation = +1,000 emo points
- Antisocial = +1,000 emo points
- Having scene hair, even in his late forties = +1,000 emo points

TOTAL = +4,000 emo points
RULING = EMO

NANCY KERRIGAN ☺

Nancy Kerrigan is probably the most emo ice skater ever. There is no denying this. When Kerrigan was clubbed in the knee after rehearsing for the 1994 U.S. figure skating championship, she cried so much that she nearly surpassed the *Guinness Book of World Records* holder for most tears shed in a half-hour period—and with this, her emo potential increased exponentially. After winning America's heart with her sadness, suffering, and Scünci'd ponytail, Kerrigan even went on to compete in the Lillehammer Olympics and managed to snag a silver medal.

$$E = MO^2$$

- Screaming, *"Whhhhhyyyyyy me? Whhhhhyyyyyy me?"* at the top of her lungs after being clubbed in the knee = +400 emo points

- Making disparaging remarks about Walt Disney at a Disneyworld parade = −250 emo points
- Pairing with Dave "Uncle Joey" Coulier on *Skating with Celebrities* for—*shocker*—Fox = −100 emo points
- Wearing Scüncis = −25 emo points

TOTAL = +25 emo points
RULING = EMO

HILARY DUFF ☺

While we doubt she would ever introduce herself as emo now, Duff *was* a classic case of emo by association. When she was dating Joel Madden of Good Charlotte, she was about 75 percent emo, maybe 80 percent when she was sporting a sterling-silver brass-knuckle necklace. However, by herself, Duff's emo stock has plummeted to zero and she is just a former tween* queen who could probably stand to eat a sandwich. And take a singing lesson.

$$E = MO^2$$

- Dating Good Charlotte's Joel Madden = +150 emo points
- Acting in movies like *The Perfect Man* and *Raise Your Voice* = −150 emo points
- Being thin = +15 emo points
- Being too thin = −15 emo points

TOTAL = 0
RULING = DECIDEDLY UNDECIDED

* *n* A commonly-targeted demographic by the Disney Channel, "tween" is the conjunction of "between," "pre-teen" and "teenage," and usually describes an eight- to twelve-year-old child who owns every Hilary Duff album and never misses an episode of *That's So Raven*.

PARIS HILTON ☹

Just to make this clear, Paris Hilton is not, nor ever will she be, emo. Not if she wears black Converse with black shoelaces, listens to Taking Back Sunday, and has a LiveJournal. Not if she dyes her hair black, wears Cranberry MAC eye shadow, and can explain the ending to *Donnie Darko*. Not even if she becomes straight edge, changes her AIM screen name to xfromwentzyoucamex, and starts dating Gerard Way. Paris. Hilton. Is. Not. Emo. Period.

$$E = MO^2$$

- Dating Sum 41 frontman Deryck Whibley (pre–Avril Lavigne) = +200 emo points
- Inspiring the tagline "See Paris Die" for 2005's *House of Wax* = −300 emo points
- Going to Warped Tour to see former flame Whibley perform = +100 emo points
- Being Paris Hilton = −10,000 emo points

TOTAL = −10,000 emo points
RULING = SO NOT EMO

STUFF

BLACK EYELINER ☺

It doesn't matter if you pick up a stick at the drug store or the beauty counter at your local department store. It doesn't matter if you're a boy or a girl. It doesn't even matter if your eyes are sunken in or pop out à la Jennifer Wilbanks, *The Runaway Bride.* Everyone is more emo with black eyeliner. The biggest secret to achieving emo eyes is to blend. Looking like a raccoon is *so* passe.

$$E = MO^2$$

- Aiden's wiL swearing by MAC Cosmetics = +250 emo points
- In a bind, using a black Sharpie to line your eyes = −850 emo points

- Being able to reapply without using a mirror = +175 emo points
- Extending eyeliner beyond the corner of the eye, creating a wing = +875 emo points

TOTAL = +450 emo points
RULING = EMO

iPODS ☺

An MP3 player by any other name would not be as emo. Actually, come to think of it, try even *naming* another MP3 player. Go ahead and take a minute. We dare you. What? Can't think of any? Yeah, we didn't think so.

$$E = MO^2$$

- More convenient (and less exhausting) than lugging your entire CD collection around with you = +500 emo points
- Your dad and tenth-grade history teacher both own one = −75 emo points
- The Muse song "Sunburn" scored an iPod commercial = +100 emo points
- They are super-expensive and there is a new model every six months, which, essentially, makes your current model obsolete = −200 emo points

TOTAL = +325 emo points
RULING = EMO

RED BULL ENERGY DRINK ☺

Whether you drink yours straight from the can or prefer it with vodka, Red Bull is more emo than Jake Gyllenhaal at a Bright Eyes concert. Considered the only acceptable stimulant for the straight-edge set, without it not only would emo bands fall asleep at the wheel while driving through the night from city to city, but emo fans would poop out before putting the finishing touches on their late-night Live-Journal entries. Now you wouldn't want that to happen, would you?

$$E = MO^2$$

- Often required on emo bands' tour riders = +1,000 emo points
- Rumors that Red Bull's stimulant ingredient is linked to the formation of brain tumors = −150 emo points
- Will give you the energy to sit through all twenty-four episodes of a *24: Season Four* marathon = +300 emo points
- Consumed by Paris Hilton = −500 emo points

TOTAL = +650 emo points
RULING = EMO

JAPANESE CARS ☺

The official car of an emo teen is a Toyota Corolla or Honda Civic—both Japanese. It's no wonder that a country whose citizens are born with hair the color of Manic Panic Deadly Nightshade and possess a flair for over-accessorization are also responsible for producing the most preferred method of emo transportation. Just know that the back window and bumper should be covered in band stickers and Peta2 propaganda at all times. Bonus points for covering the interior with buttons, meet-and-greet sticky passes, or concert tickets.

$$E = MO^2$$

- Automatic windows and roomy backseat = +100 emo points
- Naming paint jobs "Desert Sand Mica" and "Sapphire Blue Pearl" = −50 emo points

- Plastering the back bumper with Peta2 stickers like MEAT'S NO TREAT FOR THOSE YOU EAT = +75 emo points
- Car names less than eight words long = −25 emo points

TOTAL = +100 emo points

RULING = EMO

PUPPIES ☹

Cute? Yes. Cuddly? Of course. Codependent? You bet. At first glance, puppies would seem totes* emo by relying on the kindness of strangers to house them, feed them, bathe them, and pick up their poop. However, not even a studded collar can cover up the fact that puppies are, *well*, just that. Puppies. Not only do they lack the mental capacity to understand the inner workings of the Internet, but they also can't name the last three releases on Drive-Thru Records. Adorable as they may be, puppies fail the emo test—paws down.

$$E = MO^2$$

- Kissable faces = +150 emo points
- Not being house-trained = −300 emo points
- The recent availability of hoodies for dogs at American Apparel = +50 emo points
- Not recognizing the *word* blog—or *b . . . l . . . o . . . g . . .* = −500 emo points

TOTAL = −600 emo points

RULING = SO NOT EMO

* *adv* Truncated form of the word *totally*. Most often used by people who are constantly messaging each other on AIM. *See also: cruc* for *crucial, perf* for *perfect,* and *howevs* for *however.*

IN THE TIRELESS DEBATE OF EMO vs. SO NOT EMO, UNDER NO CIRCUMSTANCE SHOULD YOU EVER CONFUSE EMO WITH:

- EMO, short for *Emergency Machine-Off,* commonly known as the big red button on industrial equipment
- EMO, short for *Electronic Money Order,* a form of online currency
- IMO, that creepy sour cream substitute your weight-conscious aunt always has stocked in her fridge

fash•ion n Collection of clothing that you will revolve your entire existence around and that will cause you to say things like "I'm so glad leggings made a comeback" without the slightest hint of irony.

Fashion has always been important to emo fans. Dating back to the *really* early days of the scene, when William Shakespeare wore broderie anglaise frilly tops and high-rise trousers were all the rage, emo fans have long used fashion as a way to express their differences while still looking pretty much the same.

Acknowledging the power that emo fashion has over the scene is one thing, but wrapping your head around emo fashion is quite another. In the hope of dressing yourself properly, you have to know the basics. Not only do true emo fashionistas understand the rules of fashion, but they can apply them accordingly, and when unable to, say, find that top in their size, they can grab a pair of scissors and improvise.

Fashion is not something that emo fans take lightly. Nailing the perfect emo look is all about the details. From top to toe, no item—or accessory—is too small to agonize over. After all, there's a huge difference between merely looking the part and truly understanding the ins and outs of emo attire.

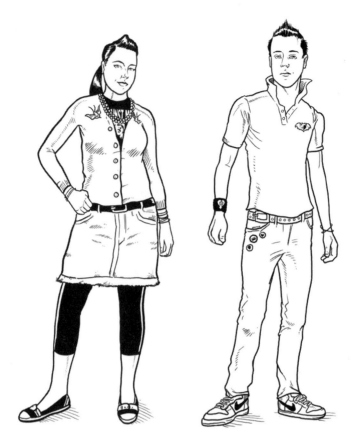

PRINCIPLES OF EMO DRESS
FOR GUYS AND GIRLS

Putting together a smokin' emo outfit isn't as easy as looking in your closet and doing the smell test to determine what's clean. There are rules you must abide by in order to sport what the emo masses consider successful emo attire. It's all about what band is emblazoned on your chest . . . and how tight the diameter of your pegged pants are . . . and how much you paid for those limited-edition Ice Cream Teddybear Flavor shoes at Sportie LA. Consider the following principles of dress a refresher course for those in the emo know.

GUYS

BAND T-SHIRTS: All tees should be made of 100 percent cotton and, ideally, should be produced in the United States, à la American Apparel or other like-minded companies. It's not that you care about boycotting sweatshop labor; it's just that tees produced in the U.S. are somehow inexplicably softer than those produced in, say, Indonesia. Choose carefully because you are what you wear. For example, there's a huge difference between rocking a Bane tee or a Something Corporate tee. The Bane tee says: "Sure, hardcore runs in my blood, but I'm not above listening to a little Saves the Day to get in touch with my sensitive side." The Something Corporate tee says: "Piano rock, well, rocks, and there's nothing wrong with owning *Billy Joel's Greatest Hits* on vinyl, cassette, *and* CD, right?"

> **Acceptable:** Any band playing the Vans Warped Tour or Bamboozle.
> **Not Acceptable:** Any band playing Bonnaroo or Gathering of the Vibes.

POLOS: Primarily a preppy staple, polo shirts have had an emo resurgence in recent years thanks to people like Bayside's Anthony Raneri and Buddy Nielsen cleaning up their act—fashionwise, of course. Many emo-approved clothing companies now produce polos, complete with broken-heart appliqués and silk-screened stars. However, the most emo way to wear said polo is to tip up the collar. Some say that this makes the wearer look like a d-bag;* we say it makes them look emo.

> **Acceptable:** American Apparel; Clandestine; Ordinary.
> **Not Acceptable:** Phat Farm; Ralph Lauren; Tommy Hilfiger.

* *n* Short for *douchebag*, meaning an idiot or someone who needs a good head cleaning.

FASHION

SWEATSHIRTS: The debate over whether or not sweatshirts are emo is not quite as simple as it seems. For example, you would think that hooded sweatshirts with a zipper (better known to emo kids as hoodies*) are unquestionably emo. But that's not exactly true. If you are, say, female, and wear an oversized hooded sweatshirt and *also* spend a fairly sizeable amount of time at the tanning salon, chances are you are not emo. The same could be said if you are a well-defined male and you wear a hooded sweatshirt that has your college's emblem on it. This would make you frat emo (as outlined in the previous chapter). Unless of course the college's logo was from a sweatshirt that was made before 1984; then you're just fashionably second-hand. For a while it seemed like crewneck sweatshirts were empirically un-emo, but they too have had a renaissance: a faded, heather-gray crewneck worn a few sizes too large on a girl has become not only acceptable, but also kind of cute.

Now, this probably all sounds a bit too selective or confusing. Your brain has probably swelled at this point. You probably can no longer recall half of the song titles on Fall Out Boy's *From Under the Cork Tree*. How complicated could wearing a sweatshirt be? But look, if you want to be able to wear sweatshirts without much thought, maybe you should move to Montana, disconnect your wireless router, and submit your application at the local Wal-Mart. *They* won't care if you want to wear a forest-green crewneck sweatshirt with a pair of indigo relaxed-fit Anchor Blue jeans.

* *n* A religious emo garment made with two pockets—or a one-pocketed kangaroo pouch—and a hood to hide any shame or insecurity.

Acceptable: Clandestine; Atticus; DCMA; American Apparel; assorted band hoodies.

Not Acceptable: Hollister; American Eagle; Abercrombie & Fitch; almost anything promoting a college, university, or technical institute.

JACKETS: For the stylish emo male, the only acceptable outerwear—second to sweatshirts—are blazers. In the summertime you can pair them with a T-shirt or tank top, and in the winter you can layer them over a hoodie or a crewneck sweater. The more tailored the better, and we would even suggest scoping out the women's section at your local thrift store—in case you don't already.

Acceptable: Black, brown, and/or gray; velvet, corduroy. and/or tweed.

Not Acceptable: Bright colors; long and double-breasted; made out of microfiber; anything with a school emblem or name tag on it.

JEANS: See Girls' Jeans.

Acceptable: Indigo-worn or faded wash; black jeans.

Not Acceptable: JNCOs; carpenter pants; anything with a drawstring at the waist or hem.

SHOES: When it comes to outfitting your feet, you need to remember only one word: canvas. Sure, the wind can cut through 'em like a knife and the arch support is nonexistent, but canvas kicks—like Converse high-tops and Vans slip-ons—are undeniable emo staples. However, if you've got money to burn and you want something a little more flashy, the only acceptable alternative is a pair of Nike Dunks, which usually cost a minimum of a hundred dollars and are sometimes so ugly, it's hard to look at them directly. Consider yourself warned.

Acceptable: Converse; Draven; Vision Street Wear; Vans.

Not Acceptable: K-Swiss; Timberland; Skechers; Birken-stock.

ACCESSORIES: Just because you're a dude doesn't mean that you can't enjoy the benefits of accessorizing. Here's an overview of emo-approved clothing garnishes.

- **Belts**

 Acceptable: Studded leather; seatbelt belt; soda-cap belt; strap belt.

 Not Acceptable: Woven leather; stretch; prong; grommet.

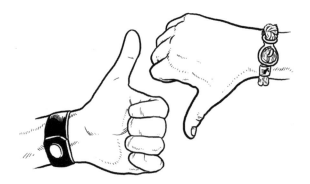

- **Wristwear**

 Acceptable: Terry-cloth wristband embroidered with band name or ironic saying (i.e., MORE ME, LESS YOU or LICENSED TO ANNOY); jelly bracelets (only if worn sparingly); leather cuffs.

 Not Acceptable: Rubber spikes; leather- or whitewater-braided cuff; anything made out of hemp.

- **Ties**

 Acceptable: Skinny; shiny; anything in a black, white, or red hue.

Not Acceptable: Wide ties; plaid; anything designed by Jerry Garcia.

- **Rings**
 Acceptable: None.
 Not Acceptable: All.

GIRLS

BAND T-SHIRTS: Much like their male counterparts, emo girls have to make very deliberate choices when deciding which bands to endorse on their chests. However, there is one important key to keep in mind: Just because you rock a band's tee doesn't mean that you have to rock along to the band's music. You'll seem way more emo if you choose to wear a tee with the Bronx's White Drugs logo on it, regardless of whether or not you can even name one song in the entire Bronx catalogue.

　　Acceptable: Any band opening for Against Me! or headlining ABC No Rio.

　　Not Acceptable: Any band opening for Nickelback or headlining the local rib cook-off.

TOPS: With the emphasis on layering, some might argue that an emo girl's top is rarely seen, so why bother? And to that we say, "What if Capitol execs told Yellowcard not to bother with the fiddle player because, well, you couldn't always hear him?" The point? Both scenarios would be below par without the added hint of flair. And so emo girls' tops should be form fitting, regardless of how much the girl weighs. Sleeve length can vary from the tank top variety to short sleeves to cap sleeves to three-quarter-length sleeves. Ideally, tops should be either striped, ruffled, polka-dotted, off-the-shoulder, or V-necked. Extra points to anyone who can find all of these elements in *one* top.

Acceptable: Drop-waist tunics; long-sleeved boat-neck tops; anything with ruche.

Not Acceptable: Tube tops; turtlenecks; halters.

CARDIGANS: Emo types might not like to hang out at the library, but they do yearn to look like they like to hang out in a library. Some consider it librarian chic; others simply call it just another layer to peel away on the emo fashion onion. We recommend cardigans with pearl buttons and some kind of flash-tattoo-inspired imagery like sparrows, cherries, or crossed guns.

Acceptable: E.C. Star; Adeline Street; anything that was handed down from your granny and faintly smells like mothballs.

Not Acceptable: Knit cardigans; cropped cardigans and/ or shrugs; anything with a roll-neck, pockets, or toggle buttons.

JACKETS: If you're an emo girl, your goal, above all, is cuteness. If you're dressing properly, there is no reason you should need a jacket in the summertime, and anyone who tells you otherwise is a liar and a fool. However, unless you live on the equator, there is no such thing as summer all year-round. And so, when it's time to top off that emo-prizewinning outfit with a layer that can withstand the elements without losing any of its cuteness, there's only one way to go: parka. Not only will a good parka keep you warmer than a polar bear, but it will also make you look kinda like a polar bear, and, c'mon, what's cuter than a polar bear? "But what about blazers?" you may ask. Sure, blazers are obviously acceptable, but anything that makes you look like a furry animal is automatically cute—and emo.

Acceptable: Parkas; fitted blazers; faux fur coats.

Not Acceptable: Fleece pullovers; madras blazers; barn/ trench coats.

JEANS: When it comes to jeans, the same rules apply to emo guys and girls. You shop in the same department, so it shouldn't come as such a shock. There are three options: straight leg (self-explanatory), pegged (kind of like tapered, but slimmer in the thighs and way more punk), or floods/capris* (hemmed between the middle and the bottom of the calf so as to show off your black-and-white striped knee socks). If you are overweight, we recommend straight leg (which gives the illusion of a thinner torso); if you are short, we recommend pegged (which gives the illusion of a longer leg); and, if you are as tall as Gabe Saporta, we recommend floods/capris (which give the illusion of nothing, but, hey, maybe you have nice ankles that are worth showing off). Unfortunately, emo girls should stay away from any pants not made of denim.

Acceptable: Indigo-worn or faded wash; black jeans.

Not Acceptable: Flared; bell-bottoms; anything with the words *loose* and *fit* in the description.

SHOES: While, yes, true emo girls recognize the importance of canvas footwear—like Converse, Vans, and Draven—they are also aware that sometimes a girl wants to look like, well, a girl, and for that, there are many options. If you need a little lift, try kitten heels. They'll make your calves look fierce and add just the right amount of height so you can see over vertically challenged dudes at the Dash- board Confessional concert. Also, ballet flats are key. As opposed

* This has become a pointless debate among emo types. Capris, it is understood, are for girls and floods are for guys. Both are pants that are hemmed to hit near the mid-calf or just below the calf. However, for some reason, emo guys get really touchy and sensitive when you tell them they're wearing capri pants instead of floods.

< 5 0 >

to pointy-toed shoes, which are most often associated with hipsters and girls who work the front desk at your local Body Rayz tanning salon, rounded toes are not only more sensitive to your toe bed, but they also remind us of shoulders, which remind us of crying, which reminds us of Bright Eyes, which reminds us of being emo.

Acceptable: Kitten heels; skimmers; ballet flats.

Not Acceptable: Clogs; stacked heels; moccasins.

ACCESSORIES: To an emo girl, accessories can oftentimes be more important that the outfit itself. Here's a rundown of emo-encouraged accessories and avoidable trend potholes.

- **Belts**

 Acceptable: Studded leather; elastic O-ring; double-wrap.

 Not Acceptable: Medallion; macramé; ribbon.

- **Purses**

 Acceptable: Tote; hobo; envelope clutch.

 Not Acceptable: Basket weave; mesh; anything from Coach.

- **Necklaces**

 Acceptable: Layered and multiple strands of (fake) pearls; anything with a heart, lightning bolt, or bow charm; chunky beads.

 Not Acceptable: Hemp; T necklaces; lace chokers.

- **Earrings**

 Acceptable: Dangling guitar picks; cut-out star; over-sized plastic hoops.

 Not Acceptable: Chandelier; pull-through; anything made out of mother-of-pearl.

TATTOOS

Though tattoos are an integral part of the current emo landscape, in the beginning they were mostly bad. You can replace the word *mostly* in that last sentence with the word *really*. Early emo tattoos were often etched by a makeshift tattoo gun consisting of a Walkman engine, guitar string, and needle, and were mostly of stars, hearts, or moons. Obviously, this was a dumb idea. Many people who have these tattoos are now thirty-five and will probably feel the need to wear long-sleeved shirts and pants for the rest of their lives. Fortunately, things have changed significantly. One major reason for this is that emo fans now know what kind of tattoos they absolutely should *not* get.

For instance, it is understood that full scenes from any Tim Burton movie are acceptable while any scenes involving Warner Bros. cartoon characters are not. If you ever get Marvin the Martian tattooed on you, please stop going to shows immediately and promptly apply for a job at your local Jiffy Lube. In addition, certain more masculine tattoos are acceptable as long as they are of anchors, maidens, or any other old-school, Sailor Jerry–inspired artwork. The one style of tattoo that is absolutely off-limits for emo fans is the tribal tattoo. This is non-negotiable. Tribal tattoos belong to the meathead athletes you went to high school with and the bald dude from Staind. It is important to stress that anyone who has a tribal tattoo cannot be trusted or liked. This includes anyone in an emo metal band. Sure, some of those bands are good. But look, they made their "I'm a jerk with a bad tribal tattoo" bed, they can lie in it.

Now, admittedly, these rules are pretty obvious.

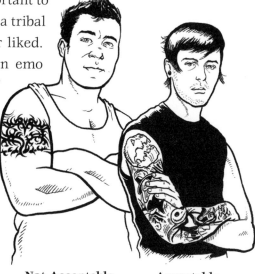

Not Acceptable **Acceptable**

FASHION

But there is some gray area we need to address. For instance, what about pledging your allegiance to a certain film or band? Seems like a good idea, right? Well, it can be, depending on *which* film or artist you choose. For instance, getting the winged insect from the Coheed and Cambria record tattooed on your bicep might seem like a great idea if you are an overweight high school senior, but ten years from now, explaining to a potential love interest that you were really into a band that wrote epic concept albums about intergalactic warfare might be a *smidge* embarrassing.

This rule doesn't just apply to emo fans—it goes for the bands, too. See, for instance, the All-American Rejects guitarist Nick Wheeler, who not only has a scene from *The Muppets Take Manhattan* on his arm but the cover of Bon Jovi's *New Jersey* and Def Leppard's *Hysteria* tattooed on his back. Now, let's talk about this for a moment. *Hysteria?* Seriously—*Hysteria?* This is the one Def Leppard album that causes nearly all drunk women in their mid-thirties to shake what God gave them every time "Pour Some Sugar on Me" comes on the jukebox in dive bars across the country. Why on earth would you ever want the image of an aging, overweight woman wearing a neon-yellow tube top, chain-smoking Winston Lights, and mouthing lyrics like "I'm hot sticky sweet" associated with a part of your body for *the rest of your life?*

This is what we mean. Tattoos are permanent, so keep your references timeless. A Smiths lyric tattooed around your ankle? Perfect. A silhouette of John Cusack as *Say Anything*'s Lloyd Dobler holding a boom box over his head? Also acceptable. But a mediocre hair-metal record like *Hysteria?* Yeah, not so much.

EMO HAIR GUIDE

Much like *Degrassi: The Next Generation* reruns and friend comments on MySpace, hair is a very important thing to your average emo fan. A certain hairstyle is not something you just rush into. Actually, given the styles listed in our guide below, maybe it is . . .

but that's not the point. The point is that if you are born an emo type you're often going to feel like an awkward social outcast and—for better or worse—you're probably going to look that way too.

BOYS

THE REVERSE FAUX-HAWK

This is quite possibly the most confusing emo hairdo ever. With its slicked-forward bangs and hair-sprayed sides, it's a faux-hawk—but for some reason in reverse—and it's allowed a lot of emo goth types the opportunity to look like the scary fat guy from A Flock of Seagulls.

THE BABY POMP

Short around the sides and combed in the front like a fifties greaser's 'do, this is a modern pompadour for wusses who aren't willing to commit to a lot of Aquanet. The Baby Pomp was originally made famous by Mexican American teenagers, Jesse Lacey circa *Deja Entendu*, and other emo types who think they're Morrissey.

THE HASIDIC

This haircut is inspired by Hasidic Jews and features a grown-out shaved head with excessive bits of hair in front of the ears. Over the years it's been a favorite of Panic! at the Disco's Brendan Urie and that annoying reggae rapper guy known as Matisyahu.

THE EMO COMBOVER

Short on the sides and the back, this hairdo centers on lots of sweeping bangs pulled over your forehead and tucked to the side of your face. Today's most prominent fans of the Emo Combover are Cute Is What We Aim For singer Shaant Hacikyan and a lot of male emo types who are going bald.

THE ADULT BOWL CUT

Once an emo staple, the bowl cut has been modified in recent years to include sheared sides, which allow emo fans in their twenties to look a little less as if their mother cut their hair. See: Death Cab for Cutie singer Ben Gibbard, or pretty much any Lego action figure.

THE FLATIRON STANDBY

Probably the most popular current hairstyle in emo, this 'do involves shoulder-length hair getting absolutely fried by a flatiron. The Flatiron Standby has been embraced successfully by the members of From First to Last as well as embraced unsuccessfully by a lot of curly-haired Jewish emo types who refuse to accept their genetic makeup.

GIRLS

THE ZELDA

This is the sort of haircut many teenage emo girls get the first time they hear the Descendents and want to piss off their parents. Incredibly short with blunt bangs, the Zelda was made famous by the Nintendo character, the film *Amélie*, and— duh!—F. Scott Fitzgerald's wife, Zelda.

THE WORKING-CLASS MULLET

Tucked into a short bob in the back with a mess of choppy highlights on the top, this haircut makes a lot of female emo fans look like their hair is throwing up from the tip of their skull. Seen mostly on cats, Joan Rivers, and emo types who hang out at the Manhattan hipster party MisShapes.

THE HAIR BLINDS

A decidedly impractical hairstyle that involves long locks that cut at the shoulders and bangs that hang somewhere between the bridge of your nose and your waist line. Hair Blinds have been popularized by Nico look-alikes, Cat Power's Chan Marshall, and female emo types who spend a lot of time bumping into things.

THE GUNSHOT WOUND

A longer version of the bowl cut with spiky hairs in the back standing at attention as if you have just been shot grassy knoll–style, this haircut has since been made famous by five-year-old little boys, lesbians, and Kelly Osbourne.

THE SIDE MULLET

An asymmetrical 'do that is not only uneven in the front and the back but also the sides, this haircut will seem totally awesome until it starts growing out. Initially made famous by the Yeah Yeah Yeahs' Karen O, the Side Mullet has since become popular with a lot of emo types who apparently let blind people cut their hair.

EMO FASHION
DO'S AND DON'TS

Sure, you can compile all the necessary emo fashion tools, but it's up to you to put together a *successful* emo outfit. Here are some of the most important emo fashion do's and don'ts. Feel free to take notes.

DO wear a bandanna. Emo-approved styles include wrapping it around your wrist, draping it around your neck bank-robber-style, or carefully placing it in your back pocket so half of it hangs out.

DO fasten your belt on the side. If you wear your belt buckle in the front, you might as well be wearing mom jeans and driving a minivan. Besides the fact that bulky buckles stick out and give the illusion of a belly (or a larger belly, at that), sidesaddle belts are another celebration of emo's appreciation for asymmetry.

DO layer. Nothing says emo like a cardigan over a hoodie over a tank top over a T-shirt. Just like the layers of an onion, the more clothing you can peel off, the deeper you are.

DO sport labret or Monroe piercings. Pierced ears come standard for most emo models, but for some that's not enough. However, pierce sparingly. Remember, less is more. And, no matter what anyone tells you, navel piercings are only for

strippers and Kappa Kappa Gamma sisters who spring-break in Panama City, Florida.

DO wear tunics. Tunics are the middle child between T-shirts and dresses. More flattering than wearing a dress over jeans (see DON'T section below), tunics, if worn in conjunction with the aforementioned layers, can hide all your problem areas without ever losing a shred of style.

DO dress like your favorite band. This one is critical. For example, if you're a girl wondering what kind of bracelet to wear with a vintage T-shirt look no further than Paramore singer Hayley Williams. If you are a guy looking for a snug-fitting blazer check out Death Cab's Ben Gibbard. Pulling cues from your favorite bands is generally deemed acceptable, however . . .

DON'T dress like your favorite band if you can't afford to. This means anyone who wears black Dickies, a pair of dogged black skate shoes, and a studded belt and thinks that it makes them look like a member of Aiden. Ditto for those who try to dress like the members of Panic! at the Disco. Unfortunately, buying a paisley-print vest at T.J. Maxx and wearing one of your mom's blouses isn't going to cut it.

DON'T outline your eyes in red or black eye shadow. The result of this makeup maneuver is affectionately called raccoon eyes, which is *not* a compliment. If you're going for the embalmed look, then mission accomplished. However, just because Gerard Way got away with it once doesn't mean *you* can.

DON'T wear jelly bracelets up to your elbow. Unless we missed the memo, rave culture went out with the Clinton era, so please toss your jelly bracelets, JNCO jeans, and bike-chain necklaces into the trash. Sure, they might reappear in a couple years,

FASHION

but we don't think Claire's is going out of business anytime soon, so you'll have plenty of time to reinvest.

DON'T wear bows in your hair. There's a difference between embracing your youth and looking like a five-year-old, and when you sport bow clips, it's definitely the latter. Plus, don't be surprised if tiny knickknacks in your hair make your head look huge, which is not at all emo.

DON'T wear a dress over jeans. If dresses were meant to be worn on top of jeans, they'd be called shirts. And, if we recall correctly, there are already things called shirts. So there goes your first argument. Furthermore, if you're wearing pants underneath for warmth, then it's probably too cold to wear a dress in the first place. Turn on the Weather Channel and plan accordingly. If you're wearing pants underneath because you're self-conscious about your legs/tummy/calves/etc., then why accentuate the negative? The dress is simply an insecurity accomplice. Finally, if you're wearing pants underneath because you think it looks good, you're wrong. Point blank.

DON'T wear girls' jeans if you can't fit into girls' jeans. And that goes for emo girls *and* guys. If it physically hurts to fasten the jeans and/or you've got a chef's hat* creeping over the top, that means you need a bigger size. Belly blubber doesn't look good on

* *n* Named for the tall, round, pleated hat worn by most professional cooks and referring to the roll of fat that dangles over a pair of jeans when they're are too small. Also called a *muffin top*.

anyone, regardless of whether it's encased in an Ordinary Vertigo polo.

DON'T over-manscape* your body hair. Sadly, the most tragic current example of this is Hawthorne Heights drummer Eron Bucciarelli, who has plucked and waxed his once-bushy eyebrows so that they are now at a constant arch. Fact: This does not make you look sexy or intriguing. It makes you look scary and it probably freaks out about 95 percent of the people you meet.

DON'T put on a band's T-shirt immediately after you buy it at the merch table. This maneuver screams emo amateur. Instead, if you're a girl, shove the shirt into your tote bag, and if you're a guy, stuff it into the back of your pants so it hangs like a tail. Acting like you don't care is essential.

CUSTOM THREADS

When you don't find something you like, the emo way is to customize. Whether that means hand-stitched tailor jobs or coloring with a Sharpie, items uniquely your own are a key part of the emo fashion philosophy. But before you just jump into making a halter top out of duct tape—and please don't do that; we're pretty sure it would look *awful*—you need to know the key items you must have in order to properly do it yourself.

☑ **A variety of needles and colored threads.** We cannot stress this enough: In the world of emo, if you do a good job tailoring

* *v* Removal or grooming of unflattering male hair. This includes nearly everything other than your sideburns and bangs.

your clothes, you are going to look pretty stupid. Tailoring your clothes so that everything looks slim-fitting is cruc', but so is doing this in a way that you can see the stitching. If you decide to take in the sides of a brown V-neck sweater, for example, you should go with a highly visible red or yellow thread and leave wide spaces between each stitch so that it partially looks like you let a near-sighted eighty-year-old do the alterations. Like many of the codes of conduct of DIY fashion, this doesn't make a whole lot of sense, but it does suggest to those around you, "I made this!" even if it does, you know, kind of look like crap.

☑ **A roll of heavy-duty duct tape.** This sticky adhesive is used to cure household accidents like a tear in your front yard's garden hose. It is not particularly attractive and there is no real reason why emo types love duct tape the way they do. But for some reason applying it to your clothes (primarily over the front of a pair of Converse All-Stars) has long been a fashion staple. For more proof, see the emo-approved Bay Area pop-punk band Crimpshine's first record, *Duct Tape Soup*, and the Long Island screamo band the Movielife, who once wrote a song called "If Only Duct Tape Could Fix Everything."

☑ **An older relative who was legitimately into heavy metal.** An older cousin or sister can be invaluable for any fledgling emo type. One reason for this is that they probably held onto that now faded-to-gray Iron Maiden concert T-shirt they bought on the *Seventh Son of a Seventh Son* tour, which is exactly the kind of thing you can expect emo fans to sew onto the back of their jean jackets or black hooded-sweatshirts. Also, a lot of emo girls like to cut these shirts into asymmetrical tops that slouch off their shoulders and look like something Madonna would have worn in the mid-eighties right before she began dressing like a dominatrix and dating total morons like Warren Beatty and Vanilla Ice.

☑ **A sharpie marker.** Though they still come in handy for those moments in life when you unexpectedly find yourself at the Metro in Chicago and decide to scrawl EFF HEY CHRIS onto the walls, Sharpies can also prove to be quick solutions for boring white T-shirts and the rubber half-circles on the front of your Converse All-Stars. Need another, more impressively emo use of a Sharpie? Just watch as a seventeen-year-old girl in line at your next Alkaline Trio concert begins filling in her nails with a marker upon realizing that she showed up with two shades of mascara, and a red neckerchief, yet totally forgot to pack any black nail polish.

RULES TO EMO ARTIST–RUN CLOTHING LINES

With so many fashion outlets aimed at emo fans, it's inevitable that emo artists would also want to get in on the act. At this point the most notable artists to have done so are former Blink-182 frontmen Tom DeLonge and Mark Hoppus (who in the early 2000s ran Macbeth and Atticus, respectively), Good Charlotte's Benji and Joel Madden (who run DCMA Collective), and Fall Out Boy's Pete Wentz (who oversees Clandestine Industries). These musicians' companies all seem to offer the same items (hoodies, T-shirts, mesh hats, etc.) but, more important, these musicians seem to run said companies based on the following five rules.

RULE NO. 1: Insist that you're "not just a T-shirt company" even though your target audience has about as much fashion sense as *The O.C.*'s Ryan Atwood and prefer to only wear T-shirts. This rule basically means that you should never allow your company to become a high-fashion line because, let's face it, emo types don't wear high fashion. For a while it looked as if Benji and Joel Madden—two punk dudes who set the precedent for clothing companies run by emo icons—were abandoning their T-shirt roots when Made, the company the

F A S H I O N

< 6 2 >

Madden brothers formed in 2002, all but disappeared. Though Made began as a T-shirt company that emblazoned all of its clothes with a simple brass-knuckle logo, it seemed to vanish when the twins started wearing white suits all the time, began constantly hanging out in Lower Manhattan, and decided that they wanted to be "real" fashion designers. When news of this reached the kind of people who bought Made T-shirts, none of them seemed to even remotely care, and soon DCMA Collective T-shirts were printed, hoodies were sold online, and the universe resumed functioning.

RULE NO. 2: Institute unsaid rule that during every photo shoot or live television appearance, you must be wearing an item of clothing from your own clothing line. This is not exactly a new rule. Emo senior citizens Samiam initiated this rule's groundwork when they gained an endorsement deal from a renowned sneaker company in the early nineties and became contractually bound to wear Converse sneakers during all of their live shows. At the time, this seemed weird to emo types who, for some reason, had a problem with their favorite band getting free clothes. Understandably, this no longer seems weird to anyone. Nearly all emo artists follow this code of conduct, and go even further by emblazoning their companies' logos onto the hoods of cars, perfectly good suits, drum kits, small children's faces, etc. Which brings us to the next rule . . .

RULE NO. 3: Waste lots of money. Chances are, you can afford to.

RULE NO. 4: Ironically act as if your clothing line is part of a hip-hop-like dynasty but also secretly wish that it were. The importance of this rule is kind of cloudy. Admittedly, creating the illusion of a "dynasty" doesn't benefit most emo fashion lines, but it is pretty funny to watch a lot of suburban emo types act like they are aspiring hip-hop moguls. This is best exemplified with Clandestine Industries and DCMA Collective. You can't read an in-

terview with Wentz these days without
seeing at least thirty-two mentions
of how he knows Jay-Z and,
similarly, the Madden broth-
ers have recently buddied
up with Houston rapper and
grillz* connoisseur Paul Wall.
While this may make you won-
der why a pop-punk band that's
obsessed with *The Nightmare Be-
fore Christmas* would want to prove
they are friends with a chubby guy
from Texas who makes diamond-
encrusted gold teeth on the side, it
also brings up an interesting side
argument: Is being into hip-hop

something that comes with being emo? There are a few ways to
answer this question.

On the one hand, desperately trying to prove that you are into
hip-hop—as the rule above implies—is totally emo. At one point,
without exception, every emo fan will try to impress someone by
claiming to be into "intelligent" rap artists like Talib Kweli. But
does that mean hip-hop fans in turn relate to emo artists? Not so
much. Despite mild fan interest and the emergence of emo rap
acts like Atmosphere and Gym Class Heroes, real hip-hop heads
could pretty much care less about emo bands. They do not read
AbsolutePunk.net. When there are disputes in hip-hop, they solve
them with gunplay, not on the Internet. They do not perpetuate
their "beefs" by saying cryptic things in interviews with MTV.com.
They shoot people. Hip-hop artists do not sit in their rooms and

* *n* Caps that fit over your teeth and are usually made out of gold or platinum.
Although made famous by rappers like Lil Wayne and Paul Wall, *fronts*, as they
are alternately called, have also made appearances in the mouths of emo icons
like Adam Lazzara.

pine over their last breakup. These are people who actually have sex all the time.

RULE NO. 5: Give free clothes to bands that are significantly less popular yet understandably much cooler than you. The primary upholders of this rule are Atticus and Macbeth, who have spent the last few years outfitting a lot of broke-ass emo bands. Now, it is important to stress that this is not something that most rich people do. Rich people, as far as we can tell, own yachts and bathe in champagne. But there is a slight difference between actual wealth and pop-punk wealth, and when DeLonge and Hoppus unload boxes full of fifty-five dollar hooded sweatshirts onto emo bands who otherwise couldn't afford fifty-five dollar hooded sweatshirts, they recognize the importance of being down.*

WHAT TO WEAR

Emo types are all about apparel appreciation. What follows is a list of Web-friendly retailers, mall standbys, and independently owned boutiques where you can get your shop on.

31 CORN LANE (31CornLane.com) Now emo's premiere tote line, 31CL's shoulder-candy empire was started back in 1998 by the Sperber sisters when they used to let bands like At the Drive-In crash at their pad in New York City.

ALLOY (Alloy.com) Sure, the main draw is emo shoes (the camo ballet flats kick ass), accessories (aviator sunglasses), and apparel (sizes 0 to 25), but Alloy also offers movie trailers, suggested book-club titles, and a dude decoder.†

* Embarrassing attempt to understand someone who is unlike you. For example, when your parents say, "I was just getting jiggy with it" while listening to contemporary jazz.

† We're not quite sure what a dude decoder is, but we're positive that no emo

AMERICAN APPAREL (AmericanApparel.net for store locations) If you have thirty-eight dollars to blow and you absolutely, positively need an olive-green polo on, say, five minutes' notice . . . well, then American Apparel is here for you.

ANOMALY FIVE POINTS (1021 Park St., Jacksonville, FL; 904-354-7002) By definition *anomaly* means "different from the norm," and while emo garb tends to be pretty formulaic, this Jacksonville emo gem offers you just the right amount of uniqueness without seeming too individualistic.
IN STOCK: Johnny Cupcakes, Threadless, No Star, Soundgirl, OK 47, Triple Five Soul

BARRACUDA SHOP (7600B Melrose Ave., Los Angeles, CA; 323-852-7179) Hardly your run-of-the-mill bait-and-tackle store, Barracuda Shop carries limited-edition swag from all over the world, which makes it a haven for emo couture collectors.
IN STOCK: Nike, Gsus, Stussy, No.l.ita, Religion

BLEEDING STAR CLOTHING (BleedingStarClothing.com) Not only does Bleeding Star's Web site drip with pink stars and broken hearts, but so do the company's designs, which are printed up on T-shirts, hoodies, and track jackets.

COMMANDER SALAMANDER (360 Talbot St., London, Ontario, Canada; 866-732-3353) Got kitsch? Not only does this Canadian catch fill your closet with drool-worthy emo threads, but it'll also help furnish your humble abode with emo-friendly home décor.
IN STOCK: Paul Frank, Hello Kitty, Emily the Strange, Edward Gorey

girl should be without one.

CREAM VINTAGE (2532 Guadalupe St., Austin, TX; 512-474-8787) Not only does this secondhand haven carry more than eight thousand pieces at any given time but they also have an on-site seamstress who can easily turn an XXL sweater-vest into a slim-fitting top.

IN STOCK: In the book of emo, one man's trash is another man's treasure, so put two and two together . . .

DELIA★S (Delias.com) From skull hoodies with huge hearts on the front to footless tights with lace around the bottom, Delia*s has all your fashion bases covered.

ELECTRIC CHAIR (410 Main St., Huntington Beach, CA; 714-536-0784) When punk exploded on the West Coast in the early 1980s, Electric Chair was there. Twenty years later, ears clad with safety pins have evolved into flare hollow Pyrex plugs, but the Chair is, well, still there.

IN STOCK: Affliction, Rockett, Paul Frank, Converse, All Mighty, Grind Queen, Draven

ENTRUST CLOTHING (EntrustClothing.com) Entrust jumped on the band-sponsorship wagon upon its inception in 2004 as a surefire way of getting its music-inspired duds—often emblazoned with stars and skulls—to the public. Judging from their ever-growing inventory, we'd say mission accomplished.

EVERYTHING GOES CLOTHING (140 Bay St., Staten Island, NY; 718-273-7139) There's more to Staten Island than just the Statue of Liberty and really, *really* bad New York Dolls tribute bands. For one, Everything Goes Clothing—a must for any thrift-store junkie who refuses to pay thirty-two dollars for an Edie Sedgwick tunic.

IN STOCK: Skinny ties, oodles of denim, more hats than you have heads

FLIPSIDE CLOTHING (La Plaza Mall, McAllen, TX; 956-661-0707) With two locations, Flipside Clothing might be a smidge progressive for lil' old McAllen, Texas; but, hey, what *wouldn't* be progressive for lil' old McAllen, Texas?
KEEP YOUR EYES PEELED FOR: Rockett, Made You Look, Local Celebrity, Miss Me, oodles of jelly shoes

FRED FLARE (FredFlare.com) With tongue successfully implanted in cheek, Fred Flare offers the latest and greatest emo threads (from Paul Frank and Scrapbook), bling (their guitar pick earrings are da bomb*), and home décor (solar-powered rainbow maker, anyone?).

H&M (HM.com for store locations) This faux–high fashion chain is where most emo fans go when they want to look like Joel Madden on the dude who used to sing for Mest's budget. Unfortunately, just about anything you'll buy from H&M will probably fall apart within three months of being purchased.

HEARTCORE CLOTHING (heartcoreclothing.com) Heartcore rose from the ashes of a subpar hardcore band and eventually evolved into a merch company whose designs place heavy emphasis on heartbreak—something *all* emo types can relate to.

HELLO DOLLYBIRD (2522 San Pablo Ave., Berkeley, CA; 510-540-7255) This DIY-run boutique—whose owner looks like a cross between Rainbow Brite and Dead or Alive's Pete Burns—is filled with too-cute-for-words tees, totes, and jewels. No hemp-drawstring backpacks here!

* *adj* Phrase breaks down into *da,* meaning *the,* and *bomb,* meaning ***explosive***. This slang was originally made popular in the mid-nineties hip-hop scene but, let's face it, being emo is all about making things that are uncool cool again. Other suggested slang terms to drop into everyday conversation include "Whoop, there it is" and "Raise the roof."

FASHION

KEEP YOUR EYES PEELED FOR: Dead UK, Happy Lucky Me, High Voltage, Lady Luck Rules OK

HOT TOPIC (HotTopic.com for store locations) Hot Topic sells more than a look; it sells all the necessary accoutrements for a successful emo lifestyle, like Green Day heart-grenade light-switch plates, cut-out saw plugs, black-and-red four-row studded pyramid belts, and military lace vests. Hot Topic was started in 1988 by a dude named Orv Madden (no relation to Joel, Benj, or John) as a punk-inspired accessories store that caught fire faster than an Avenged Sevenfold flip lighter.

Each store is a little different, but most resemble a cave covered in Misfits posters. The floor is cluttered with racks of *Alternative Press* magazines, low-rise slim-fit black stretch jeans, and mesh shirts. Plus, more times than not, the Smiths or My Chemical Romance is blasting over the loudspeakers. In other words, it's what we imagine Davey Havok's house is like. No matter how much the haters* cry sellout, we dare you to find a true emo-ite who doesn't

* *n* Bitter emo folks who think the band/movie/trend you love sucks and will

own at least one band T-shirt or pair of black-and-white striped leg warmers from this emo warehouse.

JOHNNY CUPCAKES (JohnnyCupcakes.com) Johnny Cupcakes takes this beloved confection and incorporates it into some of pop culture's most iconic images, then splatters them over T-shirts, duffel bags, belts, scarves, and skateboard decks.

JOURNEYS (Journeys.com for store locations) With more than seven hundred locations, Journeys is the perfect place to re-plenish emo footwear and accessories. Just be sure to stay away from the *Scarface* belt buckles and Bob Marley T-shirts.

MERCHDIRECT (MerchDirect.com) Although buying band merch at said band's show is the emo way, if you can't get Taking Back Sunday tickets, the only acceptable thing to do is to log on to Merch Direct.com and start adding to your shopping cart.

MEDUSA'S CIRCLE (3268 N. Clark St., Chicago, IL; 773-935-5950) Though it is filled with neon, eighties-inspired cloth-ing that can be blinding, Medusa's Circle is owned by a couple of electroclash junkies and is the perfect place for goth emos who think black is too boring.
KEEP YOUR EYES PEELED FOR: Loop, E.C. Star, Jeannie Nitro

MINI MINI MARKET (218 Bedford Ave., Brooklyn, NY; 718-302-9337) Amidst the hipster jungle of Williamsburg, Brooklyn, you'll find Mini Mini Market, an emo-friendly store where the

take any opportunity to tell you this. Haters spend most of their time on the Internet making a minimum of fifteen posts a day on the AbsolutePunk.net message boards, usually condemning some band/movie/trend that is actually popular and hailing some other band/movie/trend that is oftentimes mediocre at best. Haters also tend to live with their parents until well into their twenties and are often drastically over- or underweight.

shoes have rounded toes, the necklines are off-the-shoulder, and the jewelry is all oversized.

KEEP YOUR EYES PEELED FOR: Soundgirl, All Mighty, Loop, 31 Corn Lane, Evil Genius

NEED SUPPLY CO. (3010 W. Cary St., Richmond, VA; 804-355-5880) Sure, Dave Matthews Band may have put Richmond, Virginia, on the map, but denim haven Need Supply Co. keeps the emo types coming back—well, that and the emo meet-ups scheduled for the third Thursday of every month. (See emo.meetup.com for further details.)

KEEP YOUR EYES PEELED FOR: Levis Premium, Diesel, G-Star, Free People, Penguin, Puma

NOTHING SHOCKING (519 N. Harbor Blvd., Fullerton, CA; 714-773-5110) Despite the name, we're shocked at the number of emo duds this O.C.–sanctioned emo mecca carries. Seth Cohen would definitely approve.

KEEP YOUR EYES PEELED FOR: Audmatic, Trunk LTD, Punk Rose, Sugar, Irregular Choice, Tank Farm, Draven, TUK Shoes, Vision Street Wear

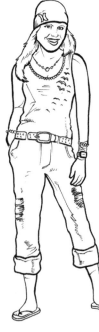

ORDINARY CLOTHING (OrdinaryClothing .com) Not only does Ordinary offer a line of threads boasting imagery scary enough to spook your parents (but not explicit enough to get you suspended), the brand also sponsors bands like the Academy Is. . . .

PACIFIC SUNWEAR (PacSun.com for store locations) In addition to meeting your frat-emo needs (by stocking everything from Paul Frank sheets to Volcom board shorts), you're sure to bond with the cashier when you both start *pas-*

sionately mouthing the words to "Ocean Avenue" as it is played on the overhead speakers.

PNUT JEWELRY (PnutJewelry.com) Designer Rusty Pistachio, himself a part of hardcore heroes H20, is heavily inspired by the style of flash tattoos and creates his sterling-silver necklaces, bracelets, and rings accordingly.

POP DELUXE VINTAGE (6 N. Prince St., Lancaster, PA; 717-299-6220) There's really no reason to ever visit Lancaster, Pennsylvania. However, if you find yourself involuntarily passing through, we recommend you make a pit stop at Pop Deluxe Vintage, an emo diamond in the rough.
KEEP YOUR EYES PEELED FOR: Anything not covered in mothballs.

REMNANT (R3mnant.com) If you live in Odessa, Texas,* and your idea of cutting-edge style doesn't include denim stirrup pants, Remnant is the perfect one-stop-shop for threads from Affliction, RZST, or Iron Fist.

ROCKETT CLOTHING (RideTheRockett.com) We think skulls are cool—and so does Rockett Clothing, who have implemented the boney lil' buddy on their tees, track jackets, tube tops, and camisoles.

THREADLESS (Threadless.com) All of the limited-edition designs for this quirky T-shirt company are submitted by the fans, most of which are of the emo persuasion. (The site even offers musical interpretations by Braid's Bob Nanna. No joke.)

TRASH AND VAUDEVILLE (4 Saint Marks Pl. #4, New York, NY; 212-982-3590) Trash and Vaudeville is not only a historic

* Cue John Mellencamp's "Small Town."

East Village landmark but a great place to perfect your goth-emo look. We even hear wiL from Aiden has a preferred shopper's card here. Hey, black-mesh long-sleeved shirts don't come cheap.
KEEP YOUR EYES PEELED FOR: Doc Martens, L.A.M.B., all things goth

URBAN OUTFITTERS (UrbanOutfitters.com for store locations) Why sift through racks of clothes at a thrift store and risk contracting some kind of airborne disease when Urban Outfitters stocks vintage-inspired swag that doesn't have brown pit stains?

VILLAINS (1672 Haight St., San Francisco, CA; 415-626-5939) Villains, along with its sister store Vault, caters to the emo type who's super label conscious. Not that there's anything wrong with that. After all, labels are important: Would you rather listen to Dashboard Confessional or the third-rate version Deep Elm is peddling?
KEEP YOUR EYES PEELED FOR: Cosmic Girls, Paul Frank, Stussy, Hurley, Volcom, Fred Perry

ZAMBOOIE (Zabooie.com) Zambooie* offers more band merch than you ever knew existed, and after you're done shopping for an All-American Rejects key chain, you can stock up on books, vinyl, and posters.

ZUMIEZ (Zumiez.com for store locations) Zumiez is the skate-shop equivalent to the Virgin Megastore; they offer everything from canvas Emerica slip-ons to a hat selection so expansive that Brand New's Vinnie Acardi could have blown half the advance for his band's third record here.

* *n* or *adj* or *v* Actually, we're not sure. We don't even know what the word means. It kind of sounds like *zamboni* but not quite. All we know is that if you say *Zambooie* over and over again it sounds sort of funny.

in•ter•net *n* An interconnected system of computer networks where emo types can often be found talking shit, bragging about friend requests, or posting flattering cell phone pictures of themselves.

These days, the Internet has become just as important—if not more important—to emo fans than the music itself. But this was not always the case. A time long ago, far before you could steal a wireless connection from your neighbor one flight up, the Internet was a form of technology that few emo fans had access to. However, the Internet has recently morphed into a far more accessible place where one can find a lot of bored emo kids who feel otherwise exiled out in the suburbs—a place to hang out, if you will, for people who generally don't have a place to hang out.

Within the comfy confines of their rooms, most emo kids will spend their time online doing a variety of things: They will post journal entries on their blogs, log onto online community Web sites, look at their profiles, look at a lot of other people's profiles, maybe check out some emo-style "adult content," and then top it all off with a series of IM

internet

conversations that will use a series of abbreviations you'll need a guide to properly suss out.

That's what this chapter is about. It's a road map to a sacred forum, a place where emo kids can celebrate their favorite subject—themselves.

HISTORY OF EMO
ONLINE COMMUNITIES

At this point, online communities are such a huge part of the emo existence that it's hard to remember what life was ever like without them. Did people really talk to each other at shows? Did they really hand out fliers about forthcoming vegan potlucks? Was there really a time before we all obsessively updated our profile photos and tried to create the perfect "About Me" description? That couldn't really be possible, could it? It was, but this began to change with Makeoutclub.com, the first online community to be embraced by younger music fans. Things really came into focus, however, with Friendster.com and then with MySpace.com, which is now ground zero for any self-respecting emo fan. The following serves as a timeline for where online communities like this got started and, possibly, where they're heading.

(A) Friendster→

(B) MySpace →

(C) Flickr →

(D) Buzznet →

(E) FriendsOrEnemies

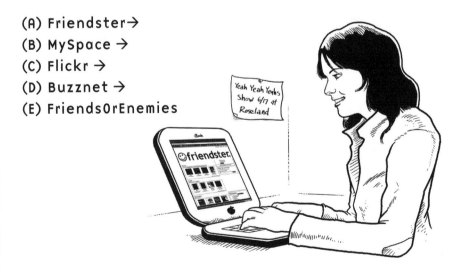

FRIENDSTER.COM

By today's standards, Friendster probably just seems like MySpace's stuffy older brother; an aging hipster who's more interested in listening to the Yeah Yeah Yeahs and talking about Noam Chomsky than interacting with other people. But when Friendster launched five years ago it seemed like the end-all, be-all of online communities. Founded by a Northern California designer named Jonathan Abrams in the fall of 2002, Friendster was an instant phenomenon. It not only provided a quick way to organize your online social circle, but it turned relatively normal people into Internet celebrities.* With this, Friendster became seemingly the only thing twenty-three-year-olds talked about in places like Williamsburg, Brooklyn, and Silver Lake, California. Bored employees began bragging at their day jobs when they had one hundred friends. *Spin* even ran a story on the site proclaiming that it may in fact be "more addictive than crack." But in a sense Friendster's users were too insular, and for a lot of emo fans who presumably didn't smoke crack, a far more accessible community was about to take shape.

MYSPACE.COM

In the midst of Friendster's fifteen minutes of fame, two guys named Tom Anderson and Chris DeWolfe began a competing site and—though this will seem hard to believe now—for its first few months, the reception was iffy. The initial problem was that MySpace offered essentially the same opportunities as Friendster but with one significant drawback: You had to build your social network all over again. Which was crucial. Unless, of course, like a lot of people who lived in between New York and California (for

* *n* On most occasions, celebrities are famous people who earn notoriety by starring in movies, selling lots of records, or being outlandish exhibitionists on reality TV. However, *Internet celebrities* are people who think they're famous because they blog about those starring in movies, selling lots of records, or being exhibitionists on reality TV. For further reference, see PerezHilton.com.

convenience we'll call this place "America"), you never entered the popularity contest for twentysomethings that Friendster became. Those people, most of them social-calendarless teenagers or members of relatively unknown punk bands, realized that the potential for self-promotion on the site was huge. So was mixing with people you wouldn't otherwise: Shins fans often shared "friends" with burly hardcore fans who would otherwise be found hypothesizing in chat rooms about why Daryl Palumbo's phone number was in Paris Hilton's hacked Sidekick.

More important, though, MySpace proved to be way more addictive than any online community that came before it—or since, really—and by early 2005, its influence was undeniable. It had shaped (as we outline elsewhere in this chapter) its own culture and its own way of dating. MySpace even had its own record label, which in 2005 released its first album: a collection of—who'da thunk it?—mainstream emo bands.

flickr™

Home You | ▾ Organize | ▾ Contacts | ▾ Groups | ▾ Explore | ▾

Dashboard Confessional

FLICKR.COM AND BUZZNET.COM

During MySpace's ascent, there was no shortage of people who would take potshots at what was clearly becoming an online giant. "Tom doesn't exist," the naysayers said. (Not true.) "MySpace is owned by News Corp.," they moaned, "and it's ruined forever." (True to the former, not to the latter.) Either way, the point was clear: It was only a matter of time before those cruising the Internet began searching for the next thing. Two options that

emerged were photo communities like Flickr and Buzznet. The second of the two offered a community similar to MySpace, but both seemed to deal with the same clientele: people who had just taken either a really blurry photo of Chris Carrabba or, like, the raddest photo ever of a bunch of twenty-somethings holding over-priced vodka tonics. While *totally* having the time of their lives.

FRIENDSORENEMIES.COM

Sometimes when you can't topple a giant it's better to simply walk around it. When Pete Wentz launched FriendsOrEnemies.com in late 2005, it was a tongue-in-cheek project he took on for the hell of it, and it was by no means meant to directly compete with MySpace. While the site allowed users to develop separate lists of the people they liked—and, in Wentz's words, "those ex-girl-friends/boyfriends" whom they didn't—FriendsOrEnemies' real selling point was its accessibility. MySpace may have allowed emo fans intimate access to their favorite bands' pages, but Wentz's site allowed them to read exclusive journals by scene fixtures like the All-American Rejects' Mike Kennerty, Gym Class Heroes' Travis McCoy, a certain traffic-stopping beauty at *Alternative Press*, and just about anyone in the greater New York area who has ever gone power-drinking with Fall Out Boy guitarist Joe Trohman.

Though more tongue-in-cheek than MySpace, the message of FriendsOrEnemies and the community sites that came before it remains clear. These are *our* communities. We love them. Except for when we hate them. And we can't help ourselves from logging on to them two or three times a day to post new pictures that we took of ourselves on our camera phones.

MAKING MYSPACE
YOUR SPACE

While just about any emo fan is aware of how MySpace fits into the evolution of online communities, that doesn't mean all of them know how to properly navigate it. Many times, emo kids will be left wondering, "How should my profile look? What emotion should I convey before snapping the shutter on my camera phone?" And, perhaps most important of all, "Will I ever lose my virginity?" These are all valid questions, and they deserve emo-specific answers.

HOW TO EMO-FY YOUR MYSPACE PROFILE

- Set your username to FirstName! at the Disco or William Beckett Is FirstName's Homeboy.
- Customize your Top Eight by including that hottie you met last week at the Cartel show. (See elsewhere in this chapter.)
- Customize MySpace layout and skins using a code generator like 123codes.com.*
- Take photos using outlined MySpace picture-taking technique (see below) and post accordingly.
- List every emo show you plan to attend from now until the end of the year on your calendar.
- Never reveal your age. (For anyone over the age of twenty-four, we recommend saying you're ninety-nine years old.)

* Beloved Web site that allows users to customize their MySpace pages. If you have ever logged onto your friend's profile and immediately got a migraine because they have hundreds of pictures of Brendan Urie as their background image, then they have probably used 123codes.com.

THE ART OF TAKING THE PERFECT MYSPACE PICTURE

Scenario One

1. Grab your digital camera.
2. Go into your bedroom.
3. Hold camera at arm's length from body.
4. Raise arms.
5. Look up and turn head to the side.
6. Pout.
7. Click shutter.

Scenario Two

1. Grab your digital camera.
2. Go into the bathroom.
3. Face the mirror.
4. Hold digital camera, lens facing out, near the middle of your chest.
5. Cock head to the side.
6. Pout.
7. Click shutter.

RULES OF ATTRACTION

Once you have an emo-ready MySpace profile, why not try to attract some kindred spirits? Dating is hard for anyone—especially

those who find it difficult to interact with the opposite sex or under-stand what happened to their bodies after going through puberty. But in the past few years MySpace has made this significantly eas-ier. (Consider just how many couples that can now say, "OMG, we totes met on MySpace!") So if you're looking to hook up online, we recommend the following do's and don'ts of MySpace courtship.

DO take a look at who's on the menu. MySpace is a virtual all-you-can-eat buffet of prospective mates who come in all dif-ferent shapes and sizes, all sporting various degrees of emo-ness. Less smoky than going to a bar and somehow less pathetic than participating in speed dating, the MySpace pickup is a great way to find the emo yin to your emo yang. Take your time. See all the pro-files in your extended network. And remember, certain MySpace photo angles (shadowed, blurry, or extreme close-up shots of one specific body part) aren't artsy; they're trying to distract you from the reality that the person you're checking out is probably ugly or overweight.

DON'T be a Lurker.* Everyone has online crushes. You know, those people and profiles you check for updates every day . . . or hour . . . or minute, depending on your level of determination (or desperation). However, thanks to software like SpySpace, your se-cret stalking ways might not be *that* secret. Lurking is one of the most unattractive emo qualities, second only to Red Bull breath.

DO strategically place a new crush in your Top Eight. Let's face it, lurking works both ways so you should prepare ac-cordingly. What if that special someone is lurking your page? Well, you should start by placing them in your Top Eight. Not in the top spot, though. That's for your best friend or favorite band. Not the

* *n* A person who observes another person's online behavior obsessively (i.e., checking someone's MySpace profile more than three times a day and/or checking a person's AIM AWAY message every five minutes).

last spot, either. That's for that one energy-sucking friend in your life that will immediately send you a message that says, "WTF, why aren't I in your Top Eight?" if they're appearing elsewhere on your profile. But put them anywhere in-between, and you should be in the clear.

DON'T brag about the size of your genitalia. Bragging about the size of your genitalia—as a courting device—is about as impressive as boasting that you're thirty-three, the assistant manager at Hot Topic and still live in your parents' basement, none of which will get you any play. Clumsy in their prowess and confused by their sexuality, saying they want to hold someone's hand or cry in someone's lap while listening to Bright Eyes is probably about as seductive as Lotharios and temptresses get. Plus, pimping your privates is really pervy.

DO brag about the size of your vinyl collection. The size of an emo fan's vinyl collection can often serve as a metaphor for their capacity to love. With that being said, colored vinyl, picture discs, and test prints will most definitely score you bonus points with the opposite sex. Please note: If you encounter anyone who attempts to woo you with any or all of the demos from Weezer's unfinished and unreleased concept album, *Songs from the Black Hole*, demand that they IM you the songs and then start looking for wedding bands, because you should totally be building a life with this person. No questions asked.

DON'T ASK, DON'T TELL

By following the do's and don'ts outlined above, hopefully your "Single" status will change to "In a Relationship" in no time. However, if your attempts at hooking up via MySpace have failed, then there's always porn done the emo way. Not that we'd know from experience or anything.

INTERNET

SUPERCULT Supercult opened its boudoir doors in 2001 and quickly became one of the most popular alt-porn hubs on the Internet. Yes, the site featured pierced and tattooed vixens, but Supercult wasn't—and still isn't—exclusive to the punctured and inked types. If you're not willing to cough up the cash, many of the pin-ups in the "free" gallery are sporting Paul Frank hoodies and Belle and Sebastian tees. For some, Julius the Monkey is a major turn-on, and for others, let's face it, some girls look sexier with their clothes *on*.

BURNING ANGEL What's an emo dude with a fascination for girls who look like Bettie Page to do? Let Joanna Angel, founder of BurningAngel.com, meet your needs. With an über-successful Web site, coffee table book, and DVD, Burning Angel seems to have the alterna-porn market cornered. Plus, it doesn't get more emo than a DIY porno featuring interviews with Against Me! and music by Rancid's Tim Armstrong. Ugh, right?

SUICIDE GIRLS Although the company grappled with allegations that its models were sexually harassed and not properly compensated for their work, SuicideGirls.com still flourishes as emo's most popular porn site. While Suicide Girls "the site" attempts to serve nudity with a side of music news, the Girls' traveling burlesque show and Epitaph-released DVD is nothing but straight-up whipped-cream-covered debauchery.

SWEET ACTION Don't worry, emo ladies. The Internet hasn't forgotten about you. Allow us to introduce you to SweetActionMag.com, acceptable emo porn for girls. Sure, Sweet Action is pay to play, but the company is the first to capitalize on a completely untapped market. Girls, emo boys are already wearing your jeans: Why not reclaim your denim . . . and take a peek at what's hiding underneath? You might not be able to

view Sweet Action's X-rated goods on their site, but you can find out where to purchase the rag. Brown paper bag not included.

"MOMMY, WHERE DOES BLOGGING COME FROM?"

Blogs (short for "Web logs") have been around for nearly ten years in various shapes and sizes, but it's only been in the last five or so years that they've been embraced by emo kids in a huge way. Most will agree that the emo timeline for Internet self-expression began with LiveJournal (a diary site developed by a mere-mortal college student), but more recent fans have been provided several choices (from Blogger to MySpace, to Xanga), where they can get their online emoting fix.

(A) LiveJournal → (B) Blogger → (C) MySpace → (D) Xanga

LIVEJOURNAL.COM In 1998, when a dude named Brad Fitzpatrick began developing a new online journal template while attending college in Seattle, LiveJournal's popularity was limited to no more than a handful of people in his dorm. At first its authors posted about things like an upcoming kegger that was being thrown during Welcome Week, but within four years LiveJournal would eventually be discovered by emo kids who began attaching AIM screen names like TasteOfInk090286 to the site's URLs. And like just about anything an emo kid touches, LiveJournal both quickly and predictably became about *them*. From the somewhat insignificant details of their lives ("Julie is such a bitch!") to the deeply personal ones (suicide, heartbreak, et al.), LiveJournal was where everyday emotional purging was not only encouraged, but also embraced.

BLOGGER.COM Though it was launched just a year after Fitzpatrick's dorm-room revelation, Blogger.com was hardly an instant success. It wasn't until after a 2003 buy-out by Internet behemoth

INTERNET

Google that it began edging out LiveJournal as the site on the Internet where online voyeurs would log on in droves. But there was a slight difference. Though Blogger seemed to take what emo kids had perfected on LiveJournal and simply streamlined its design, more important, it made blogging accessible to bored housewives and middle-aged rock critics across the country. Because of this, fewer and fewer posts on Blogger matched the emotional intensity of those that appeared on LiveJournal (probably because they weren't as frequently written by teenagers), and more and more of them seemed to be about such intimate topics as shopping at Ikea, Brooklyn indie-rock bands, and Lindsay Lohan. The online journal had grown up. So where was an emo kid to turn?

MYSPACE.COM Though many still found solace in LiveJournal, a few other sites adapted to the emo bloggers' needs. One source for journaling came in the shape of MySpace, where members were already checking their profile for "Friend Requests" approximately every seventeen seconds. When the geniuses at MySpace added blogs to their member profiles, suddenly the aesthetic that began with LiveJournal had found a new home. Blogger.com would be left to twenty-seven-year-old former hipsters while sixteen-year-

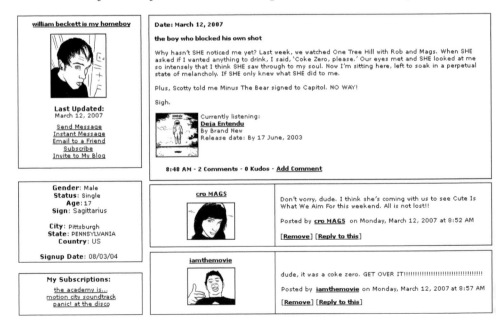

old Taking Back Sunday fans found an ideal place to write about how they didn't have a date for the upcoming junior prom.

XANGA.COM With MySpace, bloggers could apply a mood to their posts, note what they were listening to, and essentially re-create LiveJournal's intimacy within a site where they had already dedicated the best three semesters of their lives. The same holds true with Xanga.com, a pay site that shouldn't be confused with the incredibly difficult wooden-block stacking game that people used to play in the eighties. Though Xanga currently claims that it's been highly successful worldwide—which is sort of like when bands say they are "big in Europe"—it hasn't yet grabbed a real hold of most emo kids. (Its most famous user is that clueless singer for Limp Bizkit.) Whether or not Xanga will become a success is of course questionable, but its necessity is not. As long as teenagers have emotions, they'll want to share them—just, you know, maybe not without a computer screen separating them from the real world.

HOW TO EMO-FY YOUR BLOG POST

You have a blog. Now what? Having emotions is normal. But having the ability to channel those emotions into blogs that can reference both your favorite Straylight Run song *and* make your life seem more melodramatic than a scene from *The Notebook* is something that you're born with. For emo fans, these things come naturally. But it's often easy to forget not only what makes a good emo blog post, but also how to establish a setting that is conducive to online gut-spilling. Consider this a brief refresher.

STEP ONE: SET THE MOOD. The first order of business for most emo fans is setting the right mood. If it's late, they're probably going to keep some stimulants handy. This being emo, we're talking

sugar and caffeine as opposed to methamphetamines, but regardless, it might be a good idea to grab something to eat or drink and keep it a healthy distance from the keyboard. Once refreshed, they'll want to make a playlist that is appropriate for their mood. (See the lists we have provided below each step for some suggested artists.) Last, most emo fans will want to go into their post with a clear mind. Ideally the blogging experience should feel a little bit like emo yoga.* Even if your post is full of angst, writing that post should be relaxing and extremely low-impact. Venting about an unrequited crush can—and should—serve as a sort of emo version of Shavasana.

Suggested Listening > "Lucky Charm" by Jets to Brazil, "One Day I Slowly Floated Away" by Eisley, "Here (In Your Arms)" by Hellogoodbye

STEP TWO: ESTABLISH EMO CRED WITH YOUR BLOG TITLES.
With that out of the way, the first thing a budding emo author will settle on is a good title. This is the easiest part of a blog post, seeing that most emo fans have literally thousands of resources to choose from on their iPods. The titles of albums and songs by emo bands aren't only great suggestions for post titles; they're pretty much required. For instance, if you have just majorly effed up at home and have nothing to do but blog because you're grounded, the Brand New

* *n* A system of exercises practiced as part of the blogging discipline to promote control of the mind and body. *See also Rivers Cuomo.*

song "The Boy Who Blocked His Own Shot" is a perfect title for a post about how you'd rather be out awkwardly trying to make small talk with that indifferent goth girl who works behind the counter at Dairy Queen and will never give you the time of day.

On the other end of the spectrum, if you have just had a relationship end and you are writing a thinly veiled bulletin to the guy or girl who broke your heart, borrowing "If Only You Were Lonely" from the second Hawthorne Heights record is emo-blog gold.

Suggested Listening > "Red Sky" by Thrice, "Turnpike Gates" by Lifetime, "Good Things" by Rival Schools

STEP THREE: KEEP YOUR POSTS INTERESTING. The duality of an emo-blog post is that it will not only create empathy for the author, but also recap the actual pertinent information in said person's life. Chances are your friends really will be interested in how you spent your weekend, so then the goal becomes to deliver this information in a way that's more captivating than your weekend really was. If you do this correctly, people will not only read your blog: They'll even—*gasp!*—leave you comments, which should serve as much-needed affirmation and solicited validation of your entire existence.

As most emo fans know, the best method to draw in a reader's interest is to enhance the setting of where the post begins. If an emo fan was at a show, for example, they will probably write something like, "The crowd was manic while I soaked in a perpetual state of melancholy." If they were driving to Chipotle with their friends through their tiny suburban town, nine times out of ten they will throw in something about how it "felt like we could drive forever." And if they were simply at home, killing the hours online, their post would definitely start with how they're "dying to be anywhere but here."

Suggested Listening > "Everything Is Alright" by Motion City Soundtrack, "Alive with the Glory of Love" by Say Anything, "Move Along" by the All-American Rejects

STEP FOUR: WOO YOUR BELOVED WITH A BLOG ENTRY. Often blog posts can have an audience of hundreds or thousands of daily readers, but if you're an emo fan, chances are the audience you are writing for has a whopping population of one—and if you're lucky, maybe that one person will go with you to the Paramore show next week. News flash: People often use their blogs just to get dates. Don't look shocked. This is nothing to be ashamed of. At this point, it's pretty much an emo-blog must to insert cryptic messages to the guy or girl whom you like and who no doubt has your URL bookmarked.

The way most go about this is simple. Let's say that a guy and his crush watched an episode of *One Tree Hill* a week earlier with a group of seven of their friends. Never mind that there were nine people in the room. In emo terms, *this was a date.* Said guy will no doubt spend the next five days obsessing over every detail of the

evening on his blog. A typical entry will read: "When she asked if I wanted any-thing to drink, I said, 'Coke Zero, please.' Our eyes met and she looked at me so intensely that I think she saw through to my soul."

Suggested Listening > "Let Go" by Frou Frou, "From Such Great Heights" by the Postal Service, "Ghost of a Good Thing" by Dashboard Confessional

STEP FIVE: ASK QUESTIONS BUT DON'T WAIT AROUND FOR ANSWERS. Most emo blog posts will at some point introduce a sense of internal conflict; that's the stuff that LiveJournal was seemingly made for. Emo kids will often inject some of life's big questions—"Why don't people understand me?"; "Why hasn't she noticed me yet?"; "Did Rise Against sell out?"; et cetera—into their posts while providing no real answer to these questions whatso-ever. That's emo simplified. If your interest in writing a personal

blog is that it will help you solve some of your internal problems, then you are deffs* not emo. This is, after all, a culture that is not about solving problems. It's about always having them.

Suggested Listening › "Helena" by My Chemical Romance, "MakeDamnSure" by Taking Back Sunday, "Niki FM" by Hawthorne Heights

STEP SIX: SAY GOODBYE. Ending your post with one of the above questions is an emo staple. From there, an author will probably sign the post with a nickname (often their AIM screen name), and then they're through.

Suggested Listening › "Fade into You" by Mazzy Star, "Soul Meets Body" by Death Cab for Cutie, "Handcuff" by Brand New

Now, if you have just used the previous five steps while drafting up your first blog entry (that's what they're here for), you're going to want to look over your text and ask yourself a series of questions before hitting the "submit" button and releasing your deepest, most intimate thoughts into the world. Those questions are as follows:

1. Does this read well?
2. Am I making my point in a clear and efficient way?
3. Did I use actual paragraphs?
4. Did I capitalize all the words that need capitalization?
5. Is this what my life is actually like?

If you answered "yes" to any of these questions, you should probably scrap your post and start over. Ideally, a good emo blog post should be overdramatic and a bit abstruse. You know the magnets you see on refrigerators that people sometimes assemble into bizarre phrases? That's what emo posts are *supposed* to look like.

* *adv* Short for "definitely," this abbreviation has recently become pluralized for reasons that escape most of emo kids' parents.

HOW TO EMO-FY YOUR BLOG POST (WHEN YOU'RE ALREADY IN AN EMO BAND)

Even emo band members get the blues and now, with the popularity of blogs and LiveJournals soaring, it makes perfect sense that many of the scene's biggest artists have stepped forward as aspiring online authors as well. So how do they fare? Let's just say that if you're looking for a multiplatinum exhibitionist or a second-wave emo pioneer who could give you an incredible recipe for butternut squash soup, then you've definitely come to the right place.

PETE WENTZ (Found at FriendsOrEnemies.com, FueledBy Ramen.com, or FallOutBoyRock.com) Wonder what happens when a real-deal emo kid sells millions of records? Apparently, he rents a hotel room in New York City and begins writing posts about how he "sat on the balcony stark naked and read Hemingway in the moonlight." Though occasionally Wentz's journals fall under the category of TMI*—the entry he posted after the pictures of his manscaped nether regions were leaked onto the Internet in early 2006 served as a perfect example of this—he's also often so poetic and self-deprecating that his online content is just as good (if not better) than the lyrics he's spent the past five years committing to tape with Fall Out Boy.

SAMPLE TEXT: "I am a con artist. A door-to-door salesman. A snake oil seller. Cures for whatever ails you. Somehow I don't hear the violins playing. Not really the leading man type. I am a cadaver, deep-frozen. Waiting for reanimation to be invented. Wrote 'fuckoff' on my hand to remind me to call you tomorrow morning. What do you do when everything they say about you is true?"

* *adj* Short for "Too Much Information." In regards to emo, this means anything that has to do with taking off your clothes.

JADE PUGET (Found at ShyBoysWin .Blogspot.com) Only about half of Puget's blog qualifies as a "journal" (most of the posts are MP3s of his favorite songs or not-as-funny-as-he-thinks Quick-Time files of older brother and AFI's tour manager Smith goofing off), but there's no denying that the overall effect of a Web site called Shy Boys Win is going to be emo with a capital *E*. For further proof, see the titles on this thing. We just found one that read, "This guts me every time I listen to it."

It was for a song by Godspeed You Black Emperor!, a Canadian indie-rock group that no one listens to anymore. Yeah, that's sort of ridiculous. And it's also sappy. But that's okay. Puget is all about being ridiculous. Have you seen his hair?

SAMPLE TEXT: (As posted alongside a rather bizarre MP3 by a rapper named MC Stay N Skool) "For those of you who know, you will be happy. For those of you who don't, I probably wouldn't even bother listening. Remember that he had drank 10 beers by noon when this was recorded, and had already jumped out of a second story window while throwing a machete through his rolled-up car window."

WILLIAM BECKETT (Found at TheAcademyIs.com, Fueled ByRamen.com, and FriendsOrEnemies.com) As the twenty-one-year-old singer of rising emo stars the Academy Is . . . , William Beckett has good reason to be confused with his life's current state, and his journal entries often reflect that. At times totally emo (see his weepy entries about otherwise-boring tour conditions like overnight drives) and at times totally not (see his Rock God insistence on calling the four other people he plays music with "*my* band"), Beckett's posts are about as mood swingy as

your typical high school teenager. But in the end nothing says emo like a post about your band's haters that begins, "Try to put yourself into my shoes"—and ends, "Or better yet, try to put yourself into my pants, if you can manage to fit into them."

SAMPLE TEXT: "I've seen the world, played on national television for millions of people, sold over 100,000 records, toured the nation eight times, and I'm heading out on a sold out world tour that covers five countries and three continents in three months. But the real reason I know I've made it is because I'm in the new Emo Game!"

BOB NANNA (Found at Heymercedes.com/CityonFilm) Once the lead singer of post-hardcore pioneers Braid, Bob Nanna now tracks his very adult life on the blog The City on Film, which also happens to be the name of his new band. Updated every few days, Nanna's blog offers lots of posts about cooking and how much it sucks to spend your entire afternoon at the Apple Genius Bar. Often a nostalgia trip—take, for example, certain entries about At the Drive-In and Jets to Brazil (aka the good ol' days)—Nanna's blog is proof positive that most former emo icons are destined for a life of Midwestern domesticity.

SAMPLE TEXT: (In a nostalgia-heavy post about the 2005 At the Drive-In anthology *This Station Is Non-Operational*) "At The Drive-In was about to embark on a six month tour. A SIX month tour! And they barely even had a record out. I'm sure most of the shows were poorly attended, but you have to figure that those few people left there going, 'What the hell just happened?' You never realized how good ATDI were until you heard their records, since they barely even hit the strings while they were jumping around like ninjas."

RIVERS CUOMO (Found by searching "Rivers Cuomo" at MySpace.com) The still totally bizarre frontman for Weezer maintains what might be the most fascinating page on MySpace.

To start, he only has a few dozen friends, lists no musical interests, and cites S. N. Goenka (an eighty-three-year-old Indian man whom many believe to be the leading teacher of Vipassana meditation) as his personal hero. But the most surprising aspect of Cuomo's page is the fact that, in the summer of 2006, the famously celibate singer switched his romantic status to "Married" after months of cryptically blogging about his girlfriend (now wife) on the site, thus clearly following the outline we have provided elsewhere in this chapter. Though Cuomo only refers to her as "K," the few things we do know are that she's Asian (big surprise) and that he was afraid to meet her parents—proving that the teenage emo kid inside us all can only be suppressed so much with age.

SAMPLE TEXT: "When I saw her in August I was going through a crabby spell. She finally burst into tears and said, 'I'm sad because my family made a lot of effort to make you happy and comfortable here and it seems like you don't appreciate it.' Whoa. I felt an ache in my heart and immediately realized that I had been acting like a tool."

AOL INSTANT MESSENGER

Navigating an online community and whipping up an emo-friendly MySpace profile is one thing; mastering the ins and outs of AOL Instant Messenger is quite another. Of course, no upstanding emo citizen uses America Online. We're not sure whether the company's kiss of death was the fact that they'd incessantly send those stupid sample CD tins to your house on a daily basis, or that a romantic comedy starring non-emo celebrities Tom Hanks and Meg Ryan centered around the service's most annoying catch-phrase: "You've got mail." However, while the emo community might blacklist AOL's basic service, the company's Instant Messenger program is the stuff that emo dreams are made of. Imagine a place where you could have a conversation without the pesky annoyances of, umm, facial expressions. On AIM, you don't even have to talk with

words. And if you're truly AIM savvy, you'll say all you need to using emoticons and abbreviations.

Much like the number of friends you accumulate on MySpace, emo followers are often judged by the size of their Buddy

Lists. Your Buddy List could be a collection of message board friends, MySpace friends, or LiveJournal friends; in other words, they are virtual friends that you have not, nor ever will have, a face-to-face conversation with. (Because then you'd realize that they look more like Mario Cuomo than Rivers Cuomo— and, frankly, so do you.) Fear not, though. If you still value the importance of inter- personal communication with real, live human beings, you can fill your Buddy List with *actual* friends, coworkers, family, and AIM bots like AOLYellowPages, which tells you the listing information of any person or business in your area.

Perhaps the most alluring part of AIM, though, is the status menu, which lets your buddies know if you're available, away, or just plain idle. In order to get the most out of AOL Instant Mes- senger, be sure to take advantage of the customized status bar, in which you absolutely must type in at least one to three differ- ent melodramatic song lyrics as a way to reflect your oh-so-emo mood.

THE ART OF ABBREVIATION

When you're on Instant Messenger, who's got time for things like sentences and punctuation? That's why we compiled this list of trusty abbreviations guaranteed to cut your "send" time in half.

AYSC: Are You Smoking Crack?
BBL: Be Back Later
BRB: Be Right Back
CMEO: Crying My Eyes Out
DDI: Don't Do It
GWTP: Go Walk The Plank
IHY: I Heart You
IMHO: In My Humble Opinion
JK: Just Kidding
LBALT: Let's Build A Life Together
LOL: Laughing Out Loud
LYG: Love Your Guts
MMN: Meet My Needs
MOST DEF: Most Definitely
MYG: Miss Your Guts
NP: No Problem
NWI: Not Worth It
OBV: Obviously

OMG: Oh My God
OTP : On The Phone
PERF: Perfect
PMAK: Pass Me A Kleenex
RMS: Rocks My Socks
ROFL: Rolling On Floor Laughing
ROFC: Rolling On Floor Crying
SMF: Stuffing My Face
SMTM: Show Me The Money
TFB: Totally Fucking Brilliant
TTFN: Ta-Ta For Now
TTYL: Talk To You Later
WAYIML: Where Are You In My Life?
WG: What Gives?
WTF: What The Fuck?
WTP: Where's The Party?
YKM: You're Kidding Me
YW: You're Welcome

T-MOBILE
SIDEKICK

WHAT IS IT?

Ah, the Sidekick: the most loved—*and* hated—personal communication device of all time. It's a phone. It's a Web browser. It's a camera. It's an e-mail server. It's a juice extractor that makes wheatgrass shots. (Okay, that last part isn't true, but maybe future models will have that capability.) Affectionately referred to as the

INTERNET

< 9 6 >

Nerdbox, the Sidekick's compact design allows it to fit into any tote bag, back pocket, or fanny pack. Once you've experienced the unlimited convenience that goes along with having a 'Kick, you'll forget what it was like to live without it. Those who don't own Sidekicks or understand their purpose are known to refer to the 'Kick as a Devilbox. The anti-'Kicker's unruly behavior is most often caused by a condition called 'Kick envy.*

WHY DO YOU NEED IT?

Having a Sidekick is necessary for anyone who is truly emo because the device is an outlet for well-nurtured neuroses like obsessive compulsiveness ("Sure, I *just* checked John's away message, but maybe he changed it in the last thirty seconds"), insecurity ("Why isn't John writing me back? I asked him if he wanted to hang out tonight and I haven't gotten a response yet. Does that mean he wants to break up?"), and paranoia ("I wonder if John blocked me. He's *always* online and now he's not showing up. WTF?").

HOW DOES IT WORK?

Press your left thumb on the lower-left corner of the display. Push up in a clockwise direction. Start 'Kicking your little emo heart out. Once you master this basic operating method, feel free to experiment with more advanced methods like the One-Handed Flip and the Behind-the-Back Spiral.

WHEN DO YOU USE IT?

Prime 'Kicking hour† occurs between the hours of ten o'clock P.M. and four o'clock A.M., but Sidekick owners are encouraged by T-Mobile and the SAAA (Surgical Attachment Association of America) to use their 'Kicks as much as humanly possible. However,

* *n* Resentment aroused by an anti-'Kicker in conjunction with a secret desire to possess a Sidekick. This is petty. So very, very petty.

† This is considered optimum 'Kick time among more experienced Sidekick users.

beware of Sidekick Thumb.* If symptoms persist, see your doctor or your local T-Mobile dealer.

WHERE DO YOU USE IT?
Um, everywhere. *Duh.*

WHO USES IT?
Some say that unless you're a doctor, there's no reason to be reachable 24/7. However, when you're emo, Accessibility is your middle name. After all, without a status menu, how would your buddies be able to know what you're *really* thinking?

WHEN DO YOU (MIS-)USE IT?
The desirability of the Sidekick is that it allows its user to be constantly available, which is why blocking anyone—an admittedly infantile option provided by AIM wherein you can become invisible to your less desirable online "buddies"—stings like hell. In emo's world of instant dialogue, this is more than the equivalent of saying, "Talk to the hand." It's like saying, "Talk to the hand" before channeling Rick James on *Chappelle's Show* and slapping your friend across the face.

ALL THAT'S LEFT

Updating your MySpace profile and blog is a full-time job. One that requires your undivided attention, save for some rockin' emo playlists and maybe some Red Bull and Peanut Chews. However, if you've still got time to kill on the Net, be sure to bookmark these sites.

* *n* A medical condition resulting in callused finger pads brought on by the incessant pounding on the Sidekick keyboard. Treatment usually consists of Sidekick rest or, in extreme cases, a thumb orthotic.

ABSOLUTEPUNK (AbsolutePunk.net) If the real news were like this, maybe more emo fans would watch CNN. Reporting everything from the significant (band breakups, new major-label signees) to the less concerning ("Andrew McMahon from Jack's Mannequin/Something Corporate has updated his blog!"), AP.net is hands-down the most popular emo site running.

BLOGGER (Blogger.com) Although lacking the bells and whistles of LiveJournal, Blogger is the perfect online diary for dummies.

BROOKLYN VEGAN (BrooklynVegan.com) Though the guy who runs this music-news site is a small celebrity in indie circles, he definitely has emo leanings; why else would he post thirty-six photos of Lifetime's last show in New York City?

FACEBOOK (Facebook.com) Unlike MySpace or Friendster, Facebook.com comes with an IQ prerequisite because the site is geared toward emo types seeking higher education—ironic, considering its founder is a Harvard dropout.

FLICKR (Flickr.com) You can't have an online diary without an online photo album. Think of Flickr as a digital emo scrapbook without the tacky Con-Tact paper.

INTERPUNK (Interpunk.com) Leaving the house can require so much mental and physical effort. That's why Interpunk is great: You can get the new Hawthorne Heights album or issue of *Alternative Press* without ever leaving your couch.

LAST.FM (Last.fm) This is where that obnoxious guy at shows who's always talking about Blood Brothers seven-inches lists what he's currently listening to under the assumption that people care.

LIVEJOURNAL (LiveJournal.com) The ultimate emo online diary service, LiveJournal boasts a "Be yourself" motto and encourages you to make each page unique (and by "unique," they mean "the same").

MODS UNDER PROTEST (Mods.punkrocks.net) If you love to debate how underappreciated Harvey Danger is or analyze every note of the new Velvet Teen album, you probably already have Mods Under Protest as your home page.

MYSPACE (MySpace.com) This is the ultimate emo online meeting place, complete with movie trailers and music for when there's no one out of MySpace's millions and millions of user profiles that you feel like scoping. Though that will probably never happen.

OH NO THEY DIDN'T (LiveJournal.com/users/ohnothey didnt) Once you get past the picture posts of Eva Longoria pumping gas ("She's just like us!") or totally valid rants about Vince Vaughn's physique ("Seriously, when did that dude get so puffy?"), Oh No They Didn't! is a great place for emo album leaks and video sneak peaks.

PITCHFORK (PitchforkMedia.com) Written by a hyperliterate group of junior rock critics, Pitchfork offers news items on many scene-approved crossover acts (see: the Arcade Fire, Ted Leo, the Decemberists), but it's the staff's snarky attitude that most emo fans love.

PUNKNEWS (Punknews.org) Often the first, authoritative word on scene happenings, the wide scope of news that the 'Org disseminates daily means that, unfortunately, you're going to have to suffer through posts about aging ska bands like Less Than Jake if you want to find out some upcoming tour dates for the Receiving End of Sirens.

PUREVOLUME (PureVolume.com) The only word an emo follower likes to hear more than "music" is "free." Luckily, PureVolume is both.

SO MORE SCENE (SoMoreScene.com) Consider this site the bratty younger sister of TheModernAge.org, a bookmark for any Strokes fanatic or Brooklyn resident who wears Worishofer sandals and owns an excessive amount of striped shirts. Not only will So More Scene leak secret show announcements, but the blog also brings you groundbreaking posts like "Hayley Williams: So Cute I Want to Smoosh Her Face In" and "Hairwatch 2006: Emergency Update on Adam Lazzara."

WIKIPEDIA (Wikipedia.org) This free online encyclopedia allows visitors to submit content on anything from Boston terriers

INTERNET

to Bridge 9 Records. Way lighter and easier to use than the multi-volumed *Britannica*, Wikipedia's only drawback is that nothing on the site can be assumed to be, well, fact.

XANGA (Xanga.com) The latest site in the online diary race for supremacy, Xanga may prove to be the LiveJournal of the late 2000s.

YOUTUBE.COM

WHAT IS IT?

Consider YouTube to be emo's virtual VCR—or the poor man's TiVo. Either way you slice it, this is *the* online hub where you can find QuickTime files of everything from Thursday's last performance on Conan O'Brien to old episodes of *The State*.

WHY DO YOU NEED IT?

YouTube speaks the universal language of procrastination. After all, how can you *possibly* be expected to think about studying for your French midterm or preparing RFPs when you can watch that *SNL* short "Lazy Sunday" on repeat, or a couple of fourteen-year-old girls lip-syncing the Starting Line's "Best of Me" while busting out a Fly Girl–worthy choreographed dance routine?

HOW DOES IT WORK?

To find a video, enter whatever topic you're looking for in the search field and cross your fingers and toes. Or, if you've got a piece of tape that you know the masses are dying to see, follow the uploading instructions and wait for the magic to happen.

WHEN DO YOU USE IT?

You don't need a reason to use YouTube, but we've found that most people flock to the site after they receive a link via chain e-mails sporting subject lines like OMG! FUNNIEST SHIT EVER!! or YOU

WILL SHIT YOUR PANTS WHEN YOU SEE THIS! or anything else that uses the word shit and insinuates that the contents of said e-mail are so hilarious, you will more than likely lose control of all your bodily functions—which, if taped, would definitely be worth seeing on YouTube.

WHERE DO YOU USE IT?

Anywhere that has a fast network connection. Loading the videos can take time, especially when they start buffering.*

WHO USES IT?

Although not exclusive to the emo community (as illustrated by the large number of clips featuring Europeans playing soccer and golden retrievers adorably stealing food off a table), YouTube is made by the people, for the people. Finding your emo niche is easy: You just have to know where to look. We recommend starting with any one of the ten thousand matches to the keyword *emo*.

WHEN DO YOU (MIS-)USE IT?

There are only so many times people can forward you that video of animated stick figures phonetically interpreting garbled lyrics by Brand New, AFI, and Fall Out Boy. We get it. Patrick Stump's vocals are kinda hard to make out in "Sugar, We're Goin Down." And, yeah, if you weren't really paying attention, "A loaded God complex, cock it and pull it" *could* sound like, "I lonely dark cock that's going and pulling." But it's called moderation. Look into it.

* *v* A process that occurs when there's a discrepancy between the rate that one device transmits information and another device receives it. In laymen's terms, it's when that annoying rainbow pinwheel starts spinning round and round, and your computer freezes for what seems like an eternity, and you wonder if you have a better chance of getting Pete Wentz's phone number than ever being able to finish watching the Mosh Girl montage you were starting to get really into. Buffering is kind of like that.

film

film *n* A thin sheet or strip of flexible material, such as a cellulose derivative or a thermoplastic resin, that when projected properly produces images that emo types will worship, study, recite, and wish their lives were based on.

In addition to fashion and the Internet, film provides another form of escape for the typical emo fan. When the cruel outside world becomes too much to take, emo-ites can turn inward, watch a movie, and forget their troubles for at least ninety minutes. And, despite all the obvious strikes against Hollywood (i.e., propagating unrealistic plot lines, releasing crappy soundtracks, insisting on building romantic comedies around an aging Sandra Bullock, etc.), in the past twenty years Tinseltown has become a hotbed of cinematic emo activity.

When a film is deemed "emo," its actors, score, dialogue, and narrative are embedded in the collective psyche of the emo community; characters are worshiped, quotes are recited, and scenes are reenacted. Through directors with unwavering vision and on-screen heroes with untiring faith, emo cinema makes the impossible seem possible.

The following chapter takes a closer look at emo film and the fine line that exists between fact and fiction. No matter if the movie is a drama, comedy, romance, or thriller, emo fans connect with emo cinema because it offers up vignettes of their lives—only with a script supervisor and better lighting.

THE ULTIMATE
EMO DVD GUIDE

With the help of a few select directorial visionaries (most of whom were, ironically, born in the Midwest) and flawlessly created characters (most of whom, ironically, reside in the Midwest), Hollywood has managed to strike a chord with the Hot Topic crowd. Whether you're unfamiliar with what truly categorizes emo cinema or you simply want to compare our list with your personal collection, we present our ultimate emo DVD guide, complete with suggested quotes you should feel free to drop into everyday conversation.

ALMOST FAMOUS (SONY)

Being emo is all about making the uncool cool, and no one does that better than writer, director, and already established emo icon Cameron Crowe. Ignore the bell bottoms and platform shoes, and *Almost Famous*—based on Crowe's teenage years as a roving reporter for *Rolling Stone* in the 1970s—could definitely take place today. Replace the classic-rock band Stillwater with the equally-imaginary, emo-infused Hearts Hang Heavy, Penny Lane with Holly Hox, and the floppy-haired, terminally insecure William Miller with . . . actually, don't change a thing about him. He's perfect just the way he is.

Essential Quote › "The only true currency in this bankrupt world is what you share with someone else when you're uncool."

—*Lester Bangs to William Miller*

FILM

<104>

AMÉLIE (MIRAMAX)

Okay, so we all know that the last thing you want to do during a movie is read stuff, and, unfortunately, French films mean one thing: subtitles. Bummer. However, regardless of the optical strain, *Amélie* is an undeniably emo import. With a modern Zelda haircut, the highly sensitive and slim lead character, Amélie, spends

AMÉLIE

most of the movie trying to track down the owner of a book of ripped-up photo-booth pictures. Introverted and socially stunted, Amélie has two cats and even fewer human companions, but still marches on in search of her potential soul mate. Not only does Nino ("the beloved") look like a tall, dark, emo drink of water, but Amélie poses in that photo booth like a seasoned MySpace pro.

Essential Quote › "These are hard times for dreamers."

—*Amélie*

AMERICAN BEAUTY (DREAMWORKS)

Only a sensitive person can find beauty in watching a plastic bag float in the wind, and only a truly *emo* person can videotape said plastic bag, play it for his paramour, and then cry at its beauty. Without the character of Ricky Fitts—Kevin Spacey's next-door neighbor who dresses like a Quicksand fan, but is most often mistaken for a Bible salesman—*American Beauty* would be just another flick about a dude going through a midlife crisis. Instead it's about roses, mental breakdowns, and realizing that no one's life is perfect, which is something most emo types realize when they're, like, four years old.

Essential Quote › "Sometimes there's so much beauty in the world I feel like I can't take it, like my heart's going to cave in."
—*Ricky Fitts to Jane Burnham*

ANCHORMAN: THE LEGEND OF RON BURGUNDY (DREAMWORKS)

Saying Will Ferrell is sorta funny is like saying William Beckett is kinda thin. Although Ferrell isn't outwardly emo, he does represent the emo comic minority who usually don't hit puberty until the age of seventeen, seem to have an over- or under-abundance of body hair, and think that Neil Hamburger is *hilarious*. The character of Ron Burgundy also isn't overtly emo, with his drunken swagger, potty mouth, and lack of sexual-impulse control, but you've got to respect and admire anyone who calls Christina Applegate a "smelly pirate hooker."

Essential Quote › "I'm kind of a big deal." —*Ron Burgudy*

CRUEL INTENTIONS (COLUMBIA)

Wealthy private schools aren't always about kilts and cricket: Sometimes there's drugs, sometimes there's deceit, and sometimes, dare we say it, there's Sarah Michelle Gellar. However, the rather unlikable former *Swans Crossing* star aside, *Cruel Intentions* offers Ryan Phillippe's performance as Sebastian Valmont, a spoiled Upper East Side socialite who plots against the school virgin while inadvertently falling in love with her. Valmont possesses the kind of bratty arrogance and blatant insecurity that both our cinematic emo forefathers—and mothers—would be proud of. And just imagine the damage he could've done if he had traded in his leatherbound diary for a LiveJournal account.

Essential Quote › "People shouldn't experience the act of love until they are in love." —*Annette*

FILM

DONNIE DARKO (20TH CENTURY FOX)

This 2001 cult hit stands as quite possibly the only film on this list that every emo fan has seen but none can properly explain. To some degree, *Donnie Darko* is about a teenager (played by emo film icon Jake Gyllenhaal) growing up in the late eighties. He eventually discovers the space-time continuum after being haunted by a six-foot bunny that has convinced him the world is coming to an end. Oh, and his neighbor keeps checking the mail for no reason whatsoever. And Patrick Swayze is in it. Yeah, we don't get it either. But here's the thing that we do get: If you are nineteen, into emo, and are trying to look arty in front of a girl you like, without question this is the movie to do it with.

Essential Quote › "I promise that one day, everything's going to be better for you."
—Donnie Darko

EDWARD SCISSORHANDS

EDWARD SCISSORHANDS (20TH CENTURY FOX)

Despite popular belief, worshiping at the altar of Tim Burton isn't restricted to those who rock reflective bondage pants, listen to Mindless Self Indulgence, and think bike chains look better as necklaces than as, well, functioning bike chains. Not only did *Edward Scissorhands* mark the director's first on-screen hookup with Johnny Depp (and the first time emo goths *wished* they could hook up with Johnny Depp), but it also centered around a scissor-clad loner who looked like he shopped at Serious on Melrose Avenue and was paler than Robert Smith. Finally, an emo sex symbol more confusing and creepier than AFI's Davey Havok. Who knew that was even humanly possible? Oh wait . . . Edward wasn't *exactly* human. Is Davey?

Essential Quote › Kim: "Hold me." Edward: "I can't."

ETERNAL SUNSHINE OF THE SPOTLESS MIND (FOCUS FEATURES)

After the whirlwind love affair between Joel Barish (Jim Carrey) and Clementine Kruczynski (Kate Winslet) goes sour, Clementine decides to have Joel erased from her memory, resulting in one of the most surreal emo flicks in recent memory. Sure, the camera work makes you kind of nauseated, and the story line is disjointed at best, but at the crux of this film lies an important lesson: Love stinks as per the J. Geils Band.* If that's not an emo mantra, we don't know what is.

Essential Quote › "Why do I fall in love with every woman I see who shows me the least bit of attention?" —*Joel Barish*

GARDEN STATE (FOX SEARCHLIGHT)

Sure, he's best known now for blowing it with Mandy Moore, but back in 2004 Zach Braff was just that nerdy-looking dude from *Scrubs* with a big schnoz and nasally voice. However, with *Garden State*, which marked Braff's directorial debut, he assembled all the necessary ingredients for a cinematic emo masterpiece: depression, debauchery, and, most important, Natalie Portman. In addition to being filmed in My Chemical Romance's backyard in Newark, New Jersey, *Garden State* also has one of the most emo-friendly soundtracks in film history, featuring ballads from emo indie faves like the Postal Service and Frou Frou. Also, did we mention that Natalie Portman is in it?

* This is the blues-rock band from the 1970s that was famous for songs like the na-na sing-along "[Angel in the] Centerfold" and the unrequited love anthem "Love Stinks"; for anyone younger than those old dudes in Sugarcult, these guys were probably made famous by a drunken, depressed Adam Sandler singing a rad version of "Love Stinks" in *The Wedding Singer*.

FILM

Essential Quote › "I don't want to waste another moment of my life without you in it." —*Andrew Largeman to Sam*

HIGH FIDELITY (BUENA VISTA PICTURES)

More than ten years after his emo-defining role in *Say Anything*, John Cusack may have gotten a little puffy, but he hasn't entirely lost his emo appeal. Not only is *High Fidelity* based on the beloved Nick Hornby novel, but it's also a glimpse into your emo future if you intend to live with your parents and work at the local record store until you're old enough to collect social security. A cinematic ode to heartbreak, elitism, and kick-ass music are three indisputable pillars of the emo lifestyle.

Essential Quote › "What came first, the music or the misery?" —*Rob Gordon*

WET HOT AMERICAN SUMMER (USA FILMS)

Sometimes the only thing better than a good cry is a good laugh, and for that, nothing's better than David Wain's summer-camp comedy *Wet Hot American Summer*, starring Michael Ian Black, Michael Showalter, and Janeane Garofalo. For a tween, going to sleepaway camp is an emo rite of passage. Fingers crossed, this is where you'll experience a bunch of important emo firsts like your first crush, first kiss, first relationship, the first time you'll hear "No, it's not you, it's me," the first time you'll write really bad poetry and ask your bunkmate to give it to your beloved, the first time you'll overhear your beloved reading your bad poetry aloud in a very exaggerated version of your own voice that you find really hurtful, the first time you'll swear off love forever and ever . . . or at least until next summer.

Essential Quote › "You taste like a burger. I don't like you anymore." —*Andy to Lindsay*

IGBY GOES DOWN (UNITED ARTISTS)

Even J. D. Salinger would be proud of Igby Slocumb's modern-day interpretation of Holden Caulfield. In fact, from Igby's trademark scarf symbolizing Holden's red hunting hat to both teens wandering the streets of New York City searching for the meaning of life, the similarities between the two charaters are sure to be the subject of many film-school term papers. But, moreover, *Igby Goes Down* is just another reminder of how unsatisfying life can be even when you appear to have everything—which pretty much sums up why so many emo bands spawn from middle-class America.

Essential Quote › "Good things come to obsessive-compulsives who fixate." —*Jason "Igby" Slocumb, Jr.*

LOST IN TRANSLATION (FOCUS FEATURES)

When it was released in 2003, the artsy *Lost in Translation* didn't seem like the kind of film that would immediately send emo kids into a Fandango-ing* frenzy. Sure, its stellar soundtrack reintroduced the Jesus and Mary Chain's "Just Like Honey" to many teenage music fans who thought Armor for Sleep invented gauzy effect pedals, and when Charlotte first meets middle-aged actor Bob Harris in the bar of a swank Tokyo hotel, he *is* wearing eyeliner. But it was the film's ambiguous love story, which forms between Charlotte and Bob amidst a wash of awkward photo shoots and late-night karaoke sessions, that presents two key concepts that most emo fans intrinsically just get: (1) that the best relationships are those where pretty much nothing happens, and (2) most Hollywood actresses are dumb as rocks.

* *v* To use the Web site Fandango. This online organization allows moviegoers—and lazy emo fans—the opportunity to reserve seats to a movie without actually leaving their computer. Fandango is also known for using a paper-bag-puppet spokesperson in its commercials, which is somehow both endearing and infuriating.

FILM

Essential Quote › "Didn't you have anyone else to lather you with attention?"
<div align="right">—*Bob Harris to Charlotte*</div>

MALLRATS (UNIVERSAL)

As Brodie in *Mallrats*, Jason Lee represents a segment of the emo population who will probably spend the rest of their lives playing video games, reading comic books, and hanging out at home in their underwear. But with its story of two losers (Brodie and his also recently dumped best friend T.S.) trying desperately to win back their ex-flames, *Mallrats* is definitely an emo classic. At its core, this is a story of boy meets girl, boy meets Sega, boy loses girl, then boy enters some weird game show to win her back, and . . . well, if you're still unclear about how geeky and emo this film is, its closing credits roll to the sound of a Weezer song. And it's a *B-side*.

Essential Quote › "Hell hath no fury like a woman scorned for Sega."
<div align="right">—*Brodie*</div>

NAPOLEON DYNAMITE (FOX SEARCHLIGHT)

In the years since its 2004 release, for reasons that we are still not exactly sure of, *Napoleon Dynamite* made emo fans seemingly lose all common sense. In short order, they started buying Zubaz

NAPOLEON DYNAMITE

and began braiding neon friendship bracelets. They insisted on wearing VOTE FOR PEDRO pins on their messenger bags even months after you could buy them at Wal-Mart. And worse still, they took to saying *"What?"* all the time in that goofy Napoleon drawl. In ways, *Napoleon Dynamite* became a lifestyle, and while it's hard to explain what linked it to, say, your average Hawthorne Heights fan (other than the fact that neither they nor Napoleon could get a girl), the film's never-ending supply of easily recited one-liners has made it an emo classic all the same.

Essential Quote › "I caught you a delicious bass."

—*Napoleon Dynamite to Deb*

THE NIGHTMARE BEFORE CHRISTMAS (TOUCHSTONE)

This is probably the best stop-animation movie about a skeleton who ruins Christmas, like, *ever*. Released in 1993, *The Nightmare Before Christmas* follows Jack Skellington (think wiL from Aiden but, you know, more like a skeleton), as he falls for Sally (think Christina Ricci but, you know, with a smaller forehead), and tries to re-create Christmas in a place called Halloweentown. As for *The Nightmare Before Christmas*'s influence on the emo scene, well, it seems safe to say that the film has encouraged many of today's emo bands; it's even encouraged grown men like Davey Havok to begin collecting toy dolls, and budding illustrators like Billy Martin of Good Charlotte to completely rip off the film's look and feel with their "art."

Essential Quote › "Just because I cannot see it, doesn't mean I can't believe it!"

—*Jack Skellington*

OLD SCHOOL (DREAMWORKS)

Old School hardly seems emo on the surface. For one, it's about a bunch of thirtysomething men forming a *fraternity*. Second, *Old School* is about *old* people. Really, it's about old people trying to act

FILM

young, which is even worse. But for emo fans who already know that college will mark the best four to seven years of their lives, the film is essential—and, hey, when those same people become a bit flabby (like Will Ferrell's character, Frank) or a corporate, tie-wearing suit (like Luke Wilson's level-headed character, Mitch), they too will long for a time when they could watch a ninety-year-old man like Blue drop dead after wrestling two topless women covered in KY Jelly.

Essential Quote › "You're my boy, Blue!" —*Frank*

PHIL "DUCKIE" DALE

PRETTY IN PINK (PARAMOUNT)

With its tales of outcast teenagers growing up in Chicago in the mid-eighties, *Pretty in Pink* is kind of a "Where Do You Begin?"–emo classic. First of all, you've got Andie, a smart and untraditionally beautiful budding fashion designer played by then It-girl Molly Ringwald. Andie, in true emo spirit, makes her own clothes and works at an indie record store. Her best friend is Duckie, a hyperintellectual who gets the snot beat out of him on a fairly regular basis and who is in love with Andie but—*shocker!*—can't bring himself to say it. When Andie begins dating Blane, a preppy rich guy with a heart of gold, Duckie freaks out, sulks while listening to the Smiths, buys a totally fierce bolo tie for the prom, and does a lot of other things that don't exactly make him look straight. What's not to love?

Essential Quote › "How about that stock market?"
 —*Phil "Duckie" Dale, minutes before getting beat up*

RUSHMORE (THE CRITERION COLLECTION)

Emo is about many things. One of these things is wanting someone whom you can never have, which sums up the relationship that fifteen-year-old playwright Max Fischer has with a significantly older teacher named Rosemary Cross. But another emo staple is prolonging your adolescence for as long as humanly possible, which also sums up the relationship Fischer has with Rushmore Academy, the same school Cross teaches at and that he's set on attending for the rest of his life. While we could go on and on here, you don't really have to justify *Rushmore*'s emo appeal. You can merely listen to Brand New's "Sic Transit Gloria . . . Glory Fades" (a reference to Fisher's first conversation with Cross), or maybe check out any number of the discs on the Drive-Thru-distributed label Rushmore Records. Or, hell, just take a look at nearly any member of Hellogoodbye, an emo-pop band so decidedly nerdy that you get the feeling they, too, spent most of their time in high school hanging out with an eight-year-old.

Essential Quote › "I saved Latin. What did you ever do?"

—Max Fischer

THE ROYAL TENENBAUMS (THE CRITERION COLLECTION)

Already established as a highly revered film auteur among emo fans, Wes Anderson followed up *Rushmore* with *The Royal Tenenbaums*, which is about a dysfunctional old couple. It's also, in some form, about young adults growing up in New York City who like to play tennis and work out *way* too much at the YMCA. This doesn't exactly sound emo, sure, but the fact is that any film that features an antisocial, closet smoker like Margot Tenenbaum and a suicide attempt

FILM

< 1 1 4 >

soundtracked by an Elliott Smith song is destined to be an emo classic. Though many people tend to get judgmental about Richie's decision to eventually date his adopted sister Margot . . . well, just ask yourself when was the last time someone who looked like Gwyneth Paltrow tried to get *you* to have a camp-out in the living room with her?

Essential Quote › "I think he's very lonely. Lonelier than he lets on. Maybe lonelier than he even realizes."

—*Richie Tenenbaum about his father, Royal*

SAY ANYTHING (20TH CENTURY FOX)

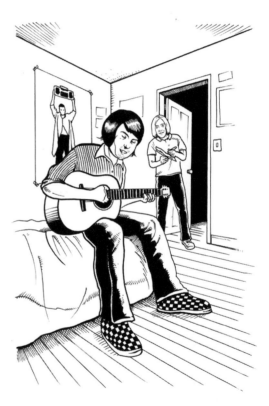

It's safe to say that no movie in cinematic history has had more of an impression and effect on the emo genera- tion than *Say Anything*. Set in pregrunge-era Seattle, *Say Anything* is a celebration of something every emo guy and gal can relate to—being average. John Cusack isn't particularly good-looking. The movie's plot isn't par- ticularly unique. Even "In Your Eyes," the song Cusack's character Lloyd Dobler plays on the boombox in *Say Any- thing*'s most poignant scene, isn't particularly emo in and of itself. (Ummm . . . Peter Gabriel? Don't go there.) However, something about the Everyman striving for—and attaining—the seemingly un-gettable girl is something that shakes just about any emo dude down to his core.

The film's influence today can be seen everywhere. Take, for example, the emo-approved punk band the Bouncing Souls' decision to write three songs about the flick: "Say Anything," "Joe Lies (When He Cries)," and "These Are Quotes from Our Favorite '80s Movies." The visual of Lloyd holding up the boombox outside Diane Court's window has also been adopted in videos by the Starting Line ("Best of Me"), Reggie and the Full Effect ("Congratulations Smack and Katy"), and Hawthorne Heights ("Niki FM," which even boasts the line, "I'm standing outside your window with my radio"). The boombox image has also been incorporated into T-shirt designs for Brand New and designer Johnny Cupcakes. But perhaps the greatest tribute comes in the form of emo wunderkind Max Bemis naming his band Say Anything at the impressionable age of fifteen.

Essential Quote › "She's gone. She gave me a pen. I gave her my heart, she gave me a pen."

—*Lloyd Dobler*

SIXTEEN CANDLES (PARAMOUNT)

Sure, in the battle for Samantha Baker's affection, "the Geek" loses out to the most popular (and inhumanly hot) guy in school, but Farmer Ted doesn't end up totally empty-handed. At the end of *Sixteen Candles*, a film about making the crush of your dreams into a reality, he's managed to woo the coif-challenged prom queen. Not bad for someone who still sleeps with orthodontic headgear. And, although Pete Wentz was only five years old when director John Hughes filmed *Sixteen Candles* less than three miles away from his childhood home in Wilmette, Illinois, the film's impact would be felt twenty years later when Pete penned "A Little Less Sixteen Candles, A Little More 'Touch Me'" on the band's third album, *From Under the Cork Tree*.

Essential Quote › "That's why they call them crushes. If they were easy, they'd call them something else."

—*Jim Baker to Samantha Baker*

FILM

THE NOTEBOOK (NEW LINE)

There's nothing like an epic love story with a heaping helping of melodrama to grab an emo kid's attention. Sure, *The Notebook*, which was adapted from Nicholas Sparks's bestselling novel, was originally targeted toward desperate housewives and their reluctant husbands, but somewhere between Talbot's and Ann Taylor, the Hot Topic crowd started catching on and worshiping the film's sappy dialogue and the clandestine relationship between the movie's star-crossed lovers. Further proof: The film's stars, Ryan Gosling and Rachel McAdams, ended up taking a cue from their characters' passion for each other and built a life together when the cameras stopped rolling.

Essential Quote › "I wrote you every day for a year."
—*Noah Calhoun to Allie Hamilton*

THE VIRGIN SUICIDES (PARAMOUNT)

The line between liking someone and stalking them has always been a fine one in the history of emo courtship, which was proven by the sheer number of emo fans who read Jeffrey Eugenides' novel *The Virgin Suicides* and flocked to this film following its 2000 release. Soundtracked by decidedly un-emo artists like nü-lounge princes Air and geriatric rock bands like Styx, *The Virgin Suicides* still told a decidedly emo story. It revolves around a group of high school boys in the seventies who are obsessed with the Lisbon girls, a set of five sheltered—not to mention suicidal—sisters who aren't allowed to leave the house unless it's absolutely necessary. Early on, when a TV reporter shows up in front of the girls' home and announces that "adolescents today are much more fraught by pressures and complexities than in years past," she's referring to the recent suicide of Cecelia Lisbon, but she might as well be talking about every emo kid who was born after 1978.

Essential Quote › "We knew the girls were really women in disguise, that they understood love and even death, and that

our job was merely to create the noise that seemed to fascinate them."

—*Narrator*

TRAINSPOTTING (COLUMBIA TRISTAR)

Those who can, turn into Pete Doherty. Those who can't (and frankly don't want to, because heroin is, like, so early nineties), watch *Trainspotting*, which was adapted from Irvine Welsh's controversial first novel. Make no mistake about it, the emo community has never looked kindly upon hard drug use; what it does condone and even endorse, however, is voyeurism, and let's face it, watching a bunch of crooked Scots with almost indecipherable accents party amidst a blur of Blur songs is voyeurism at its very finest.

Essential Quote ❯ "Living like this is a full-time business."

—*Mark "Rent-boy" Renton*

WELCOME TO THE DOLLHOUSE (COLUMBIA TRISTAR)

DAWN WIENER

Poor Dawn Wiener. Her family doesn't really like her. Her only friend is her much younger, kinda sickly looking next-door neighbor. The kids at school call her "Wiener Dog." Without recognizing the irony, she puts a sign outside her clubhouse that says SPECIAL PEOPLE'S CLUB. She's got a hopeless crush on a dude who looks more like Jamie Walters than James Dean, and she tries to seduce him by wearing a turquoise bolero crop top, pea-green stirrup pants pulled up to her waist, and elastic hair ties with huge white plastic balls on them. *Yeesh*. But through it all Dawn never gives up hope that someday she'll be cool, understood, and

FILM

accepted. It's that kind of unwavering faith that is found only in the truest of emo types.

Essential Quote › "You think you're hot shit but you're just cold diarrhea."
—*Ralphy to Dawn Wiener*

PLEASE NOTE

ACTION MOVIES ARE *SO* NOT EMO

The reasons for this should be fairly obvious. Like organized sports and long-term relationships, action movies imply the possibility of getting hurt. During any given action movie, the protagonist should have to deal with the very real possibility of getting grazed by a bullet or having to throw a punch. These are two things that most emo types are *completely* incapable of.

However, there are a few exceptions to this rule: For example, *Fight Club* is generally seen as an acceptable film by emo fans mostly because Taking Back Sunday's Adam Lazzara always talks about it in interviews and the Pixies' "Where Is My Mind?" plays over the final credits. But this is a shaky argument at best. Sure, *Fight Club* is sort of subversive and it says vaguely punk things about consumerism,* but when you get down to it, it's still a film about grown men kicking the crap out of each other. And that's about as emo as watching Spike TV in a pair of breakaway track pants.

* *n* Definitions will vary among emo fans due to the fact that most of them are natural-born consumers. Here it is used to describe the process emo fans go through, usually in their mid-twenties, when they stop attending the Warped Tour and start spending excessive amounts of money at Ikea.

DEFINITIVE EMO FILM DIRECTORS

If nothing else, the preceding list of films suggests that most emo kids turn to movies to escape their realities. But who provides the kind of escape they are looking for? Look no further than the following three directors—John Hughes (we'll call him the Emotional One), Tim Burton (we'll call him the Weird One), and Wes Anderson (we'll call him the Geeky One). Among the three, they have created films for the last twenty-five years that have resonated with emo fans in uniquely different—yet strangely similar—ways. As we examine their influence here, one thing is for certain: Reality may indeed bite, but not as much as any movie staring J.Lo and Ralph Fiennes.

JOHN HUGHES (THE EMOTIONAL ONE)

John Hughes's best films are kind of like Dashboard Confessional's best songs: He takes the elements of teenage life, magnifies their emotions, and turns them into melodramatic love stories that always seem to revolve around whether or not the main characters will win the heart of the one they love. Hughes set the standard for teen movies in the eighties with *Sixteen Candles*, *The Breakfast Club*, and *Pretty in Pink*, all of which crystallized what it felt like to be a misunderstood teenager in suburban America at the time. This is why Hughes is still considered an emo visionary despite the fact that he later went on to write total garbage like *Maid in Manhattan*, which starred Jennifer Lopez.

With that in mind, the effect that Hughes's films had on teenagers in the eighties—and many of *today's* emo teens—is considerable. They have inspired film parodies like *Not Another Teen Movie* and video tributes like Fall Out Boy's "Dance, Dance" clip. They've become rites of passage among people who weren't even born when they were originally screened. But all of this aside, the one thing that's worth pointing out about Hughes's best films is that

FILM

they filled a lot of dandruff-haired, lonely teenage girls with false hope. His movies continue to suggest to a new generation that there really are teenage boys out there who aren't just understanding but also athletic, filthy rich, and willing to accept you just the way you are. News flash—there aren't.

TIM BURTON (THE WEIRD ONE)

Unlike Hughes, gothcentric director Tim Burton wasn't all that concerned with capturing the exact details of teenagers' lives. His best films (most of which came out in the early nineties following the monstrous success he achieved with the comic book thriller *Batman*) were fantasies. There were superheroes named Stainboy in them, places called Halloweentown, and a whole lot of Johnny Depp. Early favorites like *The Nightmare Before Christmas* and *Edward Scissorhands* always seemed to revolve around a misunderstood outcast who confused—or infuriated—many of the local townspeople. You don't exactly need a degree in psychology to understand why teenagers found solace in such story lines. If you are prone to wearing black full-length trench coats in June, well, chances are this is exactly what high school felt like for you.

Burton's visual aesthetic—like an emo kid—is something you know when you see it, and today it's become instantly recognizable in the artwork of bands like AFI and Good Charlotte. But if you still need proof of the impact Burton's films have had, look no further than your local Hot Topic, where tweens can currently choose from nearly eight thousand useless items with Jack Skellington's face smattered across them.

WES ANDERSON (THE GEEKY ONE)

If Burton provided the emo set with a necessary escape from reality, then Wes Anderson provided them with a secret handshake. Over the course of eight years, Anderson's hat trick of movies—1998's *Rushmore*, 2001's *The Royal Tenenbaums*, and 2004's *The Life Aquatic with Steve Zissou*—fostered an underground society that a lot of emo fans eventually became a part of. To this day there are people—lots of them—who still recite lines from *Rushmore* on a daily basis. They argue pointlessly about whether or not there really is a 375th Street YMCA in New York City. (Which, by the way, there *isn't*.) Anderson's films generate a sort of bizarro fandom that is tailor-made for most emo obsessives, making him one of the quintessential directors of our time. If Hughes and Burton respectively understood that teenagers liked being lonely and different, then Anderson knew that they also loved being a part of something that normal people would never really grasp.

With this in mind, it's not hard to understand why the running themes in Anderson's movies—taboo relationships, great clothes, bizarre jokes that often involve small children—would have such an influence on both emo fans and musicians.

EMO *ANTIHEROES*

No discussion of emo cinema is complete without analyzing the role of the emo antihero, the character that resonates most with the emo masses. So what exactly is an antihero? In literature and film, it's someone possessing the characteristics opposite to that of the typical hero. For example, instead of being tall, dark, and handsome, antiheroes are usually short, pale, and average-looking (at best). Instead of knights in shining armor, antiheroes are usually neurosis-stricken dorks who are lucky if they remember to put on socks before leaving the house.

But what is it about these characters that makes them special? Well, the best and the brightest possess a common raison d'être:

the belief that anything is possible, despite seemingly *impossible* obstacles like bad hair and a lack of hands. It's their unwavering faith, however, that makes these characters heroic.

Generally speaking, there are four idiosyncrasies that emo antiheroes have in common.

EMO ANTIHEROES ARE USUALLY SO BLINDED BY LOVE, THEY CAN BARELY SEE THEIR OWN HAND IN FRONT OF THEIR FACE

CASE IN POINT: Lloyd Dobler in *Say Anything*

More young and hopeless than any Good Charlotte album, emo antiheroes will stop at nothing to win the heart of their beloved. Sure, in real life their beloved would probably have a restraining order out against them, but in Hollywood, emo audiences swoon over grandiose—and even totally creepy—acts of affection.

For example, regardless of whether or not you dug his trench coat or understood his obsession with kickboxing, there is something about *Say Anything*'s lovelorn Lloyd Dobler that makes him endearing. If you're a guy, you want to bro out* with him. If you're a girl, you want him to woo you. After all, what emo girl hasn't slept with one eye—and ear—open, with the hope of her crush throwing a pebble at her window only to blast a sappy ballad on a boombox held high above his head? Unrealistic? Yes. However, any less believable? No.

EMO ANTIHEROES ARE USUALLY MOCKED, INSULTED, AND THROWN INTO LOCKERS BY OUTSIDERS WHO ARE THREATENED BY THEIR EMO-NESS

CASE IN POINT: Max Fischer in *Rushmore*

Emo types are insecure enough without feeling like they need to defend their emo-ness to an unsympathetic world, and they

* *v* When two or more males spend time together in a bonding nature. Oftentimes this includes playing video games, going to a concert, or talking about the opposite sex ad nauseum. Also *to bro down*.

MAX FISCHER

often overcompensate by taking on loads of activities—such as sleeping, eating, blogging, and memorizing the lyrics to Motion City Soundtrack's *Commit This to Memory*.

Although oblivious to who Justin Pierre is, the cinematic emo icon for sublimation is definitely *Rushmore*'s Max Fischer, who also involved himself in such activities as stamp and coin collecting, beekeeping, bombardment society, kung-fu, and calligraphy. Despite being beat down by that weird Scottish kid with jacked-up teeth, and broken-hearted because the woman he loves doesn't love him back, nothing stops Max from attempting to attend Rushmore Academy for the rest of his natural-born life. Well, except for being demoted to public school because he had the same grade-point average as a guy on his way to becoming a fry cook—which just proves that nerds aren't always smart and stuff.

EMO ANTIHEROES EPITOMIZE THE PHRASE "SOCIALLY AWKWARD"

CASE IN POINT: Edward Scissorhands in *Edward Scissorhands*

Emo types often feel like the world is staring at them, the way you do after shoving a foot-long not-dog in your face and walking around the rest of the day not knowing that there's a huge glob of relish residing on your cheek. Or, when you go to the bathroom and accidentally get that toilet-paper lining stuck in the back of your pants. Or when you drunk-dial a girl you like after having just met her and leave a series of voicemails more pathetic than the series of voicemails that Mikey leaves in *Swingers*.

Yeah, it's kind of like that. But here's the thing: No matter how alienated emo kids may feel, they still have hands . . . and

FILM

those hands aren't formed like big-ass scissors. Enter Edward Scissorhands. Unassuming, easily intimidated by the opposite sex, and probably undiagnosed as clinically depressed, Edward battles with being the town's resident outcast after everybody realizes his hands are formed *just* like big-ass scissors. Townspeople laugh and point, Edward cries, but he never perishes, proving that all emo antiheroes need to be tough. But, you know, not *too* tough.

EMO ANTIHEROES ARE OFTEN UGLY DUCKLINGS WHO CAN CONQUER THE WORLD EVEN IF THEY CAN'T AFFORD TO BUY A PROM DRESS AT ANY STORE BESIDES GOODWILL

CASE IN POINT: Andie Walsh in *Pretty in Pink*

Most emo antiheroes are a little rough around the edges—and by rough we mean *rough*. Think major dental work and lots of ProActiv. Come to think of it, most emo icons are not traditionally attractive at all, but once you put them in a pair of Diesel Jeans and an American Apparel boatneck tee, they become inadvertent sex symbols.

This was the case with Andie Walsh in *Pretty in Pink*. Granted, her style was still a little wack (did you see her prom dress?), but she made boho chic famous long before Mary-Kate Olsen did. In doing so, she caught the eye of Blane McDonnagh, a resident trust-fund fratstar* in the making who always looked as if he had just come from the tennis court. Their love for each other came much to the dismay of Steff, who was a dick with a lot of money—and, one would think, a small coke habit. But the essential moral that can be taken away from Blane and Andie's union in *Pretty in Pink* is that you can overcome many things in this world when you are a hot girl who just so happens to be in the unfortunate position of having a really crappy wardrobe.

* *n* A member of a fraternity who constantly talks about his fraternity. Fratstars also have a tendency to wear Birkenstocks with wool socks in the winter, white baseball hats embroidered with the nickname for the South Carolina Fighting Gamecocks, and can single-handedly carry and tap a keg.

EMO PROM KING AND QUEEN

JAKE GYLLENHAAL AND NATALIE PORTMAN

In emo, there are certain rules you absolutely can't break. One of them is that if you're a guy, you will at some point have a crush on Natalie Portman, and if you're a girl, you will at some point long for Jake Gyllenhaal. This is non-negotiable. Many of the films that they have starred in have become emo classics (Portman's role as the wide-eyed, hyperactive Sam in *Garden State*, for instance, or Gyllenhaal's role as the title character in *Donnie Darko*). And between Portman's girl-next-door beauty and Gyllenhaal's handsome, lost-puppy demeanor, well, they are also pretty easy on the eyes. But good looks—and good roles—alone aren't enough to make you emo. So why exactly do emo kids obsess over them the way they do? A few reasons come to mind.

1. First, like Rivers Cuomo, Portman went to Harvard. But unlike Cuomo, she never grew a beard. This was probably a good idea.

2. After *Donnie Darko*, Gyllenhaal was rumored to be dating Rilo Kiley singer Jenny Lewis, which puts him in the company of other people who might have dated Jenny Lewis—like Bright Eyes' Conor Oberst, Death Cab for Cutie's Ben Gibbard, and . . . well, pretty much anyone who lives in Silver Lake, used to be a child actor, and now plays in a mediocre indie-rock band.

3. When Portman famously told Zach Braff's character in *Garden State* that the emo-approved band the Shins "could change your life," it at least suggested that, unlike every other actor in the world, she doesn't exclusively listen to Coldplay.

4. In 2006, when Portman starred in a mock hip-hop sketch on *Saturday Night Live*, she proved that her powers of attraction

FILM

are hard to comprehend. Even when telling cast member Seth Meyers to "suck my dick" with serious gangsta-rap authority, she still seemed kind of cute.

5. When Gyllenhaal was still in grade school he appeared in *City Slickers* with Billy Crystal, which . . . umm . . . well . . . okay, there's really nothing cool or even arguably emo about this. But, dude, he might have gone out with Jenny Lewis!

Okay, all of this aside, what *really* makes Gyllenhaal and Portman emo royalty are the parts that they repeatedly choose to play. As you may have noticed by now—especially if you are, say, a film theory major who has no active social life—Gyllenhaal *always* plays incredibly vulnerable characters like Joe Nast in *Midnight Mile* or Holden Worthier in *The Good Girl*. Portman, on the other hand, has always been cast as older and wiser than her years, from her role as a bright fifteen-year-old named Marty in *Beautiful Girls* when she was fifteen and on through to her role as Queen Amawhatever-youcallher in the *Star Wars* prequels—in which, at eighteen, she was already playing a queen. The emotionally spent male and the brainy, beautiful female are two of the biggest stereotypes in emo—and they are epitomized by Gyllenhaal and Portman just about every time they step onto the set.

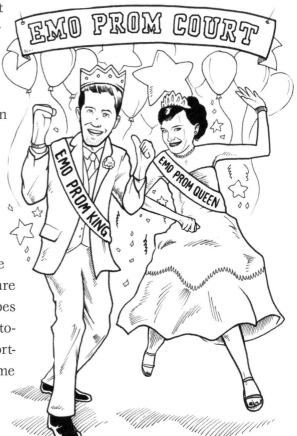

But that's not to say their king and queen status will last forever. Understandably, there are some things about both Portman and Gyllenhaal that may prove troublesome over the next few years. Portman, for instance, was once linked romantically to the bald, middle-aged electronic musician Moby, and that can't be good for *anybody*. As for Gyllenhaal, after the success of *Brokeback Mountain* he started looking a little fat. And old. But such is the passing of time, and if there's one bit of solace emo's current king and queen can take, it's that, thanks to collector-edition DVDs, you'll always have your moment in time. Just ask John Cusack.

FILM

literature

lit•er•a•ture *n* A body of written words that emo types always hear the older people they secretly wish to emulate talking loudly about.

Many assume that emo fans don't like to read, but that's not exactly true. Sure, the information provided so far suggests that they'd rather be obsessing over their wardrobes or spending their time online, but there are a lot of emo-approved tomes that have become a sizable part of any given emo fan's existence. These are the books that they spend great deals of time waxing intellectual about and, much to the displeasure of their friends, discussing loudly at the next show.

Essentially that's what literature is to your typical emo fans—something that they inherently know they are supposed to brag about in social situations. Because of this, it is now not uncommon, for example, to overhear emo fans talking about authors just as frequently as they talk about their favorite band's new CD. Even the fanzine, an archaic form of do-it-yourself media, has become something for them to boast about.

In the following chapter, we look at the books, fanzines, magazines, and authors that all emo fans

will at one point read—and, since emo literature is all about bragging rights anyway, we also look at the ones they know they should read, but never will.

ANATOMY OF AN EMO BOOKSHELF

Emo fans are nothing if not consistent. They listen to the same bands, wear the same clothes, and, by and large, read the same books, many of which will find their rightful home in a pair of milk crates. A few essential titles include:

THE PERKS OF BEING A WALL-FLOWER (MTV) BY STEPHEN CHBOSKY

The Perks of Being a Wallflower, a book about a friendless teen's traumatic high school career, was released in the late nineties and soon became a huge hit among the kind of people who didn't play sports and couldn't get the opposite sex to notice them if their life depended on it. This explains why so many emo types still buy this book and why—no joke—Motion City Soundtrack singer Justin Pierre tried to obtain the film rights to it.

THE BELL JAR (HARPERCOLLINS) BY SYLVIA PLATH

Without this book, sadly, there would be a whole lot of chubby girls wearing outfits from Torrid with absolutely *nothing* to read on their bus ride home. Plath is often credited as the mother of art-house poetry—yeah, about that, *thanks*—but the harrowing tale of *The Bell Jar* is essential emo fare, and its author even inspired

LITERATURE

emo-approved alt-country singer Ryan Adams to pen a song called "Sylvia Plath."

GO ASK ALICE (SIMON PULSE) BY ANONYMOUS

This book sits on most emo fans' shelves because it's a lot like a really messed-up LiveJournal. The chapters are formed like diary entries and though the whole "Anonymous" thing has caused a lot of people to doubt its authenticity, *Go Ask Alice*'s disturbing tales of teenage depression and drug addiction has kept it a must-read even thirty years after it was originally printed. So you may be wondering, How disturbing is it? Well, let's just say that at one point the unnamed main character tries to sell drugs to some *grade schoolers*. That's effed.

THE CATCHER IN THE RYE (LITTLE, BROWN) BY J. D. SALINGER

Along with *The Bell Jar*, this is the other literary classic that emo fans still tend to read. The reason for this? Main character Holden Caulfield. Caulfield is the red-cap-donning, rebellious thinker at the heart of *The Catcher in the Rye*'s story, and he will probably be name-checked in the "Heroes" column of most emo fans' MySpace pages forever.

AT LEAST ONE OR TWO VOLUMES OF HARRY POTTER (SCHOLASTIC) BY J. K. ROWLING

The thing that attracts most emo kids to *Harry Potter* books is that they're literally easy to read. The type is huge, and Rowling's primary audience is a bunch of eight-year-olds. But the thing is, a lot of emo fans act as if they've just read some literary masterwork once they complete *The Goblet of Fire*. Chances are you know someone who has bragged about reading one of these books, and that's just crazy. While we do not want to discourage anyone from reading, this seriously has to stop. If you are saying things like, "Dude, I totally made it through *The Chamber of Secrets* in

<131>

six days," it's not that different from saying, "Dude, I just played a game of pick-up basketball with a guy in a wheelchair and *totally* schooled that retard."

INVISIBLE MONSTERS (W. W. NORTON & COMPANY) BY CHUCK PALAHNIUK

Invisible Monsters became a must-own after Panic! at the Disco wrote a song about it (as noted elsewhere in this chapter) but Palahniuk had a cultlike following on the Internet that pored over his deranged books even before that. This classic about a female model who loses her jaw in a car accident is where most emo types start, but 2005's *Haunted*, which includes a short story about masturbation injuries, is also a great selection.

A HEARTBREAKING WORK OF STAGGERING GENIUS (VINTAGE) BY DAVE EGGERS

Eggers loves giving his books ridiculously long titles, which has made him an obvious hero for any band who has out put an album on Fueled by Ramen in the past few years. For further proof of this phenomenon, see Eggers's ridiculously titled "What It Means When a Crowd in a Faraway Nation Takes a Soldier Representing Your Own Nation, Shoots Him, Drags Him from His Vehicle and Then Mutilates Him in the Dust" which, incidentally, is a *short story*.

DRESS YOUR FAMILY IN CORDUROY AND DENIM (LITTLE, BROWN) BY DAVID SEDARIS

Like Morrissey's lyrics, Sedaris's books are brilliantly sarcastic, which is one reason why emo fans read them. The other reason is that Sedaris makes a lot of off-color jokes that are surprisingly smart, which is crucial to the kind of emo fans who like bad comedies like *Bad Santa* but who also feel incredibly guilty about it. But with Sedaris there is no guilt. For some reason you can laugh at his stories about white-trash parents and not feel like you have all the intelligence of a gas station attendant.

SEX, DRUGS, AND COCOA PUFFS: A LOW CULTURE MANIFESTO (SCRIBNER) BY CHUCK KLOSTERMAN

Klosterman is an obsessive music geek not unlike Nick Hornby who (as outlined elsewhere in this chapter) is an emo literary god. So, while many emo fans couldn't care less about this book's actual subject matter (basketball, Guns N' Roses cover bands, etc.), his ability to overanalyze pop culture instead of actually fixing the flawed relationships in his life has made *Sex, Drugs, and Cocoa Puffs* a geeky emo literary staple.

NOTHING FEELS GOOD: PUNK ROCK, TEENAGERS, AND EMO (ST. MARTIN'S) BY ANDY GREENWALD

Duh, it has the word *emo* in the title.

THE HEART IS DECEITFUL ABOVE ALL THINGS (BLOOMSBURY) BY JT LEROY

Despite the fact that this book was really written by a middle-aged stay-at-home mom instead of a former child-prostitute hermaphrodite, *The Heart Is Deceitful Above All Things* is the hippest book most emo fans will ever own. It is important to note, however, that having this book on your shelf doesn't mean that you will ever end up at the kind of parties that Chloë Sevigny attends. But if reading a book written by someone who overuses semicolons makes you feel otherwise, dude, go for it.

THE RULES OF ATTRACTION (SIMON & SCHUSTER) BY BRET EASTON ELLIS

Fact: The reason that most emo fans like Ellis is because he is obsessed with being nineteen. Now, granted, *The Rules of Attraction* is about rather un-emo college students who do lots of drugs and get laid on a regular basis, but at the heart of this book, Ellis writes

in a voice that suggests he, too, knows exactly how it feels to think you're going to spend the rest of your life dry-humping a pillow.

EMO CLIFF'S NOTES

There comes a point in all emo fans' lives when they feel as though maybe they should read a little more than the texts above. This often comes up after hanging out in a large group in which some self-assigned genius begins making references to books that most emo fans had never even thought of reading. But let's be realistic: That doesn't mean they're going to do something rash like read a six-hundred-page book about the afterlife. They just need to be clued in a little.

To make this easier, what we've provided below is a short summary and a few pieces of vital info on some of the books that emo types should read, but often don't.

THE PICTURE OF DORIAN GRAY (MODERN LIBRARY)
BY OSCAR WILDE

Most emo fans know that Wilde is an important literary hero. His wry wit has been adapted by countless writers and was even referenced by Morrissey on the classic Smiths album *The Queen Is Dead*. So why exactly is it that emo fans need to be told what this classic novel is about? Because when you get down to it, emo fans will always prefer to read back issues of *Alternative Press* instead of the sort of novels that are on their high school required reading lists.

WHAT YOU NEED TO KNOW: Pretty much the only thing you'll need to know about *The Picture of Dorian Gray* is that its storyline

revolves around a young Dorian Gray who, after having his portrait painted, wishes vainly that the portrait will age over the years instead of him. And that's pretty much what happens throughout the rest of the book.

WHAT TO SAY TO YOUR FRIENDS: One potential scenario wherein you could use this knowledge is the next time you're at a show and one of your friends starts complaining about how he's really plumped up post–high school. Upon doing so, simply respond, "Dude, who are you, *Dorian Gray?*" To which said fatso will either applaud your clever Wilde reference or pour his just-opened Red Bull on top of your head.

THE DIVINE COMEDY (NAL TRADE) BY DANTE ALIGHIERI

At one point, all emo fans will hear someone they know talking about Dante's *Inferno*, but chances are very few of them will have any first-hand knowledge of it. The reason for this is that the *Inferno* appears in a six-hundred-page poem that was written around the year 1300 by some Italian dude. That's enough to scare off just about anyone.

WHAT YOU NEED TO KNOW: *The Divine Comedy* plays out in three parts. Its main character is first taken through what Dante calls the Inferno (which is essentially hell), and then Purgatory (which is an in-between stage where people are placed to repent their sins), and then finally through Paradise (which is like heaven with varying levels of achievement). By the end you're supposed to learn about life or death or something, we think.

WHAT TO SAY TO YOUR FRIENDS: Considering *The Divine Comedy*'s at-times dark subject matter, you may want to appear really deep and say something like, "You know, Dante really twisted up my feelings on mortality, man," the next time you and your friends are staging a *Six Feet Under* marathon or listening to the Cure.

COMPLETE POEMS, 1909–1962 (HARCOURT) BY T. S. ELIOT

Most emo fans know they should like Eliot because so many of their favorite bands essentially rip him off. Yet while it may have been

okay for At the Drive-In to sing stream-of-consciousness muck for four minutes, after a few dozen pages, all of Eliot's poems start to feel like a blur and . . . well, there's probably a PlayStation in the next room, right? Hey, wouldn't it be sweet to play a few practice rounds of *Guitar Hero II*?

WHAT YOU NEED TO KNOW: Of all the poems in this book, the one that most literary types will cite is "The Love Song of J. Alfred Prufrock." In it, the title character wanders around a city fearing that he'll never find a wife and dwells on the fact that he'll never be anything more than an average character that gets lost in the scenery. By the end of the poem—in typical emo fashion—he finds absolutely no resolution to any of this.

WHAT TO SAY TO YOUR FRIENDS: As a way of illustrating its influence, you could point out that the early emo band Joan of Arc once took the line "In the room women come and go, talking of Michelangelo" from "Prufrock" and used it in one of their songs—though they altered the end to be about Leonardo DiCaprio. Now, *theoretically* this could impress your friends, but first you'll need a time machine to take you back to 1998 when people still cared about Joan of Arc.

NOTES FROM UNDERGROUND (VINTAGE) BY FYODOR DOSTOEVSKY

Dostoevsky is often seen as the founder of existentialism, which means you can credit him for *Dawson's Creek* and a lot of teenagers asking each other, "What's the meaning of life?" in a Taco Bell parking lot on a Friday night. Despite the influence you would think Dostoevsky would have on emo types, very few of them can even manage to get past page thirteen of this dense and philosophically complex novel.

WHAT YOU NEED TO KNOW: *Notes from Underground* is the story of an admittedly bored retiree—the "underground man" as he eventually becomes known to the reader—who recalls his life in

LITERATURE

a series of events that reflect, first, how he interacts with himself, and then how he interacts with others. Throughout, many impossible-to-solve questions are asked.

WHAT TO SAY TO YOUR FRIENDS: The one concept that people—and by "people" we really mean uptight nerds who go to college in Northern California—tend to focus on in *Notes from Underground* is its argument that humans will always feel the need to rebel against the nature of the world. Considering that last bit of info, feel free to call Dostoevsky "one of the world's first punk thinkers" the next time famous dead philosophers come up in conversation.

A PEOPLE'S HISTORY OF THE UNITED STATES (HARPER PERENNIAL MODERN CLASSICS) BY HOWARD ZINN

Most emo fans try to read this book because they've heard bands like Rise Against talk about it in interviews. Then again, Rise Against talks about books like *A People's History of the United States* because . . . well, that's what bands like Rise Against are supposed to do. So what's the problem here? Dude, this is still a history book.

WHAT YOU NEED TO KNOW: The primary objective of Zinn's book is to tell the history of the United States through alternate perspectives, which is perfect for emo types who hang out with a lot of liberal-minded people. Throughout the book Zinn reexamines a lot of other things you may have originally missed in your tenth-grade history class and further proves the point that, yes, in fact, the U.S. government might be a little screwed up.

WHAT TO SAY TO YOUR FRIENDS: Emo types and politics don't mix that often, so chances are you won't really need any ammunition from this monster of a text. On the off chance your friends do pull themselves away from YouTube long enough to talk about U.S. foreign policy . . . maybe you should just steal something from Jon Stewart, seeing that everyone agrees with what he has to say.

FOR WHOM THE BELL TOLLS (SCRIBNER) BY ERNEST HEMINGWAY

A lot of emo types have been led to believe that not reading *For Whom the Bell Tolls* is like not knowing what *the White Album* by the Beatles sounds like. But, hey, *For Whom the Bell Tolls* is nearly five hundred pages, and as long as we're being honest, most emo fans don't have a clue what *the White Album* sounds like, either.

WHAT YOU NEED TO KNOW: *For Whom the Bell Tolls* is the story of a soldier serving in the Spanish Civil War who falls in love with a woman behind enemy lines. It's also about the divisions of culture and the complexities of death and, well, a lot of other things that would take way too long to explain. So with that in mind . . .

WHAT TO SAY TO YOUR FRIENDS: Unlike every other book on this list, you're probably better off *not* faking like you've read this

one. If this ever comes up in conversation, get the hell out of there. Change the subject to the latest Wes Anderson movie. You know, something—nay, *anything*—that you actually know about.

Don't feel bad about this, either. If some Poindexter thinks spending two months reading a Pulitzer Prize–winning work of fiction is cool, good for him. But you don't have time for that. Okay, maybe you *do* have time for that, but the Spanish Civil War is, like, so last year.

A BRIEF HISTORY OF FANZINES

Like many of the books above, fanzines* are something emo types rarely know firsthand. This is not because they don't like reading fanzines: far from it. It's because it's pretty much impossible now to find any of the really good fanzines that were produced in emo's early or middle periods. Once emo bands started doing unheard-of things like making money, fanzines—as many elderly emo types came to know and love them—pretty much disappeared.

But like a lot of elements of emo's history, pretending that you know about fanzines that were being published roughly around the time most of today's emo fans were still playing with pogs is an essential part of the emo experience. That being said, you should start by pretending you know at least *something* about the following.

COMETBUS

This fanzine came to prominence in the late eighties and was written by famed East Bay scenester Aaron Cometbus, a pro-

* *n* An ancient artifact that came to be in the late eighties and early nineties. A fanzine is like a magazine, but without budgets, glossy pages, or annoying rock critics who use words like *searing* to describe guitar solos.

fessional crusty punk who knew Green Day back when they still had dreads and wore cut-off shorts onstage. Most issues of *Comet-bus* contain surprisingly well-written stories about riding around in Greyhound buses and spanging* for change on Telegraph Avenue in Berkeley with dudes who have face tattoos. All issues are literally handwritten by Cometbus himself. This is something that *Cometbus* fans talk about constantly, which leaves its author in the odd position of being the only person in the world who is just as famous for his handwriting as he is for the stories he's written.

ADD SCENE POINTS: For younger emo types who are trying to look old school in front of their friends, one potentially quick route is to say you're getting something tattooed on your calf in "the Cometbus font."

NO ANSWERS

If you ever manage to see a copy of this fanzine—which was published by Ebullition Records owner Kent McClard before he launched yet another influential fanzine called *HeartattaCk*—you're pretty much guaranteed some serious bragging rights. *No Answers* was probably the best example of what a perszine† was like in the early nineties. At the time McClard ran eighteen-page interviews with hardcore bands and wrote ridiculously dramatic poems about slam-dancing. Let us repeat that last part for you again. Kent McClard was a grown man who wrote poems about *slam-dancing*. That's just priceless.

* *v* Activity in which subject asks total strangers for "spare change" in heavily populated shopping areas. You know those jerks who sit in front of record stores with "clever" signs that say things like FISHING FOR BEER? That's who we're talking about here.

† *n* Derived from the words *personal* and *fanzine*. This kind of publication died a slow, painful death somewhere around the year 1997. Perszines were usually the size of a piece of paper folded in half, and were best characterized by overwrought poetry and poor photocopied images of bands with awesomely bad names like Prozac Memory.

ADD SCENE POINTS: The next time any oversensitive emo type writes something like, "Fires rage inside me, fanned by your sorry discontentment" on their LiveJournal, following this with the insistence that they were just "having a Kent McClard moment" is a good way to look like a scene historian.

ANTI-MATTER

Fanzines had become fairly professional by the mid-nineties due in large part to publications like *Anti-Matter*. Throughout the zine's brief run, the artist formerly known as Norm Arenas* used words like *nascent* and *emblematic* in his writings—but, unlike a lot of fanzine writers before him, *he* knew what they meant. The thing that separated *Anti-Matter* from most major music rags, though, was that you got the feeling that virtually no writers at *Rolling Stone* would have ever asked Rage Against the Machine frontman Zach de la Rocha when the last time he cried was, nor would they have ever started their Letter from the Editor section with a rant about how they had just signed up for food stamps.

ADD SCENE POINTS: Though Arenas is probably better known now for the band he played guitar in after *Anti-Matter* folded—the influential emo act Texas Is the Reason—saying that you bought the Split Lip 7-inch on eBay that came with *Anti-Matter*'s fifth issue will surely impress anyone with a screen name like Johnny-OnTheSpot97.

PUNK PLANET

Punk Planet came to fruition around the same time as *Anti-Matter*, with editor Dan Sinker attempting to create a less-rigid alternative to the punker-than-

* In 2006 Arenas, not unlike Prince, stunned his fans when he suddenly changed his name. Sadly, unlike the Purple One, Arenas—who now goes by the last name Brannon—did not also begin wearing assless yellow trousers.

thou 'zine *MaximumRocknRoll*, thus resulting in reading material for the kind of people who bathe on a regular basis and occasionally listen to bands that write discernible choruses. In its early days, *Punk Planet* didn't exclusively cover emo bands but it did grant extensive coverage to some of its core artists like Lifetime, Jawbreaker, and the Promise Ring. In the time since, it's kept the emo flame lit by interviewing everyone from Bright Eyes to Atmosphere to Taking Back Sunday.

ADD SCENE POINTS: To really look like you knew what was going on with *Punk Planet* in the mid-nineties, you should claim you loved when coeditor Josh Hooten was still penning columns for them about how he spent most of his nights at home listening to Lungfish and getting drunk with his dog.

HIT IT OR QUIT IT

Back in the late nineties, *Hit It or Quit It* solicited new writers by placing ads in its pages that read, "If you can't say something nice, you could probably write for *Hit It or Quit It*." That was a fairly good indication of how editor Jessica Hopper and her sharp-witted school of writers handled oh-so-pressing topics like whether or not the incredibly thin members of the the Locust were "ruining the scene" for fat people. And while it may not be quite as scathing as it used to be, *Hit It or Quit It* continues to be published, albeit on an extremely infrequent basis, to this day.

ADD SCENE POINTS: Ironically, the best way to impress your friends might be to say that your band got absolutely trashed in the reviews section—but in lieu of having a band, one other way to look cool among your peers is by saying you read Hopper's blog "Tiny Lucky Genius" every morning before your nine a.m. gender studies class.

BURN COLLECTOR

With its largely hand-crafted layout and long, existential rants about crummy roommates and crappy jobs, *Burn Collector* suggested

LITERATURE

that author Al Burian could become the Aaron Cometbus of the 2000s, which doesn't seem completely far off considering that he's the only other underground author out there who can talk about his rather unremarkable life as eloquently as Cometbus did. Plus, the major reason this comparison still sticks is that both fanzines attract emo types who are way too smart for the temp jobs they will inevitably spend the best years of their twenties working.

ADD SCENE POINTS: Most indie-emo types will want to point out to their friends that Thrice singer Dustin Kensrue named his band's third album, *The Artist in the Ambulance*, after reading a story in *Burn Collector* that Burian wrote about his ambulance-driving brother.

LAW OF INTERTIA

This fanzine first came to be while editor Ross Seigel was going to school in upstate New York at Cornell, a prestigious university where Bad Religion singer Greg Graffin occasionally lectures students about evolutionary history. Along with a few other 'zines at the time, *Law of Inertia* marked the point where "fanzines" basically became "magazines." Seigel embraced certain things you might call "professional" (like full-color pages and interviews with actual famous musicians) and other things that weren't (take, for example, a photo essay he ran once of one of his writers backing over with a car what the 'zine decided was the worst CD it received for review that month). Unfortunately, Seigel eventually left *Law of Inertia* to go to grad school, which pretty much ended the fanzine's run.

ADD SCENE POINTS: With Seigel out of the picture, *Law of Inertia* turned into the current emo rag *Death and Taxes*, but scene types who want to look really informed should say that they liked the magazine better when they were letting *Law of Inertia* coeditor Jonah Bayer write columns about his rap band the Whatever Dudes.

A BRIEF HISTORY OF *ALTERNATIVE PRESS*

Alternative Press is pretty much the emo scene bible. Its glossy pages are filled with advertisements for the kind of bands that rule MySpace, and it's packed with articles on nearly every emo act that currently exists. But there was a time, back in the dark ages of really bad new-wave haircuts—this period is also known to some as the mid-eighties—when *Alternative Press* was without a doubt a "fanzine." After taking out a loan from his grandmother, founder Mike Shea published a two-page newsletter about the goings-on in his hometown of Cleveland. (A copy of that first issue is now hanging in the Rock and Roll Hall of Fame, where its front page announces the shocking—we repeat, *shocking*—headline, SMITHS START 1ST U.S. TOUR, CLEVO NOT ON LIST.)

For the next few years, *AP* remained a cheaply printed black-and-white affair that spotlighted local punk bands like Numbskull, who later went on to . . . well . . . complete obscurity. But soon thereafter *AP* got more popular bands to talk to them, and by the mid-nineties it wasn't uncommon to find influential artists like Radiohead and the Cure on the magazine's cover. While this was an admittedly cool time for *AP*, it was also when the magazine found itself competing with glossy mainstream music rags, which eventually convinced the staff that they needed to put then-

mainstream rock acts on the cover like Korn, Limp Bizkit, Papa Roach, and Insane Clown Posse, whose Faygo-loving members were on *eight* different covers.

But what was known as *AP*'s "nü-metal" years eventually led to the magazine putting soon-to-be-hallmark emo bands like Saves the Day, Dashboard Confessional, and Thursday on the cover—at a time when *no one* in the music industry was paying them any attention. It was a huge risk, but that's basically *AP*'s history in a nutshell. For years it has been one of the greatest music magazines in the world, and in the last five, it's been the *only* music magazine that emo fans read on a regular basis. But it couldn't have reached that point had its staff not taken lots of chances and made some occasional mistakes. As for Insane Clown Posse, they later went on to become professional wrestlers. Go figure.

A BRIEF HISTORY OF EMO LITERARY REFRENCES

Emo bands have long had a history of naming themselves after famous authors. In the mid-nineties, for instance, both beard enthusiasts Hot Water Music and intramural indie-emo act Rainer Maria looked to their bookshelves for inspiration. While they were both trying to pay homage to their favorite writers (Charles Bukowski and Rainer Maria Rilke, respectively), this said to their fans more than just, "I like to read." It in fact said, "Yes, I am a daytime drinker" and, "No, I don't find cardigan sweaters and spending all day at a coffeehouse to be particularly passé."

It's important to note, however, that Rainer Maria and Hot Water Music were not alone. Around this same time the emo-approved post-punk band June of 44 also emerged. They dressed like auto mechanics and derived their name from a series of letters that *Tropic of Cancer* author Henry Miller wrote to his wife in 1944. While it seemed fairly ridiculous that this same band also used arcane sailing terms in their lyrics despite being from the

great port towns of Chicago, Illinois, and Louisville, Kentucky, June '44 was important because they suggested emo bands didn't have to know all that much about what they were referencing in order to reference it.

With that in mind, the next few years saw the emergence of bands like As I Lay Dying, who asserted that even Christian emo metal outfits should pretend to read Faulkner. Then there were emo bands like Gatsbys American Dream, named after F. Scott Fitzgerald's *Great Gatsby*, and post-hardcore acts like Silverstein, who took their name from children's author Shel Silverstein. Looking back, both of these band names seem totally arbitrary. For one, Silverstein is a band led by a former molecular science major, yet they took their name from an author who wrote poems like "Ickle Me, Pickle Me, Tickle Me Too." Similarly, Gatsbys American

Dream's entire existence seems to rely on referencing books that teenagers are forced to read in high school and that, furthermore, they don't ever seem to enjoy. (For further proof consult their second album, which was a concept disc based on George Orwell's *Animal Farm*.)

Now, on the surface this implies that there are some huge literary snobs in Gatsbys American Dream. But really, what self-respecting literary snob would allow their band to ignore the use of proper possessive punctuation? (It's called an apostrophe, dudes, and it belongs at the point between the y and the s.) But the significance of Gatsby—and even a band like Hawthorne Heights, who took their name from *The Scarlet Letter* author Nathaniel Hawthorne—is that they represent the moment in this brief history when the literary-emo nod changed.

In fact, Hawthorne Heights might be the best example of this. In their case, sure, *The Scarlet Letter* is kind of emo.: There are some sex issues in there, and it's about feeling like a social outcast. But it's not a book emo fans read. After getting through *The Scarlet Letter*, no self-respecting emo fan has ever felt as if they were being "taken to new heights," as Hawthorne Heights insists that their name implies. They probably felt like, "Dude, I seriously should have just gotten the Cliff's Notes for this book report due on Monday. I bet Professor Mackenzie wouldn't have been able to tell the difference." So what's the point here? The point is that naming yourself after a dead writer has become an absolute emo staple and, furthermore, it really doesn't matter who that author is anymore.

OTHER NOTABLE
EMO BOOK WORMS

THRICE

This Orange County–bred group might be the only act in emo whose members are in their late twenties and are still absolutely obsessed with C. S. Lewis. Thrice have also further proven their literary interests in recent years by naming their albums after short stories that none of their fans have read, while also donating percentages of their album sales to writing workshops in both Brooklyn and San Francisco.

DEATH CAB FOR CUTIE

While this probably doesn't come as a big shock to anyone who's ever looked at him, Death Cab guitarist Chris Walla is a big reader and manages to talk about author Sarah Vowell in just about every interview he ever gives. Aside from Walla, the band also features bespectacled singer and corduroy-blazer enthusiast Ben Gibbard, who looks and acts *exactly* like most freshman-year lit professors.

EVERY TIME I DIE

Though they probably seem like odd literary representatives considering that they sing about doing blow and hanging out at strip clubs, every so often this screamy metalcore band uses words like *pliable* and *inharmonious* in their songs' lyrics, which probably has a lot to do with singer Keith Buckley's former job as a tenth grade English teacher.

MEG & DIA

Considering that the two sisters who front this emo-pop band are stupid hot, we're guessing that they could reference that guy who wrote *Chicken Soup for the Soul* and your average emo dude would still have a crush on them. But instead singer Meg Frampton bases her lyrics on John Steinbeck novels and publicly claims that after she read George Sands's *Indiana*, she "hurled the novel to the floor and called my sister, wailing with sobs of uncontrollable volume." Now *that's* emo.

MURDER BY DEATH

That this indie emo band is well read may seem kind of surprising considering that they are from Bloomington, Indiana, former home to increasingly irrelevant rock stars like John Mellencamp and David Lee Roth. But MBD defied their hometown's odds in 2006 when they wrote a record called *In Bocca al Lupo*, which was partially based on Dante's *Divine Comedy*.

PANIC! AT THE DISCO

The members of Panic! aren't particularly subtle about their bookish leanings. They try to dress like dead English poets, write songs

that are made up entirely of references to Chuck Palahniuk novels, head up a book club, and do a lot of other things that scream, "Look at me, I don't *just* read *Alternative Press*."

EMO HALL OF FAME

NICK HORNBY

You may be wondering, "How could Nick Hornby really be considered the most emo author of all time, when there is so much evidence to suggest that he's not emo *at all*?" That's a good question. However it is also one with a simple answer. Now, sure, Hornby is British, and everyone knows that the English didn't really get into emo until a few years ago (and when they did they just gave it a ridiculous nickname like "Xtremo"*). But if that weren't enough, Hornby is also old. At this point he is fifty, which is way too elderly to vent your spleen on Blogger.com. Worse yet, the Berkshire, England-bred author really likes sports—as proven by his soccer-obsessed first book, 1992's *Fever Pitch*. As we all know after reading the first chapter of this book, liking sports is bad. Adapting one of your books into a movie about sports, though, and then allowing said movie to become a romantic comedy starring Jimmy "Friggin'" Fallon (as Hornby did with *Fever Pitch*), is even worse.

But there is one simple reason that Hornby is considered *the* emo author, and it can be summed up in two short words: *High Fidelity*. *High Fidelity*, without question, is a classic emo read. The book's main character is a record-store owner named Robert Fleming who reduces everything in his life to a Top Five list, judges everyone he knows on their musical tastes, and watches most of his girlfriends leave him because he refuses to grow up. This may sound sort

* *adj* British slang for the strain of emo that includes screaming vocals and fast, harmonized guitars. No one uses this term anymore, possibly because around the same time a bunch of British blokes began calling bands like Funeral for a Friend *Xtremo*, it emerged as a brand of Gatorade that, in the case of flavor Mango Electrico, was primarily marketed toward Hispanics.

of familiar. Fleming is also a character who doesn't seem to particularly mind his average-ness and who revels in his obsessions.

Again, this may sound familiar. Like Fleming, most emo fans spend a great deal of their lives obsessing over things they can't control—like girls and their favorite band's career—and ignoring the things that they can. As Hornby's book suggests, the end result of such behavior will always wind up the same: You become a thirty-year-old version of your seventeen-year-old self. And while some people in society might find this sad . . . hey, who needs society? Or a girlfriend? Or a respectable career? Or his own place to live? If at any point these thoughts have raced through your head, then you should have no trouble understanding why Hornby is considered an emo literary god. He epitomizes the kind of music fan who is obsessed with his faults almost as much as he is with side two of *Rumours*.

Which leaves you, one imagines, with one last question: What's *Rumours*? Ehhh, go ask your parents.

mu•sic *n* Something that will probably get in the way of every relationship a fan of this genre will ever have.

When one stops, looks around, and really begins to examine what it takes to be emo, it becomes clear that music influences nearly every aspect of an emo fan's life. If emo fans just composed a blog post about an unrequited crush, for example, there's no question that they were listening to their favorite band while completing it. If they attended a show the night before said post, it's a given that they were blasting their favorite mix CD on the car ride back home. The life of your average emo fan is never short on opportunities to express a sense of devotion to a particular artist.

But how does that make an emo fan any different from any other music fan, you may ask? After all, most music fans create a soundtrack for their lives with their favorite songs or CDs. The difference, however, is in the details: If you were to ask emo fans what *type* of emo fan they are, they'd have at least a dozen idiosyncratic categories to chose from. Say you wanted to know the implications of a band's name. They'd boil it down to a science. And if you were curious about the

everchanging list of albums they deem essential, well, most emo fans would already have one chronologized.

Emo fans are obsessed with the music this scene produces—obsession, after all, is the emo way—and throughout the following pages, such obsessions will play out alongside the kind of debates that only a true emo fan could possibly engage in.

WHAT'S IN A NAME?

How do you know if the band you're listening to is an emo band? Until someone invents an emo band-name generator, the following formulas will have to do.

- **Emo bands often take their namesake from a season and/or calendar marking.**
 For example:
 "Did you see the merch for The Autumn Coronary? I love that track jacket with the tree stemming out of a bleeding heart. I just hope they still have extra-smalls available."

- **To achieve maximum emo-ness, said measurement of time should be coupled with the name of a completely unrelated and obscure bodily organ, like "mesentery," which is a bunch of folds that connect the intestines to the abdomen.**
 For example:
 "Do you know what time Those Ides of Mesentery is playing this weekend? I have to work at Ruby Tuesday's until, like, six, and I really don't want to miss their set!"

- When in doubt, emo band names should definitely reference deceased poets like Rainer Maria Rilke and Elizabeth Barrett Browning. It proves that the band's members read more than just their e-mail.
 ### For example:
 "Have you heard Illuminations & Detonations yet? According to PureVolume, fifty thousand people downloaded their demo EP *The Scene Is Bleeding Me Dry* . . . and that's just *today*. These guys are gonna be *huge*!"

- Literary references are best bookended with synonyms for "explosions." The more syllables, the better.
 ### For example:
 "After five weeks of passing out CD samplers of the Bucolic Deflagrations album, I finally got promoted to the head of their street team. That's *mad* cred."

- In order to tap into an emo band's spiritual side, said name should reference one of the eight limbs of Raja yoga. Despite its New Age leanings, it's a vague enough reference for most metal-leaning emo bands to seem mysterious—and athletic.
 ### For example:
 "Last week I went to the Samadhi Birch show. You know, that sort of metal-core band on Bloodied Marrow Records, and some d-bag totally ruined my glasses when he came down from a stage dive."

- In order to keep with the theme of wellness, emo bands should then add a tree genus to their name.
 ### For example:
 "I think I saw the lead singer of Kaivalya Pada Pine at the Starbucks across the street from my house. He ordered a vente caramel machiatto, which was weird because I thought I read in *Alternative Press* that he was vegan."

MUSIC

- **Many emo bands will combine some measurement of time with an obnoxious use of punctuation. For proper effect, the measurement of time should be as overdramatic as possible and should reflect a general sense of longing.**
 For example:

 "The new Eternal Cadence, Everlasting Silence video premiered on Fuse this week and I totally voted for it as an *Oven Fresh Keeper*."

- **As for the use of punctuation in the above formula, it should be really unnecessary, annoying, and a bit dramatic.**
 For example:

 "Dude, I just read on PunkNews.org that Forever . . . and a Day is going to be playing on the SmartPunk stage at this year's Warped Tour. Sweet! This is gonna be the best summer, ever. But, like, for real this time!"

WHEN ALL ELSE FAILS, NAME YOUR BAND AFTER A DAY OF THE WEEK

Thursday. Taking Back Sunday. Saturday Looks Good to Me. As you go through your MP3 playlists, you might be wondering, "Why do so many emo bands have days of the week in their names? What gives?" We're not sure. But evidently bands—specifically from New Brunswick, New Jersey, and Long Island, New York—have found a special place in their collective hearts for naming themselves after days of the week. Perhaps Thursday's Geoff Rickly just couldn't wait for the weekend or Taking Back Sunday's Adam Lazzara wanted to reclaim the Sabbath or . . . maybe, it's just that naming your band is something a lot of emo bands think of five hours before they're supposed to play their first show.

WHAT DOES YOUR FRONTMAN SAY ABOUT YOU?

We all have our heroes. But in the case of emo fans, whom you look up to can say a lot about your future path in life. So what does worshiping some of today's most popular emo-band frontmen say about you? Let's suss this out.

CHRIS CARRABBA

WHO: The baby-pomp-sporting singer-songwriter behind Dashboard Confessional.

WHY EMO FANS LOVE HIM: Carrabba is sort of like the Jason Priestly of emo frontmen. In real life he might be in his early thirties, but he plays a seventeen-year-old on TV. In the past five years, Carrabba has made a good living by taking average teenage emotions and turning them into timeless three-minute pop songs. It's not exactly brain surgery, but Carrabba has become a cult figure among emo fans because of this. Also, he's gained a lot of respect for his resilience. Seriously, if you had to sit through as many dumb jokes about your height, hairdo, and masculinity as Carrabba has, you would have probably showed up at the guy who created Emogame's house offices with a semiautomatic weapon a *long* time ago.

WHAT LOVING HIM SAYS ABOUT YOU: Be careful. Like Carrabba, you may find yourself publically admitting that you are a big fan of the Counting Crows.

SEE ALSO: Pint-sized Rocket Summer singer (and Carrabba's former protégé) Bryce Avary.

RIVERS CUOMO

WHO: The incredibly neurotic leader of the pioneering emo band Weezer.

WHY EMO FANS LOVE HIM: Over the past ten years, there's been no shortage of questions that surround Cuomo's often-erratic behav-

ior: "Did Cuomo really have leg extension surgery during the record-ing of *Pinkerton?*" "Has he really sold all his worldly possessions and begun volunteering at a soup kitchen?" "What's up with the whole celibacy thing?" And, perhaps most important of all, "When is this guy going to write another decent record?" These are all incredibly valid questions, and at the very least Cuomo's unusual life is what's kept emo fans interested over the past few years as he and his Weezer bandmates continue to release one crappy album after another.

WHAT LOVING HIM SAYS ABOUT YOU: You may also be celibate. But perhaps not by choice.

SEE ALSO: The Early November's Ace Enders, who, while less crazy, is prone to writing way too many songs like Cuomo, as evi-denced by the fact that his band released a *triple* CD in 2006.

RYAN KEY

WHO: Diminutive singer and guitarist for the world's only violin-toting emo band, Yellowcard.

WHY EMO FANS LOVE HIM: Key is the emo scene's Everydude. He looks and acts like 85 percent of his audience, has a tendency to only wear clothes from American Eagle Outfitters, and can pound tallboys like nobody's business. Thus, the kind of emo fans that continue to flock to Key are usually college students who tear through Keystone Lights while blasting "Way Away" in their dorm rooms. That these same people ignore the fact that his hair is a little fauxmosexual-ish* and that he occasionally consorts with terrible pop groups like the Black Eyed Peas is another story.

WHAT LOVING HIM SAYS ABOUT YOU: You will probably never have a better six days in your life than you did at Spring Break '03 in Cancún. *Duuuuuuuude . . . Caaaaaaan-cooooon!*

* *n* A straight man prone to paying excessive detail to his appearance. Often tries to impress everyone with his knowledge of wine, most of which he learned from watching the movie *Sideways*. See anyone who listens to Belle and Sebastian constantly and loves HGTV.

SEE ALSO: Tyson Ritter from the All-American Rejects. He may look a bit more like a male model, but he definitely attracts the same audience.

JESSE LACEY

WHO: The kind of, sort of enigmatic frontman for emo rockers Brand New.

WHY EMO FANS LOVE HIM: Lacey is the type of frontman whose fans often theorize about his lyrics and whereabouts with surprising dedication. Brand New's breakthrough album, *Deja Entendu*, is a modern emo classic and serves as a gateway for fans into a lot of the guitar-based indie-rock that Lacey pulls his cues from. The only problem? Lacey is boring. He's nowhere near as interesting as someone like, say, Rivers Cuomo. He's never fined his bandmates, for instance, or become a public advocate for Vipassana meditation. But he did disappear for three years while Brand New wrote *The Devil and God Are Raging Inside Me*, which, at the very least, allowed such intrigue to grow. Regardless, Lacey is still someone who cultivates ambiguity far more than he possesses it; after all, no one in his mid-twenties who still lives with his parents can be *that* much of a mystery.

WHAT LOVING HIM SAYS ABOUT YOU: You will be that one person at the party who says obnoxiously "deep" things like, "I don't know, sometimes I feel like we're all just atoms, bumping into each other haphazardly," while your friends are making small talk.

SEE ALSO: The similarly mysterious but surprisingly normal Chris Conley from Saves the Day.

ADAM LAZZARA

WHO: The mic-swinging lead singer of Taking Back Sunday.

WHY EMO FANS LOVE HIM: Lazzara is the polar opposite of most emo frontmen. While others are humble, quiet, and shy onstage, he's prone to wrapping a microphone cord around his neck, doing the robot, and jumping off speakers. Seeing as he's never been able

<158>

to show restraint, the first Taking Back Sunday album is essentially one rather lengthy indictment of how terrible a girlfriend his high school sweetheart was, and, to put it mildly, Lazzara wasn't exactly subtle with his words. But for most emo fans his honesty is also a huge part of Lazzara's allure, and if he were any less sensational, well, chances are he would still be delivering Chinese food on Long Island.

WHAT LOVING HIM SAYS ABOUT YOU: Your first breakup will probably be *rough*. Come to think of it, your second, third, and fourth breakups might not be so hot, either.

SEE ALSO: The Academy Is . . .'s equally flamboyant toothpick of a singer, William Beckett.

CONOR OBERST

WHO: Often-stalked leader of the emo-folk band Bright Eyes.

WHY EMO FANS LOVE HIM: On the surface, Oberst is the definitive emo frontman. His sad eyes, unruly bangs, and quivering voice suggest that there may not be another person on this planet who has as much pent-up hurt as this twentysomething songwriter. But let's be real. Supposedly Oberst has hooked up with every hot girl in indie-rock (from Rilo Kiley's Jenny Lewis to Azure Ray's Maria Taylor) and drinks pints of beer like a fraternity pledge, yet can still fit into a youth-large hoodie.

Both are enviable qualities, and while it may be tempting to suggest that emo fans worship Oberst because of the way they see themselves in his grief-stricken songs, the real reason seems far more simple: The dude's got Michael Stipe, Bruce Springsteen, *and* Winona Ryder's phone numbers in his cell phone. Bastard.

WHAT LOVING HIM SAYS ABOUT YOU: There may be the serious need for either a haircut or an AA meeting in your immediate future.

SEE ALSO: An Angle singer Kris Anaya, a similar-sounding songwriter who insists the major difference between him and Oberst is that he's Mexican.

CLAUDIO SANCHEZ

WHO: The impressively Afroed singer and guitarist for the prog-emo band Coheed and Cambria.

WHY EMO FANS LOVE HIM: If the emo scene were high school, then Sanchez would be the awkward freshman who is always drawing on his folder during homeroom. In simpler terms, he's not your typical frontman. He reads comic books constantly, writes songs about intergalactic warfare, and probably knows way more about Dungeons and Dragons than any twenty-eight-year-old man should. It seems safe to say that you will probably never confuse him with a member of Franz Ferdinand. So does that make him emo? Absolutely. But the thing about Sanchez that *really* strikes a chord with a lot of male emo fans is that—like them—he seems like the type of guy who has spent all of five minutes in the presence of an actual girl.

WHAT LOVING HIM SAYS ABOUT YOU: Your date to the winter formal, unfortunately, may in fact be a twelve-sided die.

MUSIC

SEE ALSO: The Receiving End of Sirens' Nate Patterson, an admitted geek who is also prone to writing "concept records."

GERARD WAY

WHO: Mascara enthusiast and singer for the goth-emo band My Chemical Romance.

WHY EMO FANS LOVE HIM: Time was, if you were willing to put on face paint, you meant business. You could be Marilyn Manson singing about being the Antichrist or some psychopath at a New Jersey Devils game, but chances are you weren't very popular with fourteen-year-old girls. In fact, it was more likely that you *scared* fourteen-year-old girls. But when Way began donning Mac cosmetics a couple years ago, he suggested that you don't have to be scary at all. Sure, his lyrics are all about death and the afterlife, but we're talking about a guy who's nearly thirty, spent most of his royalties from *Three Cheers for Sweet Revenge* on collectible action figures, and still looks like a Campbell's Soup Kid.

WHAT LOVING HIM SAYS ABOUT YOU: Like Way, you will probably wear black for the rest of your life.

SEE ALSO: The loads of emo frontmen who have taken to wearing eyeliner despite the fact that they are nearly old enough to be your father.

PETE WENTZ

WHO: The one member of Fall Out Boy whose phone number might honestly be in Jay-Z's BlackBerry.

WHY EMO FANS LOVE HIM: Wentz is the emo scene's only true mogul. While this is usually a role associated with hip-hop artists (like Wentz's idol, Shawn Carter), his ability to be involved in pretty much every corner of the mainstream emo scene and still have enough time to post esoteric poems on Fall Out Boy's Web site is admirable. In the past two years, Wentz has developed his own online social network, run a clothing line, launched a record label, penned two books, acted on *One Tree Hill*, coached

the Miami Heat to their first-ever NBA championship, and adopted a Namibian baby after a half dozen humanitarian aid missions in sub-Saharan Africa. What did *you* do? Buy a tote bag from ClandestineIndustries.com?

WHAT LOVING HIM SAYS ABOUT YOU: You really like hoodies and probably have *a lot* of cash to burn.

SEE ALSO: Used-car salesmen, rappers, or the always-enterprising Madden brothers from Good Charlotte.

JT WOODRUFF

WHO: Hawthorne Heights' freakishly well-adjusted lead singer and guitarist.

WHY EMO FANS LOVE HIM: Woodruff is living proof that you don't actually have to be interesting in order to be famous. His backstory is admittedly blah. He has never overdosed on drugs, never locked himself in the back of a tour bus, and he can really go the distance when it comes to talking about fixed income rates. This is someone whose idea of decadence is overspending on flatware at Crate and Barrel. Woodruff is so normal it's almost abnormal, and the reason emo fans continue to love the Hawthorne Heights frontman is the same reason they don't really care about Bono. He's not now, and probably never will be, an actual rock star.

WHAT LOVING HIM SAYS ABOUT YOU: If you worship at the altar of Woodruff, these six words will probably mean a lot to you: *Grey's Anatomy* Season Two box set.

SEE ALSO: Proudly well-adjusted people like Jimmy Eat World's Jim Adkins or, ostensibly, the guy who bags your groceries at Safeway.

IN THE MIX

Any dummy can burn a CD (thanks in part to books like, well, *CD Burning for Dummies*), but it takes a true savant to create a sick mix.* Although the mix originally started with the invention of the compact audio cassette, it has evolved with modern technology. Sure, some old-school peeps insist on staying true to traditional mix-tape production—which involves either a boombox with two tape decks or a CD player and a tape deck—but more technologically advanced individuals, particularly of the emo kind, opt for mix CDs or mix MP3 playlists.

While mixes can be created for any occasion (i.e., the "I Got Grounded for Spray-Painting the Bartskull on My Parents' Garage Door and I Feel Like Rebelling" mix or "I May've Fallen into a Porta Potti at Warped Tour but I'm Hardcore Bumming That Summer's Almost Over" mix), there are two specific occasions in which emo types earn their mix-making stripes: attempting to woo a member of the opposite sex and coping with the inevitable breakup with said member of the opposite sex. Such mixes might look a bit like this:

* *n* A custom-made compilation of songs that are carefully picked in order to evoke a very specific emotion from the listener. Mixes, if used properly, can be quite successful as grand gestures of affection.

"THIS IS THE FIRST DAY OF MY LIFE; GLAD I DIDN'T DIE BEFORE I MET YOU" MIX

(Aka "You Just Met Someone on MySpace You Hope to Build a Life with and You Want to Show How Much You Totally Heart Them" Mix)

1. "All Is Full of Love" – Björk
2. "Always Love" – Nada Surf
3. "Anywhere with You" – Saves the Day
4. "Best of Me" – The Starting Line
5. "Bury Me Deep Inside Your Heart" – H.I.M.
6. "Falling for You" – Weezer
7. "Fatally Yours" – Alkaline Trio
8. "First Day of My Life" – Bright Eyes
9. "Goodnight and Go" – Imogen Heap
10. "I Love You So Much It's Killing Us Both" – Jawbreaker
11. "I Want to Save You" – Something Corporate
12. "I'm Glowing and You're the Reason" – Braid
13. "Only One" – Yellowcard
14. "This Modern Love" – Bloc Party
15. "XO" – Fall Out Boy
16. "You Remind Me of Home" – Ben Gibbard
17. "You're So Damn Hot" – OK Go
18. "Your Star" – The All-American Rejects

"DON'T APOLOGIZE (I HOPE *YOU* CHOKE AND DIE)" MIX

(Aka "You Just Got Dumped by Someone You Met on MySpace Who Didn't Appreciate or Understand Your Emo-ness and Now You're Convinced That You'll Never Love—or Be Loved—Again" Mix)

1. "Heaven Knows I'm Miserable Now" – The Smiths
2. "If Only Duct Tape Could Fix Everything" – The Movielife
3. "It's Going to Get Worse Before It Gets Better" – Piebald
4. "Jude Law and a Semester Abroad" – Brand New

5. "My Friends over You" – New Found Glory

6. "Nothing Feels Good" – The Promise Ring

7. "Pain" – Jimmy Eat World

8. "Papercuts" – Gym Class Heroes

9. "Purging" – Boys Night Out

10. "See You in Hell . . ." – Aiden

11. "So Jealous" – Tegan And Sara

12. "The Best Deceptions" – Dashboard Confessional

13. "The Despair Factor" – AFI

14. "The Heart Is a Lonely Hunter" – The Anniversary

15. "The Suffering" – Coheed and Cambria

16. "The World Is Black" – Good Charlotte

17. "When We Two Parted" – The New Amsterdams

18. "You're so Last Summer" – Taking Back Sunday

FOLLOW THE FORMAT

All of this mix-making brings up a crucial question: Which medium is the most emo—vinyl, tapes, or MP3s? As it turns out, there is no right answer to this question. Each has its pros and cons, and each has its own sect of devotees.

There are first, of course, the Vinyl People, who are not to be confused with audiophiles.* These are the sort of emo fans who obsess over bands and eras they never got a chance to properly experience. The most frequently

* *n* An emo fan, usually male, obsessed with high-fidelity sound reproduction. Said persons have a tendency to recite all of Jack Black's lines in *High Fidelity*, and drop words like *analog* and *flanger* into normal conversation.

obsessed-over times and places among the Vinyl People are the early eighties in Manchester, England, the late eighties in New York City, and the early nineties in Northern California. Those obsessed with Manchester usually look like Ian Curtis, pay a lot of money for vintage Smiths T-shirts on eBay, and, ever since *24 Hour Party People,* have been obsessed with finding original vinyl EPs issued on Factory Records. The fans of New York City, on the other hand, usually listen to seminal (though since disbanded) local hardcore bands like Beyond and scour dusty record stores for early Revelation Records singles that they will never actually touch a needle to. As for the last camp, these are the kind of people who are obsessed with every early band on Lookout! that wasn't named Green Day. This means spazzy punk acts with awesomely bad names like Sewer Trout, Blatz, and Brent's TV.

The overall vibe you get from the Vinyl People is that they don't really live in the here and now. While dwelling in the past is a pattern of behavior among most emo fans, it doesn't seem wholly accurate to call vinyl the emo format. The reason for this is that no one really *owns* a record player anymore. This is roughly the same problem the Tape People have to deal with. Sure, it's a lot easier to buy a brick of cassettes at Rite Aid than it is to find an original pressing of Jawbreaker's *Chesterfield King* 12-inch, but playing a tape automatically rules out the possibility of anyone listening to said music on the go, considering that iPods have made most Walkman's* obsolete.

The best piece of evidence that the Tape People have in their favor, however, is the aforementioned mix tape. As proven by John Cusack's famously music-obsessed character in *High Fidelity,* there really is no better token of one's affection than the mix tape. Most older emo types today have held onto the mix tapes they've been given over the years, which is a fairly persuasive piece of evidence in the Tape Peoples' favor. The only problem is that hold-

* *n* An archaic instrument popularized in the eighties. Most current emo fans have only seen Walkman's in John Hughes movies.

MUSIC

ing onto mix tapes from the mid-nineties suggests that you could also very easily be the type of person who hoards strands of your ex-girlfriend or boyfriend's hair or clippings of their toenails. Now, granted, holding onto a bunch of TDK cassettes because your favorite Lync song is on one of them isn't exactly pathetic, but it does suggest you may need to let go *just a smidge.*

The modern adaptation of the mix tape is the MP3 playlist, which has become just as popular, though not quite as revered. The reason for this is that you can't really decorate an MP3 playlist with star stamps and glitter like you could a mix tape, and no matter how "exclusive" the touted exclusives on iTunes are, they'll never be as sweet as a limited-edition 7-inch EP. File sharing has created a sense of community that doesn't need to rely on the old way of doing things: Finding bands and discovering music is far easier now than it ever has been. But at times it can also be slightly less personal. This is why MP3s couldn't possibly stand up as the sole emo medium. Seeing a scratched-up cassette tape cover that reads SUMMER MIX '97 in someone's music collection may seem like a foreign concept now, but the mix tape at least evoked some degree of intimate devotion. Really, who could be intimately devoted to LimeWire?

PLEASE NOTE

While arguing over the most emo way to listen to music may seem like a silly debate to some, what this scene has proven is that there are no silly debates in emo. Case in point: online message boards. In the past five years or so, message boards have been *the* place where emo fans will take the most meaningless "controversies" and blow them wildly out of proportion. Though just about every news-related Web site features a message board these days, those who post on AbsolutePunk.net are probably the most entertaining. The fans of AbsolutePunk.net realize something that's crucial to the world of online debates: On the Internet, there's not a lot of

accountability for your actions. That being said, you can pretty much imagine what kind of things are posted in a forum where the debates span from whether or not Armor for Sleep are total poseurs because they signed to Sire to whether or not Anthony Green is a bigtime pothead.

ESSENTIAL EMO RECORDS 101

If universities offered a course on the history of emo, then the following records would definitely be on the first quiz. From the debut by Rites of Spring to the first multiplatinum album by My Chemical Romance, no fan would sit in the back of this hypothetical emo classroom and not have at least *something* to say about why the following records have been so essential to their music scene.

RITES OF SPRING, *RITES OF SPRING* (DISCHORD; 1985)

WHAT TO KNOW: Rites of Spring formed in the mid-eighties—not a great time to be an overly sensitive dude in punk rock. Yet singer Guy Picciotto often sang onstage holding a bouquet of flowers and appeared as if he was about to cry.

SO, WHY IS IT ESSENTIAL?: Because it was the first emo album ever . . . or at least that's what a lot of old people think.

EMBRACE, *EMBRACE* (DISCHORD; 1987)

WHAT TO KNOW: This was the band that Ian MacKaye* sang in before Fugazi and after Minor Threat; in hindsight, this record is only kind of good, historically.

SO, WHY IS IT ESSENTIAL?: Because the same aforementioned old people tend to think that this is, like, the *second* emo album ever.

SUNNY DAY REAL ESTATE, *DIARY* (SUB POP; 1993)

WHAT TO KNOW: This was the first real emo album to have a hit single, 1993's "Seven."

SO, WHY IS IT ESSENTIAL?: Because it inspired a lot of emo frontmen who couldn't sing to try and hit a falsetto like leader Jeremy Enigk.

JAWBREAKER, *DEAR YOU* (GEFFEN; 1995)

WHAT TO KNOW: This was the final album by this pioneering emo band, and when it came out in 1995 no one liked it—but now, for some reason, a lot of people do.

SO, WHY IS IT ESSENTIAL?: Because frontman Blake Schwarzenbach managed to reference Sega and taking speed in the same song. (See "Lurker II: Dark Son of Night.")

LIFETIME, *HELLO BASTARDS* (JADE TREE; 1996)

WHAT TO KNOW: This is often considered the album that influ-

* A legend in the D.C. punk scene, MacKaye founded the pioneering emo label Dischord Records in the early eighties. Later, when he got sick of playing hardcore, he went on to play in Embrace, and then with Picciotto in the band Fugazi. The three things that any self-respecting emo fan should know about Fugazi are as follows: (1) They only played all-ages shows; (2) They didn't sell T-shirts; and (3) They wore beanies and ill-fitting Dickies nearly every day of their decade-plus existence. The band has since broken up and MacKaye currently plays in the accoustic indie duo the Evens. Sadly, the Evens kind of suck.

enced latter-day New Jersey emo bands like Thursday, Midtown, and Saves the Day.

SO, WHY IS IT ESSENTIAL?: Because if you have ever been in a mosh pit and thought, "God, does everyone really have to push so *hard?*" this album proved that there was at least one band that could feel your pain.

TEXAS IS THE REASON, *DO YOU KNOW WHO YOU ARE?* (REVELATION; 1996)

WHAT TO KNOW: This album, written by a group of ex-hard-core kids, helped kick-start the second-wave emo movement in the mid-nineties.

SO, WHY IS IT ESSENTIAL?: Because, for six months in 1996, this album convinced a lot of other ex-hardcore kids that they could get away with dressing like they were in Oasis.

WEEZER, *PINKERTON* (GEFFEN; 1996)

WHAT TO KNOW: This is Weezer's one true emo record, and it features a song about masturbating to fan mail written by an eighteen-year-old Asian girl.

SO, WHY IS IT ESSENTIAL?: Because it's Weezer's one true emo record, and it features a song about masturbating to fan mail written by an eighteen-year-old Asian girl.

THE PROMISE RING, *NOTHING FEELS GOOD* (JADE TREE; 1997)

WHAT TO KNOW: This essential emo record gave hope to singers everywhere who, like Promise Ring frontman Davey von Bohlen, sounded like a Muppet with a lisp.

SO, WHY IS IT ESSENTIAL?: Because without this album, author Andy Greenwald would've had to find another album by a Midwestern emo band to name his book after.

THE GET UP KIDS, *SOMETHING TO WRITE HOME ABOUT* (VAGRANT; 1999)

WHAT TO KNOW: This was the flagship emo release by now scene staple Vagrant Records; up until the Get Up Kids, Vagrant's biggest hit was a fairly unlistenable compilation record of punk bands covering eighties ballads.

SO, WHY IS IT ESSENTIAL?: Because it proved that you could look like you worked at Barnes & Noble and still be in a popular emo band.

JIMMY EAT WORLD, *CLARITY* (CAPITOL; 1999)

WHAT TO KNOW: This is the album that got Jimmy Eat World dropped by their label at the time, Capitol Records, which may or may not have been because many of the jammy songs on *Clarity* suggested that the members of this band were smoking a ton of weed while recording.

SO, WHY IS IT ESSENTIAL?: Because you have not lived until you've listened to the album's sixteen-minute-closer, "Goodbye Sky Harbor," while blazing Kush herb out of a $175 vaporizer.

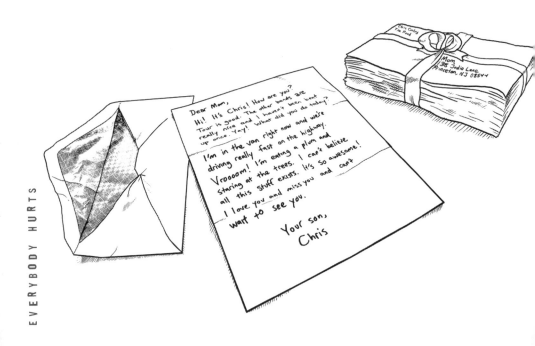

Dear Mom,
Hi! It's Chris! How are you?
Tour is good. The other bands are
really nice and. I haven't been. best
up once. Yay! What did you do today?
I'm in the van right now and we're
driving really fast on the highway.
Vroooom! I'm eating a plum and
staring at the trees. I can't believe
all this stuff exists. It's so awesome!
I love you and miss you and can't
wait to see you.

Your son,
Chris

SAVES THE DAY, *THROUGH BEING COOL* (EQUAL VISION; 1999)

WHAT TO KNOW: This was Saves the Day's breakthrough album, and it is best known for its cover art, which depicts the band as a bunch of squeaky-clean teenagers looking bored at a party.

SO, WHY IS IT ESSENTIAL?: Because it marked the first time an emo kid wrote a song about missing his mom (see the track "Your Vandal") and then played it on tour opening for a bunch of tough-guy hardcore bands.

GLASSJAW, *EVERYTHING YOU EVER WANTED TO KNOW ABOUT SILENCE* (ROADRUNNER; 2000)

WHAT TO KNOW: This is widely considered the first album to bridge the gap between emo, metal, and poor taste.

SO, WHY IS IT ESSENTIAL?: Because what lady hasn't daydreamed about a hunk like Daryl Palumbo writing a song about her that goes, "Suck the cum from my dick that bleeds lead?"

AT THE DRIVE-IN, *RELATIONSHIP OF COMMAND* (GRAND ROYAL; 2000)

WHAT TO KNOW: This album inspired a thousand magazines to prematurely proclaim ATDI to be "the next big thing."

SO, WHY IS IT ESSENTIAL?: Because it inspired a whole new generation of emo singers to write their lyrics with a pen in one hand and a thesaurus in the other.

BRIGHT EYES, *FEVERS AND MIRRORS* (SADDLE CREEK; 2000)

WHAT TO KNOW: This album contains the Conor Oberst classic "Haligh, Haligh, a Lie, Haligh," the one song that you're bound to have some moron screaming for behind you at your next Bright Eyes show.

SO, WHY IS IT ESSENTIAL?: Because if there's one thing emo fans can't get enough of, it's oversensitive singers with uncombed hair.

MUSIC

THURSDAY, *FULL COLLAPSE* (VICTORY; 2001)

WHAT TO KNOW: This album features the biggest song of this band's career, 2002's "Understanding in a Car Crash."

SO, WHY IS IT ESSENTIAL?: Because if you were rail thin, wearing Diesel jeans, and had a voice like nails on a chalkboard, putting out a record on a major label in 2002 had just gotten a whole lot easier.

DASHBOARD CONFESSIONAL, *THE PLACES YOU HAVE COME TO FEAR THE MOST* (VAGRANT; 2001)

WHAT TO KNOW: In addition to being the first emo album to sell five hundred thousand copies, the video for the song "Screaming Infidelities" (which, despite the lyric, "Your hair is everywhere," apparently isn't about male-pattern baldness) won an MTV2 Viewers' Choice Award.

SO, WHY IS IT ESSENTIAL?: Because it made a little guy like Dashboard leader Chris Carrabba (five feet five, according to Wikipedia) into a big star.

TAKING BACK SUNDAY, *TELL ALL YOUR FRIENDS* (VICTORY; 2002)

WHAT TO KNOW: This was Taking Back Sunday's first album, and the success it brought the band caused two of TBS's founding members to split a year after its release.

SO, WHY IS IT ESSENTIAL?: Because Adam Lazzara's woe-is-me sing-alongs proved that if emo kids could handle breakups maturely, then this genre would be about as interesting as an episode of that self-help reality show *Starting Over*.

THE USED, *THE USED* (REPRISE; 2002)

WHAT TO KNOW: This is the album that ushered in screamo to the masses and made lead singer Bert McCracken a C-list celebrity, due in large part to his brief relationship with Kelly Osbourne.

SO, WHY IS IT ESSENTIAL?: Because it led McCracken to his real calling in life: acting in a Virgin Mobile commercial.

THE ALL-AMERICAN REJECTS, *THE ALL-AMERICAN REJECTS* (DOGHOUSE; 2002)

WHAT TO KNOW: The All-American Rejects was the first emo band to play on MTV's spring break programming, thanks to this album's ubiquitous hit "Swing, Swing"—and the band's audience of underage female followers.

SO, WHY IS IT ESSENTIAL?: Because when singer Tyson Ritter later coupled up with a bathing-suit model, it signified that emo was no longer just about pasty Web dwellers who couldn't get a date if their lives depended on it.

BRAND NEW, *DEJA ENTENDU* (TRIPLE CROWN; 2003)

WHAT TO KNOW: This album made singer Jesse Lacey seem like the second coming of Morrissey, mostly because he sang like him, wore blazers constantly, and had a huge chin.

SO, WHY IS IT ESSENTIAL?: Because, thanks to Lacey, every emo frontman whose band has sold more than one hundred thousand records now automatically becomes an arrogant prick!

COHEED AND CAMBRIA, *IN KEEPING SECRETS OF SILENT EARTH: 3* (EQUAL VISION; 2003)

WHAT TO KNOW: This is a dense concept album about intergalactic killers that even singer/guitarist/hair farmer Claudio Sanchez can't seem to properly explain.

SO, WHY IS IT ESSENTIAL?: Because for a lot of emo fans who looked like the Comic Book Guy on *The Simpsons*, their moment had finally come.

YELLOWCARD, *OCEAN AVENUE* (CAPITOL; 2003)

WHAT TO KNOW: This album featured the *TRL* hit "Ocean Avenue," one of the best songs about being sixteen that someone in their mid-twenties has ever written.

SO, WHY IS IT ESSENTIAL?: Because it expanded the horizons of who could be considered "emo," seeing that the band's lineup

included a violin player who kind of looked like a bartender and a singer who used to be a drama student.

HAWTHORNE HEIGHTS, *THE SILENCE IN BLACK AND WHITE* (VICTORY; 2004)

WHAT TO KNOW: This is the album that made freshman girls everywhere who weren't named Niki wish that someone would write a song about them like the Hawthorne Heights hit "Niki FM."

SO, WHY IS IT ESSENTIAL?: Because teenage emo anthems this good are rarely written by a group of recently engaged men who are obsessed with college football.

MY CHEMICAL ROMANCE, *THREE CHEERS FOR SWEET REVENGE* (REPRISE; 2004)

WHAT TO KNOW: This album didn't invent goth emo, but it did bring the genre to the mainstream when commercial radio began playing the album's second single, "Helena," roughly every eighteen seconds.

SO, WHY IS IT ESSENTIAL?: Because even the most jaded scenesters had to admire the way this album made emo fans out of fifth graders.

FALL OUT BOY, *FROM UNDER THE CORK TREE* (ISLAND; 2005)

WHAT TO KNOW: This album sold somewhere in the neighborhood of thirteen billion copies (give or take), but a year prior to its release Fall Out Boy could literally have been found playing bowling alleys and record stores.

SO, WHY IS IT ESSENTIAL?: Because when Ryan Seacrest turns up on *I Love The '00s* in a few years humming "Sugar, We're Goin' Down," don't front; you'll be singing along too.

PANIC! AT THE DISCO, *A FEVER YOU CAN'T SWEAT OUT* (DECAYDANCE/FUELED BY RAMEN; 2005)

WHAT TO KNOW: This album proved that even if your band had

EVERYBODY HURTS

really long titles and wore ridiculously frilly shirts, you could still find a place on *TRL*.

SO, WHY IS IT ESSENTIAL?: Because what other emo act has ever hired a contortionist to perform onstage with them after only being a band for two years?

MAKING THE SCENE

From Portland, Maine, to Portland, Oregon, the emo scene remains the same. However, some scenes *are* better than others. While a few may be less influential than they once were, all of the following emo scenes continue to be essential to this day.

CHICAGO, ILLINOIS

KNOWN FOR: A lot of upper-class emo kids—and bands—who still live in the suburbs with their parents.

Though in the late nineties Chicago's emo scene was made up of downtown party animals like Alkaline Trio and the Lawrence Arms, its sound today is mostly coming from outside the city thanks to October Fall, The Academy Is . . . , Spitalfield, and just about any other band that overuses alliteration in their song titles.

GAINESVILLE, FLORIDA

KNOWN FOR: Beards, organic food co-ops, and unironically tearing through a six-pack of Budweiser at eleven a.m. on a Tuesday.

Located in less-than-picturesque northern Florida, Gainesville is a punk rocker's paradise and, at the very least, a nice place for emo fans to visit, considering that over the years Gainesville's highly politically minded indie scene has produced emo-approved acts like Against Me! and Hot Water Music.

LAS VEGAS, NEVADA

KNOWN FOR: All-you-can-eat buffets, men going through midlife crises, and, up until a couple years ago, not a lot of bands that people under the age of forty listen to.

Fortunately, that last part has changed considerably with local bands like Haste the Day signing to Epitaph, You in Series signing to Equal Vision, and Panic! at the Disco riding around in limos with hot chicks.

MINNEAPOLIS, MINNESOTA

KNOWN FOR: Lots of geeky dudes who only drink cheap beer.

Minneapolis is a bar town, which automatically makes it slightly less appealing for the type of teenage emo fans who have really shitty fake IDs. But many of the city's musical exports—from natives the Hold Steady (who look like they are fronted by a TV weatherman) to Motion City Soundtrack (who look like they are fronted by a guy who combs his hair with a glue stick)—remain huge in their iTunes playlists.

NEW YORK, NEW YORK

KNOWN FOR: Aspiring DJs, former members of Long Island hardcore bands, and white guys in their early twenties who incessantly say "yo."

Though it's in fairly close proximity to New Brunswick, New Jersey, the emo community in New York City is slightly more mature than the other emo scenes dotted across the country. For one, the emo tyes living in Manhattan spend 90 percent of their in-

come drinking in bars and, by and large, none of them still live at home with their parents.

NEW BRUNSWICK, NEW JERSEY

KNOWN FOR: The best basement shows you've never been to.

Starting with local legends Lifetime in the mid-nineties and on through to newer bands like Armor for Sleep, New Brunswick has had a long history of emo basement shows thrown by sixteen-year-old emo fans at their parents' house. While many of New Jersey's bigger emo groups have since signed to major labels, a group of younger acts like Paulson and Tokyo Rose continue the tradition to this day.

OMAHA, NEBRASKA

KNOWN FOR: A group of twentysomething emo rockers who all drink, hook up, and occasionally record albums with one another.

Though Omaha has gained a lot of notoriety in the past couple years for highly popular emo bands like Cursive and Bright Eyes, the real proof of the scene's magnitude is the lurker girls who camp out in front Conor Oberst's parents' house and riffle through their garbage, despite the fact that he hasn't lived there for a long, long time.

ORANGE COUNTY, CALIFORNIA

KNOWN FOR: Loudmouth metalcore bands and geeky indie-music fans who will probably all get married before the age of twenty-three.

In comparison to Adam Brody's neurotic, comic-reading character Seth Cohen on *The O.C.*, the emo fans—and group of musicians—who currently reside south of Los Angeles are a slightly more disparate bunch; which means they can be as brainy as post-hardcore thinkers Thrice and as mookish as metal deviants Avenged Sevenfold.

PORTLAND, OREGON

KNOWN FOR: Twentysomething bike messengers and granola-nourished hippies.

Quite a few emo heroes have come out of this perpetually dreary place, including Elliott Smith, who recorded his first three solo records in the Rose City. Pat Wilson from Weezer also lived here briefly during the late nineties. But these days, the local emo scene is indie, defined mostly by the gauzy guitar band Crosstide and piano balladeers Desert City Soundtrack.

SAN DIEGO, CALIFORNIA

KNOWN FOR: Being a confusing place in emo's history.

In the early nineties, San Diego was all women's-blouse-wearing punks who released records on the seminal emo label Gravity and wore their hair like Mr. Spock from *Star Trek*. But these days it's better known for emo metal acts like As I Lay Dying and My American Heart, as well as being where ex-Blink-182 frontman Tom DeLonge has been counting his millions and writing epic arena rock songs with Angels and Airwaves.

SAN FRANCISCO, CALIFORNIA

KNOWN FOR: Balding indie rockers who are prone to drinking obnoxious microbrews and discussing their rent far more than they are to listening to new music.

San Francisco will always be considered an emo haven, considering that Jawbreaker made their best records here. In recent years, however, many Bay Area music fans have snubbed the emo scene's newer artists. But those people are old. And cranky. And fat. And old.

SEATTLE, WASHINGTON

KNOWN FOR: A lot of indie rockers who probably don't consider themselves emo.

Like San Francisco, people in Seattle are a bit defensive about being called the E word. But these people need to face facts: between Death Cab for Cutie's sensitive alt-rock, the Blood Brothers' spazzy artcore, and about half the roster on local Christian emo label Tooth & Nail, you can't deny that the Emerald City still has some serious emo tendencies.

WASHINGTON, D.C.

KNOWN FOR: Being the birthplace of emo.

While the members of Good Charlotte grew up in the suburbs that surround the nation's capitol, Washington, D.C., is still primarily known for being home to Dischord Records, Ian MacKaye, Guy Picciotto, and a whole lot of old people who still hang out at the local punk club the Black Cat. Who knows, in another twenty years maybe they'll turn that place into a retirement home?

FESTIVAL ETIQUETTE

One thing that will bring emo fans out of their hometown music scene and into the music scene of another is the summer music festival. Many emo fans are prone to drive great lengths, spend great amounts of their parents' money, and, hopefully, apply great amounts of sunblock all to see a shitload of their favorite bands play on the same bill.

Because of this, though, emo fans are forced to coexist with other people, which isn't something that comes easy. Most are used to staying in their rooms and cruising message boards, so when they are forced to stand among thousands of people like them (or in some cases, thousands of people *unlike* them), there are some precautionary measures that need to be taken.

RULE NO. 1: WHEN ATTENDING A FESTIVAL WHERE BANDS ARE PRONE TO PERFORMING TWENTY-FIVE-MINUTE-LONG GUITAR SOLOS, BE PATIENT. ALSO, BE PREPARED TO GO HOME STINKING LIKE PATCHOULI.

Emo fans don't often attend jam-band festivals. But in recent years they have reluctantly begun attending Bonnaroo, a three-day

festival in Manchester, Tennessee, where emo favorites like Rilo Kiley, Bright Eyes, and Death Cab for Cutie have begun taking the stage alongside jam band favorites like the String Cheese Incident, Trey Anastasio, and Medeski, Martin & Wood. While these festivals can be quite annoying for most emo fans, it's important that they remain calm and cool, as opposed to going apeshit on some guy who is eating a goo ball and trying to form a drum circle.

RULE NO. 2: WHEN AT THE KIND OF ALL-DAY METAL FEST THAT IS PRIMARILY ATTENDED BY BURLY METAL DUDES, BE SURE TO NEVER BE SEEN WEARING EARPLUGS OR ASKING FOR BOTTLED WATER.

Generally speaking, emo types rarely end up at outdoor, all-day metal fests like Sounds of the Underground, and with good reason—emo fans do not belong there. People who like to beat up emo fans do. Yet with the more frequent appearances of emo metal bands like Every Time I Die and Trivium at such festivals, it is important for an emo type to remember to tread lightly. Maybe bang your head a little or pretend that you know quite a few strippers by their real names.

RULE NO. 3: WHEN AT THE KIND OF PUNK-ROCK FESTIVALS THAT ARE HELD IN VFW HALLS AND THAT FEATURE BANDS LIKE THIS BIKE IS A PIPE BOMB, DO NOT JOKINGLY YELL, "SHOW US YOUR TITS!" AT THE ONE ACT ON THE BILL THAT HAS A FEMALE BASS PLAYER.

You know, it's just a hunch, but we get the feeling it could probably end badly.

RULE NO. 4: WHEN AT A SNOBBY INDIE-ROCK FESTIVAL, DO NOT ADMIT, UNDER ANY CIRCUMSTANCE, THAT YOU HAVE NO IDEA WHO JEFF MANGUM* IS.

* The singer for the indie-rock band Neutral Milk Hotel and a great source of intrigue for many indie snobs, primarily because he has spent the last ten

Though emo types will often attend festivals like Coachella or Lollapalooza, they will probably find themselves wondering, "Who are these people? Why are they all wearing headbands? Why do they all have the same 'ironic' mustache?" And, finally, "Who the hell is this Jeff Mangum guy they keep talking about?" While these are all reasonable questions, whatever happens, *do not* say these things out loud. Someone is liable to throw a small child at your head.

RULE NO. 5: WHEN AT EMO-FRIENDLY FESTIVALS LIKE WARPED TOUR, DO NOT SING ALONG TO CERTAIN RADIO HITS.

Most emo types should feel at home at festivals like Bamboozle and Warped Tour, where the majority of the bands on the bill are of the emo variety. But that does not mean that they should get *too* comfortable. For instance, there will inevitably come a time when one of the dozens of bands onstage launches into a song that everyone in your high school knows the words to. What should you do? That depends on the band. If the band is a scene favorite such as Hellogoodbye and the "hit song" in question is only a minor hit, then singing along is perfectly acceptable. However, if the band is the Offspring, do not sing along to "Pretty Fly for a White Guy" under any circumstances. If you find yourself doing this in earnest, it may be time to reevaluate your life.

PARKING LOT CONFESSIONS

When you think about it, emo fans really aren't all that different from the sort of jam-band devotees who drive for hours and hours just so they can say that they saw Widespread Panic thirty-seven times in a single summer. Now, admittedly, no emo fans in their right minds would agree to this comparison. For one, jam-band fans are prone to wearing Birkenstocks, hemp necklaces, and ridiculously outdated *Cat in the Hat* hats. On occasion they

years shying away from interviews and releasing albums of recorded beach sounds.

also smell bad. But let's be real here: Emo fans are just as likely to do something stupid like drive overnight to see the Mars Volta play three states away during midterms. And usually the payoff is the same: some small bragging rights and an afternoon standing in a field while your favorite band plays the same set you saw a day earlier. Granted, drinking Red Bull in the sun at Coachella isn't exactly the same as dropping acid at Gathering of the Vibes, but chances are some band is going to overindulge in a guitar solo at both concerts, and, trust, it's not as if the Mars Volta exactly smell like a $145 bottle of cologne.

NOTABLE EMO RECORD STORES

These days, emo types acquire most of their music online. But in the unlikely event that they, you know, leave the house, there is a small chance that you can find them browsing through the racks at the following emo-approved records stores.

MUSIC

RECKLESS RECORDS (1532 N. Milwaukee Ave., Chicago)
While this is a great spot for the emo record connoisseur, chances are someone from the staff will be playing a Captain Beefheart record *way* too loud when you get there.

ZIA'S RECORD EXCHANGE (4225 S. Eastern Ave. #17, Las Vegas) It's not odd to catch the members of Panic! at the Disco browsing the racks at this local indie record store. Ditto for bassist Mark Stoermer of the Killers (but according to one staff member, no one ever recognizes him).

TREEHOUSE RECORDS INC. (2557 Lyndale Ave. S., Minneapolis, MN) Treehouse is the place in Minneapolis where emo fans can buy records without having to bypass the "tobacco water pipes" that clog up space at the city's other major indie retailer, Electric Fetus.

OTHER MUSIC (15 E. Fourth St., New York, NY) Though the staff seems to get paid primarily to talk about Japanese imports and ignore any customer who walks in the door, this East Village record shop is an essential New York City experience.

VINTAGE VINYL (51 Lafayette Rd., Fords, NJ) With three locations in New Jersey and a long history of locals like Armor for Sleep playing in-store, this is the prime record shop for emo fans living south of the city.

THE ANTIQUARIUM (1215 Harney St., Omaha, NE) This is where Conor Oberst used to hang out as a teenager, and so should you. But be warned: You'll need to bring one of those plastic slipcovers your grandparents use if you're gonna sit on any of the couches in this place.

VINYL SOLUTIONS (18822 Beach Blvd., Huntington Beach, CA) Located in a nondescript strip mall in Huntington Beach, Vi-

<185>

nyl Solutions offers up most new emo releases, rare old-school punk records, and a bathroom that, oddly, doubles as a shrine to David Lee Roth.

LOU'S RECORDS (434 N. Coast Highway 101, Encinitas, CA) Located a half hour outside of San Diego, Lou's provides emo geeks with two storefronts to search for the last Finch record: one for new releases, another for used discs. (We bet you'll find it in the latter.)

AMOEBA RECORDS (2455 Telegraph Ave., Berkeley, CA) Located on Telegraph Avenue, just a stone's throw from the UC Berkeley campus, you get the feeling that this East Bay gem will be around as long as college students have trust funds to blow through.

SONIC BOOM (2209 NW Market St.; 514 15th Avenue E.; 3414 Fremont Avenue N., Seattle, WA) This trio of emo-friendly record stores gets extra scene cred for employing Death Cab bassist Nick Harmer far before the music supervisors on *The O.C.* cared about his band.

SMASH (3285½ M St. NW, Washington, D.C.) Since 1984, Smash has made a killing selling CDs, leather bracelets, and bottles of raven-blue hair dye to college students who are *really* into looking like vampires.

WAYWARD COUNCIL (807 W. University Ave., Gainesville, FL) This volunteer-run store may seem a little archaic to emo fans who buy CDs online, but if you've ever wanted to see what a thirty-year-old man in a Spitboy T-shirt looks like up close, here's your chance.

MUSIC MILLENNIUM (3158 E. Burnside St., Portland, OR) Though indie types prefer Jackpot, this is the only place in Portland

where you can ask for the new Rocket Summer record and they won't look at you like you're speaking Cantonese.

NOTABLE EMO CLUBS

THE METRO (3730 N. Clark St., Chicago, IL) Though many Chi-town emo acts came up playing at the Fireside Bowl (which stopped hosting shows a few years ago), the Metro is where they end up once they get popular.

COMMON GROUNDS (210 SW Second Ave., Gainesville, FL) Originally a coffeehouse, Common Grounds has since moved to a larger venue and has switched from java to Miller High Life tallboys, which are sold to local punks for a buck and a half a pop.

JILLIAN'S OF LAS VEGAS (450 Fremont St., Las Vegas, NV) This being Las Vegas, Jillian's offers a dozen big-screen TVs, a pool table, a bowling alley, a steak-and-eggs special, tons of ridiculously named cocktails, and . . . oh, right, a stage where emo bands often perform.

TRIPLE ROCK SOCIAL CLUB (629 Cedar Ave., Minneapolis, MN) This Minneapolis club, which offers both cheap drinks and vegan eats, should be familiar to many emo fans, considering that scene faves Motion City Soundtrack and Limbeck have both immortalized it in song.

KNITTING FACTORY (74 Leonard St., New York, NY) It's as hot as a sauna in the summer and uncomfortably crowded year-round, but when bands like Fall Out Boy want to play an intimate venue, in New York, guess where they choose to do it?

STARLAND BALLROOM (570 Jernee Mill Rd., Sayreville, NJ) While it doesn't have all the makings of an emo haven—for just as many times as Thursday has played here, so has the Marshall Tucker Band—that's exactly what the Starland has become.

SOKOL AUDITORIUM (2234 S. Thirteenth St., Omaha, NE) During the week, the Sokol Auditorium is a real-deal gymnasium that many of the locals use, but for most of Saddle Creek's artists (you name 'em, they've played here) it's become a second home.

SOKOL UNDERGROUND (2234 S. Thirteenth St., Omaha, NE) Also worth checking out, this spot is a few floors below the Sokol Auditorium, where bands with smaller draws can often be seen without the distraction of a basketball hoop.

CHAIN REACTION (1652 W. Lincoln Ave., Anaheim, CA) Like all great venues, this O.C. spot is where unknown bands play on their way up and where established artists will appear the next time they want to look humble and "down."

LOVELAND (320 SE Second Ave., Portland, OR) Filled with old eighties video games to keep your attention between sets, this cavernous warehouse is an emo kid's dream . . . or at least any emo kid who's not afraid of parking in a sketchy neighborhood.

SOMA (3350 Sports Arena Blvd., San Diego, CA) Soma is a longtime So-Cal emo staple, with one stage for out-of-town head-liners and another for smaller local bands like Weatherbox, who continue to perform there on a regular basis.

BOTTOM OF THE HILL (1233 Seventh St., San Francisco, CA) This club's décor hasn't aged well since the early nineties (it still kind of looks like the set of *In Living Color*), but Bottom of the Hill remains an essential emo dive. It is, however, twenty-one and up. So don't forget your fake ID.

NEUMOS (925 E. Pike St., Seattle, WA) Though it kind of looks a carnival funhouse decorated by Pier 1 Imports, Neumos has quickly joined venues like Graceland and the Crocodile Café as a great spot in Seattle to see touring emo bands.

BLACK CAT (1811 Fourteenth St. NW, Washington, D.C.) This legendary club (which is financially backed in part by Foo Fighter Dave Grohl) has two stages, a vegan kitchen and lots of old guys who used to record for Dischord Records.

eat•ing hab•its v A settled tendency of eat-
ing and drinking so that you don't look to-
tally lame in front of your friends.

To eat meat or not to eat meat: that is the ques-
tion.

While some emo fans still adhere to the kind
of diet in which all six of the basic food groups are
represented, for the past three decades there has
been a strong historical bond between vegetarian-
ism and the emo scene. True, fewer bands sing
about vegetarianism now than they did in the late
eighties, when most seminal emo bands seemed
to be tripping over each other trying to pen songs
about the subject. And, sure, we're not any closer
to answering the question of whether or not be-
ing emo requires a meat-free diet. But there's no
arguing that many emo fans follow strict vegan or
vegetarian regimens.

In this brief chapter, we look at the few ways
such diets have played out in the emo scene—from
"cruelty-free" clothing to the select vegan and
vegetarian-friendly ingredients that many emo
types have already committed to memory.

GO VEGAN?

Emo fans may be rather predictable when it comes to clothes and music, but can the same be said for when they sit down at the dinner table? While many assume that all emo fans are vegan or vegetarian, trying to determine if that's true isn't as easy as you might think.

In some cases, yes, being vegan—that is, someone who abstains from eating meat, dairy, chicken, eggs, and a lot of other things that taste good—is an undeniable part of emo culture. If you grew up going to emo shows in cosmopolitan areas like Los Angeles or New York, for example—where people who have eating disorders realized a long time ago that not eating meat and/or dairy products will make you look like Kate Moss—being vegan is almost an afterthought. Not only is veganism seen as a legit stance among many city dwellers, but it helps emo types keep their svelte figures, which is helpful for those who are prone to wearing ridiculously snug—not to mention ridiculously expensive—designer jeans.

On the other hand, if you grew up in the Midwest—and enjoy eating food and/or wearing sweatpants—then being vegan will probably seem like a fad that only models and actors fall victim to. Still, no matter what side of this debate you fall on, there is no denying that veganism (as outlined elsewhere in this chapter) has played an ongoing role in emo's history. The reason for this is simple: Emo types are notoriously sensitive. They cry easily and get emotional about matters that are relatively minor in the grand scheme of things. The death of animals (which, okay, is kind of major) is just one more thing for emo types to be sensitive about. Subsequently, taking an interest in animal rights is something that makes them look deeply compassionate and unconcerned with their own inevitable humanistic urges—two tenets of the emo ideology that can permeate nearly everything an emo kid does.

WHAT THE HELL ARE THESE PEOPLE TALKING ABOUT?

There will inevitably come a time when a group of emo fans will commence in a large group to eat together— usually before a show. Chances are, if you're not dining at one of the restaurants listed in our Top Emo Eateries, you will be at one like them, which does not exactly signal an easy hour of chowing down for those nonvegan types out there. Looking at the menu at your typical vegan restaurant for a nonvegan can be like trying to read a foreign language for the first time, and thus can result in some potentially embarrassing moments.

That said, here's what you'll need to know:

TAHINI: This is a sweet paste made from sesame seeds. When this comes up in conversation, be careful not to confuse it with the French Polynesian island where many hair-metal douchebags did lots of drugs and had crazy orgies during their glory days. Because, well, tahini isn't an island. It's a dressing.

CAROB: This sweet is derived from the carob tree, which is traditionally found in the Mediterranean and is often used in vegan cakes and pastries. It would be easy to think that your vegan friends are talking about "carrots" when this is brought up, because phonetically it's sort of pronounced that way. But beside your anorexic friend Brenda, no one would choose to eat a carrot over carob, considering that they make egg-free brownies out of this stuff.

TEMPEH: This fermented block of soybeans is often used to replicate various types of meat. It would be wise not to confuse this vegan favorite with the guitar player in Thrice who likes to do finger-tapping solos. That dude's name is actually Teppei.

SEITAN: Yet another meat alternative made from wheat gluten that miraculously taste just like steak when prepared correctly. When your friends are talking about seitan, do not confuse this with Satan. Unless your friends are into Norwegian black metal bands, in which case carry on . . .

VEGANISM 101
A BRIEF HISTORY

So where exactly did the connection between veganism and emo begin? Aside from mopey forefathers like the Smiths—who released a record called *Meat Is Murder* in 1985—emo's most logical ancestors began in eighties hardcore punk rock. For those who don't know, emo grew out of the hardcore scene, and many of the seminal New York City hardcore bands from the late eighties were vegetarian. For example, Youth of Today once wrote a song called "No More," a vegetarian rally cry that included the lyric, "Our numbers are doubling in '88 / Because the people are starting to educate." Unfortunately, many YOT fans missed the incredible irony of singing this song live while not "educating" themselves to the fact that the Nike Air Flights they were wearing were made out of leather.

After Youth of Today, there was a band called Vegan Reich who sang about shooting people who weren't vegan. But in the end they were more laughable than menacing, as extreme veganism in the hardcore scene existed solely as an idea with very little action to go along with it. Bands like Earth Crisis followed Vegan Reich's lead and wrote songs about starting "firestorms" in the name of animal liberation. However, Earth Crisis leader Karl Buechner eventually decided that lighting things on fire was bad and that buying pricey Starter basketball jerseys was much better. By the mid-nineties

many hardcore musicians started emo bands, and it became common to see them playing music festivals that included Food Not Bombs, with local activists speaking about animal rights between sets.

Food Not Bombs remains a punk staple to this day. It's basically a DIY soup kitchen that feeds bland vegan stews to the homeless—and a lot of unemployed punk kids. If you have ever tasted this stuff you were probably in the band Econochrist or are the kind of person who likes to spange around People's Park in Berkeley.

To some degree, the emo scene's interest in Food Not Bombs paved the way for Peta2, which is basically PETA for the Internet age. You remember PETA, right? The folks who wait outside restaurants in Beverly Hills to pour buckets of fake blood on rich people wearing fur? Yeah, well, this is them, only the difference is that when you align yourself with Peta2 you're significantly less likely to get arrested and significantly more likely to get junk e-mail. Peta2 is an organization, and, moreover, a Web site (viewable at Peta2.com) that includes a lot of emo-friendly content. You want to see a QuickTime file of Conor Oberst talking about how he stopped eating meat after he got salmonella poisoning when he was young? Sign up and it's done. You wanna read an interview with Hellogoodbye frontman Forrest Kline, one of Peta2's sexiest vegetarians? They can make that happen, too.

Many bands will often align themselves with Peta2 (even the ones who—*cough*Yellowcard*cough*—actually eat meat) the same way that they align themselves with Angels and Airwaves singer Tom DeLonge's company Macbeth (who make an all-vegan shoe called the Elliot). These days, animal rights is both fashionable and a way to get your band noticed on the Internet, which is admittedly

a long ways away from Vegan Reich's reign of terror. Which is fine—one band singing bad hardcore songs about capping fools for eating White Castle is enough to last most emo fans a lifetime.

TOP EMO EATERIES

There are few places you are as likely to see emo types—vegan or not—than the following restaurants, all of which are dotted across the United States.

CHERRY STREET CHINESE (1010 Cherry St., Philadelphia, PA) Also known as the Place Where the Two Dudes Who Run Jade Tree Will Take You When They're Trying to Sign Your Band, this vegan- and vegetarian-friendly Chinese food spot has become an incredibly popular haunt for the emo scene in and around the Tristate area. When you walk in, you've got a fifty-fifty shot of running into someone who's tight with at least one of the members of Lifetime, and even though it's located off a particularly sketchy street in downtown Philadelphia, most emo types will tell you that the food here is *way* worth the possible mugging.

CHICAGO DINER (3411 N. Halsted St., Chicago, IL) If you think that you can't indulge in buffalo wings, Philly cheesesteaks, and milkshakes just because you're vegan, then think again. The Chicago Diner is conveniently located less than a mile from emo Mecca the Metro and is a longtime hangout for hometown veggie heroes like Alkaline Trio's Matt Skiba and Rise Against's Tim McIlrath. Who says being vegan means you have to be healthy?

HERBIVORE (983 Valencia, San Francisco, CA) In the early nineties the Mission District in San Francisco was the kind of dicey neighborhood that inspired Jawbreaker's Blake Schwarzenbach to write a lot of songs about speed freaks and late-night drinking. Now it's mostly home to graying, middle-aged health nuts and

emo-leaning college students, both of whom you are likely to find at Herbivore, a slightly upscale vegan eatery that serves plates of grilled portobello mushrooms over polenta. And unlike the food at a lot of other slightly upscale vegan eateries, the grub here somehow manages *not* to taste entirely like dirt.

KATE'S JOINT (58 Avenue B, New York, NY) We don't know what's dirtier: the bathrooms at Kate's Joint or the waitstaff. Either way, it's the grime and grit that adds to the emo atmosphere at this East Village veggie haunt. On a Sunday morning, be prepared to rub shoulders with scores of wilted-lettuce-looking kids coming straight from MisShapes, or Conor Oberst sopping up his hangover with a huge plate of disco fries.

POKEZ (947 E St., San Diego, CA) It's a wonder how anyone in the San Diego emo scene manages to shimmy into a pair of tapered jeans with this place around, but ever since the mid-nineties Pokez has been an emo staple. The walls are covered in old flyers from all-ages punk shows, the goth-emo waitresses look like they went straight to their shift from an AFI concert, and even if this place were whitewashed and bought out by McDonald's tomorrow, emo types would probably *still* come here for their incredible soyrizzo burritos.

REAL FOOD DAILY (414 N. La Cienega Blvd., Los Angeles, CA) Finding a yummy veggie restaurant in Los Angeles isn't that difficult, but finding one that caters to questionably health-conscious celebs like Anthony "Red Meat Bad, Heroin Not So Bad" Kiedis and puffy C-List celebs like *Married with Children*'s David Faustino is. Enter Real Food Daily, a high-end West Hollywood diner that specializes in organic vegetarian cuisine and blog-worthy star sightings. Whether you're coming from yoga class or are on your way to catch Say Anything play at the House of Blues on Sunset, Real Food Daily will satisfy your veggie appetite *and* your need to catch a glimpse of Tobey Maguire.

RED BAMBOO (140 W. Fourth St., New York, NY) Red Bamboo has earned the New York City nickname "punk rock cafeteria," which seems about right considering that on any given afternoon you're likely to walk into this soul food joint and spot someone like Taking Back Sunday guitarist Fred Mascherino eating a plate of butterfly soy chops next to a group of industry blowhards who have no table etiquette. That being said, if you're not intimidated by the thought of getting barbecue sauce all over your face in front of one of your favorite artists, and you can deal with some aspiring manager from New Jersey talking *way* too loud about one of his bands' unimpressive first-week sales, then there's probably no better place in the country for a vegan to eat than here.

R. P. TRACKS (3547 Walker Ave., Memphis, TN) This Memphis dive might not look like much from the outside, but R. P. Tracks is one of the only places in Memphis that a vegan can get some quality barbecue minus all the typical animal carnage. Located near the Memphis University campus, R. P. Tracks attracts your typical college crowd of fratstars and girls two drinks away from going wild. But during the day, the bar transforms into a diner that serves up steaming plates of BBQ tofu, both as slabs and sandwiches. Plus, when you're done stuffing your face, you can make your way across the street to MarkedFlesh.com and get your flesh marked with, say, an Earth Crisis crossed-wrench tattoo.

TOMMY'S (1824 Coventry Rd., Cleveland Heights, OH) The area that Tommy's resides in is half-heartedly referred to as "Cleveland's Greenwich Village" and houses a resident schizophrenic who wears a court jester's hat and lives on the steps outside of C-Town's emo concert haven, the Grog Shop. Then, down the street, there's a smoke shop where you can buy a bong *and* a pair of pleather chaps. Uh . . . beat that, New York City. Regardless of its questionable surroundings, Tommy's is a must for anyone craving some heavy-duty salads with a side of seitan. Plus, if you get there early, there's a good chance you'll catch Grog headliners getting some sustenance before they tear up the stage.

tele•vi•sion *n* The box in your living room that Rory Gilmore lives in. At least on Tuesday nights.

Similar to film in its influence on emo fans, television is a vital part of the emo experience. How so? Well, it helps them understand their place within pop culture. Emo fans, after all, cannot truly enjoy a television show unless they see a piece of themselves in it. If a show's star happens to be a distraught teen, for example, then it will definitely become an emo must. If it revolves around a dysfunctional family, it's also a shoo-in. And if an emo band actually makes a cameo on the show, forget it. It will become an indelible part of the emo scene's fabric.

See, emo fans relate to TV shows in a way that goes far beyond your average viewer. Their parents may enjoy a casual viewing of their favorite procedural-crime series, but for emo teens there are a number of required shows to obsess over, memorize, and live for in the days between airings. The experiences they can have with these shows is similar to their relationships with most emo-approved films: Certain quotes and references will inevitably become part of the emo dialogue. As with film, many emo fans can go too far with the amount of TV they end up watching.

television

In the following pages, we look at this particular obsession—the role it plays among emo fans and, more important, when it's time for them to intervene with friends who are coming dangerously close to enjoying *really* bad sitcoms.

SHOWS YOU HAVE TO TIVO

Emo fans have an incestuous relationship with TV. They obsess over its characters, and they go hours without seeing sunlight because of it. The following is a list of emo-approved programs. But what makes these shows so emo? Allow us to explain.

AMERICA'S NEXT TOP MODEL (CW; 2003–PRESENT)

At first glance, there's nothing really *that* emo about watching a bunch of models not eat, and talk about how hard it is for them to walk properly. However, look a little closer and you'll realize that not only did Cycle One's Elyse Sewell wear T-shirts advertising the emo-approved indie rock band the Shins (because she was dating keyboardist Marty Crandall at the time), but after Cycle Two's Shandi Sullivan admitted to her boyfriend that she cheated on him with a hot Italian dude, her boyfriend let out such a high-pitched, ear-piercing squeal that it probably made Davey Havok jealous.

AQUA TEEN HUNGER FORCE (CARTOON NETWORK; 2000–PRESENT)

Sure, the plot of *Aqua Teen Hunger Force* is kind of nonexistent. What do you expect from a show whose main characters are a milkshake, a box of fries, and an amorphous wad of meat?—but that doesn't mean it's without connection to the emo scene. As legend has it, before forming My Chemical Romance, Gerard Way—a college-trained graphic designer—was pitching a food-based show to the Cartoon Network. However, unbeknownst to him, the cable network had already signed up for this hilarious fast-food comedy

and Way was left to his own Chemical devices. Looks like everyone's a winner.

ARRESTED DEVELOPMENT (FOX; 2003–2006)

No one was really surprised when this show got canceled in 2005, not even the emo fans who lived by it: It revolved around a totally screwed-up family that included a convict father, a questionably heterosexual thespian-in-law, and a kid named George Michael. Plus the show's story lines were so weird, they made it hell for the people at the *TV Guide* channel to write those two-sentence descriptions they have to come up with for each episode.

But one reason it remains an emo essential to this day is David Cross. Cross has long been a favorite among emo fans. Such devotion can usually be traced back to *Mr. Show*, the much beloved HBO sketch-comedy series that Cross created with Bob Odenkirk, which inspired catchphrases like, "Kiss my aunt, you motherfather," that, unfortunately, emo fans still do poor imitations of to this day. From there, however, Cross became even more beloved for playing alternate Blue Man Group member Tobias Fünke on *Arrested Development*. If the *Mr. Show* imitations weren't enough, now emo fans have three seasons' worth of box sets from this series to quote from.

But really, why do emo types obsess over him? Yeah, he's funny— we get it. But many emo fans feel a certain kinship with Cross

that's hard to quantify—that is, until you listen to the two stand-up comedy albums that Cross released on Sub Pop, 2002's *Shut Up You Fucking Baby* and 2004's *It's Not Funny*. With these albums, Cross displays his hate for just about everything. Gay guys with big, bushy mustaches? Affirmative. George W. Bush? Definitely. He even hated his role on *Just Shoot Me* in which he played a character who is affectionately known as the Chicken Pot Pie Guy. The only things that Cross doesn't hate, apparently, are indie-rock bands and alcohol.

Now, as far as we can tell, that's exactly what most emo fans like about him. Obviously, looking like you don't care about anything is a lot of work, and they can respect that. But beyond this, Cross represents the cynic that lives in most emo fans but only comes out when they're spewing venomous posts on Internet message boards from the safety of their bedrooms. To many emo fans, Cross's undying cynicism makes him a sort of comedic hero. He's older, braver, and funnier than most emo fans. Plus there's a lot you can learn from a guy who makes jokes about senators executing retarded children and doesn't feel the least bit remorseful about it.

DEGRASSI: THE NEXT GENERATION (THE N; 2001–PRESENT)

With the tagline "It goes there," *Degrassi: The Next Generation* is one of the most provocative and realistic depictions of teen life since, well, *Degrassi: The Original Generation* (aka *Degrassi Junior High*). Leave it to the Canadians to produce casts that are full of kids who have zits, know their way around a flatiron, and drop the "OMG" bomb into everyday conversations. Face it: If

the central character, struggling songwriter Craig Manning, were any more emo, he'd be sponsored by Entrust Clothing and already have an album set for release on Fueled by Ramen.

FAMILY GUY (FOX; 1999–PRESENT)

Some might say that *Family Guy* isn't exclusively emo, and those people would be kind of right. Sure, your Maroon 5–obsessed RA might watch it, not to mention that kid at the local coffee shop who never puts on gloves before fondling the danishes. Hell, your dad may've even made it through an episode when he couldn't sleep because your mom was snoring louder than a Mack truck. However, it's the show's ongoing themes of teen angst, unhappiness, and paranoia that any emo type can relate to, and this has allowed it to become an emo staple. Think of the Griffin family as the Simpsons on crystal meth: delusional, chaotic, and completely addictive.

FREAKS AND GEEKS (NBC; 1999–2000)

Freaks and Geeks is about exactly that—outcasts and outsiders trying to make it out of high school in one piece while maybe, just maybe, getting a piece too. The seventies dramedy lasted only one season and, unfortunately, propelled the cast in the direction of shows like *Dawson's Creek* (in which James Van Der Beek turned pining and whining into a bona fide hobby) and *Yes, Dear* (which is kind of like *Everybody Loves Raymond* but worse . . . if that were possible). But the impression it left on young emo minds was indelible. If you were to update the Jordache jeans with Diesel and the cast's obsession with the prog-rock band Rush with a few references to Coheed and Cambria, *Freaks and Geeks* could totally make a comeback, *The Next Generation*–style.

<202>

GILMORE GIRLS (THE CW; 2000–PRESENT)

Odds are your Tuesday nights already revolve around watching
Gilmore Girls, which is why we'll make this brief.
What started as a humble little family drama on
the CW about a quirky single mother (Lorelai)
and her quirkier teenage daughter (Rory)
inexplicably morphed into one of the most
emo shows on television, thanks in part to
the rapid-fire dialogue and Doog-worthy*
bloglike musings on life, love, and pop cul-
ture. Plus, the main characters on *Gilmore
Girls* have the ability to name-drop Dave
Eggers and Slint without looking like po-
seurs.

LAGUNA BEACH (MTV; 2004–PRESENT)

So what if Jason drove a BMW 330Ci? Who cares if through her par-
ents' connections, Christina snagged a much-coveted audition with
a Broadway casting director? The constant melodramatic breakups
and make-outs of the *Laguna* cast were every bit as emo as any of
the lyrics on Taking Back Sunday's first album, and in the second
season alone, Jessica burst into tears in almost every episode. So
what's the greater emo truth here? Rich people have feelings too.

* Doogie Howser is perhaps one of the most underrated—and unexpected—
icons in the emo scene, and he is single-handedly responsible for bringing
blog communications to the masses. With his oversized features, way-too-
skinny frame, and near-crippling inability to interact with anyone his own
age, the teenage doctor nurtured the kind of neuroses just about any emo kid
can relate to. Howser's connection to the emo scene has been further proven
by Hawthorne Heights singer JT Woodruff's constant appraisal of the show
during interviews. But most of all it's been cemented by the fact that when
Doogie ended each episode by writing a journal entry on his computer, he was
unknowingly creating the world's first blog.

MY SO-CALLED LIFE (ABC; 1994–1995)

Most modern-day teen-themed soap operas* only wish they had the cast, candor, and overwhelming emo-ness of the tragically canceled, true-to-life drama *My So-Called Life*. The show revolved around the postpubescent existentialism of Angela Chase, a fifteen-year-old girl struggling with who she was and how that differed from who she wanted to be. Once a bland wallflower who suffered from nothing more than a mildly unhealthy obsession with wearing baby-doll dresses over leggings, Angela decides to dye her hair Crimson Glow in an act of middle-class rebellion. She soon falls in with a fast crowd (alcoholic-in-training Rayanne Graff and her eyeliner-wearing BFF Rickie Vasquez) and realizes there's more to life than getting to class on time—like Jordan Catalano.

My So-Called Life might not have been with us for very long (nineteen episodes, to be exact), but it's safe to say that the show had an impact on anyone and everyone who ever watched it. First, it left us with dialogue like, "You're so beautiful, it hurts to look at you" (and though Conor Oberst was only fourteen when the show premiered, we're sure he's kicking himself for not writing a lyric like that first). Second, even dudes could relate to the realistic plotlines, as proven by the Ataris writing a sweet (yet kind of creepy) tribute to Angela's real-life alter-ego, Claire Danes, entitled—*shocker*—"My So Called Life." Third, if not for *My So-Called Life*, many teens would never have discovered Boston's now-defunct alt-rock band Buffalo Tom and the song "Late at Night," which scored a particularly poignant scene between Danes and her emotionally detached

* By and large, daytime soap operas are not emo unless they are being viewed for irony and mocking purposes. Nighttime soap operas, however, are *always* emo if they air on the CW (*One Tree Hill*) or Fox (*The O.C.*). Nighttime soap operas airing on other networks past eight p.m. must be judged on a per-show basis. Criteria include setting, age of characters, and soundtrack. Note: Just because a Death Cab for Cutie song is used in an episode or promo does not ensure that show is altogether emo. And, regardless of who the guest star is, teenage emo fans never watch court and/or crime dramas.

TELEVISION

beloved. (And that, obviously, would have been a total shame.)

Finally, Danes's on-screen paramour, Jordan "I Can't Read but I'm So Pretty I Don't Really Need To" Catalano, also went on to pursue a music career with his prog-emo band 30 Seconds to Mars, even managing to open for My Chemical Romance and Aiden. The only problem? Catalano's real-life counterpart, Jared Leto, seems to have trouble singing and playing guitar at the same time. But whatever, the dude *used* to be Jordan Catalano. He could wear a potato sack and be covered in ants and he'd still be hot.

ONE TREE HILL (THE CW; 2003–PRESENT)

There's hardly anything about *One Tree Hill* that isn't emo. It takes place in a small town called Tree Hill where people like Chad Michael Murray (who plays Lucas) and That Girl Who Used to Be an MTV VJ (who plays Peyton) continue to throw themselves in and out of relationships that seem to start or end every few weeks. While such an existence would probably be enough to inspire some emo band's first EP for Drive-Thru, *One Tree Hill* really took it to the next level emo-wise when bands like Jimmy Eat World and Fall Out Boy began playing live on the show. Fall Out Boy's Pete Wentz even had a recurring role during the third season as one of Peyton's brief romantic trysts, causing quite a bit of controversy

with emo-scene purists. Thankfully, Wentz's cameo was over a few episodes later and the universe was once again at peace.

THE O.C. (FOX; 2003–2007)

If you were hedging bets back in 2003 about what the next definitive show would be for emo fans, an hour-long drama about dysfunctional rich people probably wouldn't have been at the top of your list. But shortly after its release, *The O.C.* became *the* TV addiction for emo fans, with a role model who, in the character of Seth Cohen, was a true emo archetype. A neurotic mess who looked like he could bench about forty-three pounds on a good day, Cohen was a huge role model for emo fans because, let's face it, no one who checked their MySpace page fourteen times a day was ever going to say that they related to that lughead Ryan (who, in the show's final season, joined a rather un-emo underground fight club).

No, it was Cohen—the guy who overthought everything and who was just as sensitive as Chris Carrabba—that emo fans were

bound to latch onto. Even when the show's plotlines seemed about as believable as an episode of *Passions*, Cohen stood tall as *The O.C.*'s emo center. He hated sports and loved Japanese animation. He was smarter than everyone he surrounded himself with, yet felt inadequate pretty much all of the time. Plus, he thought that Ben Gibbard was God, which was probably why he dressed like him more and more each week.

But here's the thing: While there have been many times over the years where a character on a television show seemed vaguely emo, there was nothing vague about Cohen whatsoever. This was a guy who was obsessed with comic books and who seemed like he was going to spend the majority of his life worrying about which band posters to hang up in his bedroom. Why? Because he was one of us. And, for four seasons, that's what made Cohen essential. He was a slightly too skinny kid who liked all the same movies, authors, and CDs that *you* did.

THE OFFICE (BBC; 2001–2003)

Life can be frustrating when you're emo. You suffer through people at the mall saying things like, "Hey, did you get to keep the bowl when they were through cutting your hair?" or "Dude, your sister called and she wants her jeans back." These people think nothing of how they are *obviously* crippling a small piece of your soul and—again—they should *obviously* live a life of eternal damnation because of it. That being said, this is how many of the employees on the original BBC version of *The Office* must have felt about their insensitive boss, David Brent, which may explain why the show became a huge hit with emo fans who have no idea what British terms like "I was arse over tit" mean.

THE REAL WORLD (MTV; 1992–PRESENT)

In recent years *The Real World* has cast the Emo Girl as one of its members with surprising regularity, but that's not why emo kids watch it. No, the real reason is that *The Real World* is about seven

strangers who are picked to live together in a house in order to find out what happens when people stop being polite and start acting like it's spring break in Daytona Beach *every day* for three months straight. While that might not sound like an emo kid's version of Utopia, the truth is that emo kids will always love to laugh and point at morons who take body shots more seriously than anything else in their lives.

A Brief History of the Emo Girl Character on *The Real World*

Did you ever notice there's *always* an emo girl on *The Real World*?

Well, there is. Not *always*, per se, but ever since *The Real World* took its drunken antics to Miami in the mid-nineties, after five years of boring social commentary and dudes in bright yellow Cross Colors pants, it's become an integral part of the show. That year in Miami, viewers were introduced to a skateboarding punk-rock fan named Sarah who legitimized the fashion aesthetic of teenage girls everywhere who like to wear Dickies seven days a week. Following Sarah there was Melissa from the New Orleans cast. Melissa has been romantically linked to longtime Glassjaw guitarist Justin Beck and, apparently, now makes a living as a stand-up comedian.

In between Sarah and Melissa, the only person even remotely emo on *The Real World* was Justin from the Hawaii season, but he just turned out to be gay.* Thankfully, shortly after Justin there was Rachel from the "Back to New York" cast. Rachel continued

* PLEASE NOTE: When singling out a male emo fan, be careful *not* to confuse them for an effeminate gay man. This is a pretty simple mistake, seeing that both use Kiehl's products and worry about losing their hair. But the fact is, if you make fun of either Madonna or Cher in front of the wrong one, things are gonna get *ug-lee*.

the Emo Girl tradition by wearing an I'M WITH DUBIN* T-shirt while hanging out with Midtown singer Gabe Saporta. Three seasons later, *The Real World* began filming in Austin, Texas, where the Emo Girl tradition continued with Lacey, an uptight gossip who apparently loved to talk about how her roommates were a bunch of drunken, stupid morons, despite the fact that she willingly auditioned for a show that is often *about* drunken, stupid morons.

Lacey obviously shopped at Delia*s and almost certainly learned how to make ridiculous looking broaches by reading *Bust* magazine. She claimed that she hated the emo band Hellogoodbye and also dated a guy in a wheelchair, which is . . . well . . . something we've been advised not to make any jokes about. But trust us, Lacey was just as emo as any girl at the Warped Tour wearing a homemade FORREST IS HOT T-shirt.

24 (FOX; 2001–PRESENT)

Other than the presence of Kimberly Bauer (who is played by frequent emo crush Elisha Cuthbert), it's hard to say what's emo about *24*. There's no teen angst or high school romance, and no one broods over the meaning of life. Instead, *24* is about the life of a federal agent whose days are lived out every week in real time, and the show is often loved by the same people who talk about how "fantastic" *The Shield* or *CSI: Miami* is. Now, for most emo fans these people often look like their parents. Actually, there's a good chance these people *are* their parents. So why is it that emo fans in huge numbers still list *24* as one of their favorite shows? Honestly, we have no idea. But we're hoping it's because they've thought Kiefer Sutherland was cool ever since they first saw *The Lost Boys*.

* T-shirt that emo luminary Mike Dubin made in the early 2000s. That Dubin was able to get virtually every band on Vagrant Records to wear one of these T-shirts at one point in their careers is a feat unto itself.

THE SIMPSONS (FOX; 1989–PRESENT)

In emo terms, *The Simpsons* is sort of like Weezer. Both were bet-
ter in the nineties and both have totally lost the plot in the past
seven years. Because of this, most emo types haven't liked a new
episode of *The Simpsons* in forever, and even the members of Fall
Out Boy, who took their name from the sidekick of Radioactive
Man—a comic book character whom Bart is obsessed with—don't
seem particularly proud of their association with the show. But
here's the thing: *The Simpsons*, at one point, was *way* funny, and
it remains emo because none of its characters will ever age. You
know how you look around at the Warped Tour year in and year
out and every singer seems to be twenty-three and every person
in the audience is seventeen? Well, that's what the Simpsons are
like, except they're yellow.

LATE-NIGHT TV, EMO-STYLE

When it comes to television appearances, emo bands often get
treated like a lot of punk rockers when they walk into Denny's
at two a.m. After all, anyone with a Mohawk looking for a Moons
over My Hammy at that hour is going to get the booth in the back
that's been falling apart since the Clinton administration. And so,
when it comes to TV appearances, emo bands get stuck with late-
night slots. Thus, for most emo fans, late-night TV has been defined
by the following three shows.

120 MINUTES (MTV; 1986–2003)

During the mid-nineties, this late-night MTV staple was hosted
by Matt Pinfield, a guy who looked like Uncle Fester and whose
encyclopedic knowledge of music could somehow be both annoy-
ing and impressive. At the time, *120 Minutes* was virtually the only
place where you could see music videos by emo artists, which was
the good news. The bad news, however, was that you were going to
have to stay up until two A.M. on a Sunday night to do so. Sadly, by

TELEVISION

the time *120 Minutes* reached its inevitable end, Pinfield had begun kowtowing to crappy nü-metal bands like Limp Bizkit. But hey, it's not like any other show in the history of the world ever had the Promise Ring on as guest hosts.

ALL THINGS ROCK (MTV2; 2001–2003)

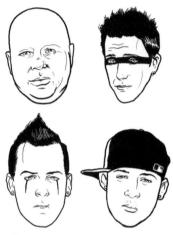

Following *120 Minutes*, MTV2 premiered this short-lived program. *All Things Rock* was hosted by Benji Madden and his brother Joel many years before Joel became temporarily known as That Guy Who Was Always with Hilary Duff While She Was Shopping at the Beverly Center. The Maddens' tenure on *All Things Rock* began in 2001, so they often ended up playing the clip for their first hit single, "Little Things" (which starred, umm, Mandy Moore), as well as some of the old-school punk videos by the bands that inspired them. Unfortunately, since the Maddens didn't have control over all the videos that got played on *All Things Rock*, the twins had to grit their teeth while they played the then-latest video by 3 Doors Down.

STEVEN'S UNTITLED ROCK SHOW (FUSE; 2004–PRESENT)

When this show premiered on the emo-leaning music network Fuse in 2004, things had improved significantly for emo bands. Groups like the Used and Thursday had become household names, and bands like A Static Lullaby and From Autumn to Ashes who hadn't still received regular airplay. Host Steven Smith is a genuine emo fan who isn't afraid to occasionally look "unprofessional" while conducting on-air interviews: For example, Smith once broadcasted a one-on-one chat with the Used's bassist Jeph Howard while Howard wore nothing but a strategically placed pineapple. You just don't get that on *Live with Regis and Kelly*.

WOULD YOU LIKE CHEESE WITH THAT?

Sure, cheesy family-oriented sitcoms might not be as cool as music television programming, but they are still vital to an emo type's understanding of pop culture—past, present, and future. Where else would you learn life's tough lessons (i.e., how *Full House*'s D. J. Tanner taught us that eating disorders are, like, really bad for you) or the invaluable catchphrases (like, *Ay-oh. Oh-ay*, courtesy of *Who's the Boss?*'s Tony Micelli) that many emo types are prone to repeating? Here we explore what makes these shows so emo.

WHO'S THE BOSS? (ABC; 1984–1992)

After eight seasons and a seemingly endless run in syndication, we're still not any closer to figuring out who the boss was. Was it Tony and his shaggy bowl cut? Or Angela and her dangerously sharp shoulder pads? Maybe Samantha, before she got her teeth done and became kind of slutty? Or Mona and her Zestra-free elderly sex drive? Perhaps Jonathan, who . . . ughhh . . . errrr . . . well, that kid never had any story lines. What was up with that? Anyway, *Who's the Boss?* was one of the first sitcoms to reverse the gender roles, making the woman the breadwinner and the man the housekeeper. Seeing this at a young age not only taught emo boys that it was all right to be sensitive, obsessive-compulsive, and anal-retentive, it also taught them that it was also acceptable to fall for a demanding girl who seemingly had no interest in them.

FULL HOUSE (ABC; 1987–1995)

Before Mary-Kate and Ashley Olsen were spokeswomen for oversized sunglasses and dropping out of college, they simultaneously

played the annoyingly lovable (and lovably annoying) Michelle Tanner on *Full House*. You remember Michelle. She was the spoiled youngest daughter of Danny Tanner and creator of such memorable catchphrases as, "You got it, dude," "Aww, nuts," and "Whoa, baby." Upon closer examination, the story line of *Full House* was kind of depressing (i.e., young father who has *major* OCD issues is left to raise three girls by himself when his beloved wife dies in a car crash caused by a drunk driver). But there wasn't anything that a hug and a bottle of Windex couldn't fix at the end of a half hour.

GROWING PAINS (ABC; 1985–1992)

Back in the eighties, Kirk Cameron played smart-ass Mike Seaver on *Growing Pains* and quickly became a teen idol whose face was splashed across the covers of *Bop* and *Tiger Beat* on a monthly basis. Who wouldn't want thousands of girls drooling over pictures of himself holding golden retriever puppies and talking about his favorite foods? Well, Kirk didn't, making him an inspiration for many emo singers who would later renounce their sex-symbol status.

But here's where things differ for good ol' Kirk: He became a Christian and eventually hoofed it off TV altogether. Sort of. See, Cameron went on to become a minister for The Way of the Master, a ministry that teaches Christians how to be *good* Christians. He also starred in 2000's *Left Behind*, based on the first in a series of fundamentalist Christian novels by Tim F. LaHaye and Jerry B. Jenkins. The Mike Seaver we knew who glued his little brother's butt to the coffee table isn't exactly emo these days, but come to think of it, maybe he could be out there somewhere listening to Christian emo bands like Norma Jean.

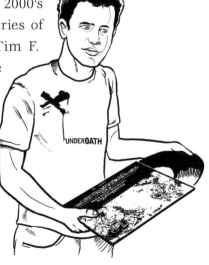

FAMILY MATTERS (ABC; 1989–1998)

The character of Steve Urkel was only supposed to be in a couple episodes of this TGIF family sitcom, but due to overwhelming demand he was brought on as a cast regular. Sure, he may've been one of the most annoying human beings alive, but he still encapsulated many characteristics of the emo lifestyle. First off, he was a social outcast who was constantly denied by the woman he loved. Second, he wore pegged, high-water pants and thick-rimmed glasses, which predicted a look that would be worn by a slew of emo types a few years later. Unfortunately, Steve's emo icon status is often tarnished by that god-awful, grating "Urkel Dance" song, which included the lyrics, "Now point your fingers up to the sky / And talk through your nose way up high / Spin and dip and jump and cavort / And finish it off with a laugh and a snort." F'reals, who uses the word *cavort*?

SAVED BY THE BELL (NBC; 1989–1993)

Saved by the Bell might look dated now, what with all the references to New Kids on the Block and A. C. Slater's totally awesome collection of neon tank tops. And, yes, it may have been one of the most illogical shows in the history of television. (Honestly, did anyone believe that lead character Zack Morris could somehow stop time, but he couldn't manage to get head cheerleader Kelly Kapowski to go on a date with him?) Regardless of how cheesy and out-of-touch the series might seem to emo teens today, at its core *Saved by the Bell* was about the desperate antics of Zack and the fact that he would stop at nothing to win Kelly's at times tragically perky heart. For those emo types who think lurking is just another way of saying "I love you," Zack will always be an inspiration.

CHANNELS TO CHANNEL

TBS AND NICK AT NITE

If you're unsure of where to find these bad-yet-somehow-good situation comedies and the *TV Guide* Channel easily intimidates you, then look no further than two stations: TBS and Nick at Nite. Here, you can effortlessly switch between *Full House* and back-to-back episodes of *Saved by the Bell*. Prime viewing hours are early morning (until about noon) and late evening (until about midnight). However, if you turn on either of these channels any time from noon to six p.m., don't be surprised if you stumble upon a Steven Seagal movie or inexplicable episodes of *Bonanza*. And don't panic either. Instead, simply play a TiVoed episode of *Gilmore Girls* and take a couple deep breaths. Zack Morris is probably just talking on his eight-pound cell phone and lost track of time.

TELEVISION OVERDOSE

In all emo fans' lives, there comes a time when they ask themselves, "How much TV is *too* much TV?" Certainly, watching—and in some cases, overwatching—your favorite television programs is an important part of the emo lifestyle. But it is also important to remind emo types that this a *life*style, and that implies that you might want to, you know, live a little—at least for the sake of your family and friends.

Of course, it is often difficult to know when you've stepped over that line, and when you need to modify your life. With that in mind, here are five signs that you might want to change your viewing habits.

WHEN YOU ANXIOUSLY WAIT FOR TV DVDS TO GO ON SALE.

Now, you're probably thinking to yourself, "But tons of emo kids buy box sets of their favorite TV shows; what's the big deal about that?" Nothing, except that when you add to the equation things

like waiting out in front of Best Buy at 9:45 a.m. or Netflixing* the *Aqua Teen Hunger Force: Season Six* DVD so that it arrives a few days before it's due to hit the shelves, you are only steps away from being the kind of grown man whose bedroom walls are made up of collectible action figures. And unless you're Claudio Sanchez— and probably even then—such behavior could have a considerably negative effect on your social life.

WHEN YOU'RE ON MESSAGE BOARDS ABOUT TELEVISION SHOWS. Being on a message board about your favorite emo band isn't really considered a waste of time because . . . well, it just isn't. But if you are spending more than forty-five minutes a day paging through the comments about this week's episode of *24*, you will seem a little more than "delightfully nerdy." If you are wondering about the sort of life path this could lead you down, please refer to the previous entry.

WHEN YOU'RE WATCHING JUDGE SHOWS. ALL OF THEM. EVERY SINGLE DAY. This includes Judge Judy, Judge Hatchett, Judge Joe Brown, Judge Mills Lane, Judge Mathis, and whoever that

* *v* The act of renting a movie from the online company Netflix, which delivers copies of DVDs directly to your home. Netflixing is an action used primarily by the kind of emo fans who have stopped going out, have lost the ability to squeeze into slim-fitting clothing, and apparently require some additional viewing options outside their favorite programs on Bravo. See the Adulthood chapter.

surprisingly nice bald guy is on *Texas Justice*. At this point we all know how the case is going to turn out and we all know how, eventually, the defendant is going to be asked to shut up by the gavel-toting, self-righteous, gown-wearing minor celebrity on the other side of the courtroom. Also, there is *nothing* emo about judge shows, so why would you watch them? Stop, put down the remote, and begin to try to repair the damage this may have already caused to your sense of self-worth.

WHEN YOU RATIONALIZE WATCHING BAD TV SHOWS SIMPLY AS A WAY TO CONTINUE WATCHING TV. This often happens with reruns of shows that are always on but that you never cared to watch in the first place. For example, if you are sitting at home because you have developed the unfortunate habit of watching *Dharma and Greg* every night at ten thirty—under the rationale that you "want to keep up with the story line"—this is a major sign that you need help. For one, there is no story line, and two, anything starring Jenna Elfman is physically nauseating. How anyone has the immune system it takes in order to tolerate her is a miracle of science and nature.

WHEN YOU TRY TO INVENT CATCHPHRASES AMONG YOUR FRIENDS FROM SHOWS THAT NO ONE WATCHES. Face it, no one is going to join you in saying, "Had a bad day? *Cheesesteak!*" just because you thought it was funny that one time when you were alone watching an episode of *Joey*. Seriously, nobody.

adult•hood *n* The tragic and unceremonious end to your social life. For emo types, *see also* the moment in your postadolescence at which you suddenly feel like you are three weeks away from assisted living.

Adults have never played a huge role in the emo community. Sure, occasionally you'll see them at a show lingering around the bar, but for the most part emo is about young, brokenhearted fans who are ready to spend every summer darting between all-ages clubs and dusty outdoor festivals to watch one of their favorite bands play a live set filled with angsty teen anthems. But sadly, such times cannot last forever. One day your average emo fan is a teenager singing along in a parking lot, and the next he or she is in his or her late twenties, wondering how the last ten years managed to breeze by.

And then what? For many emo fans, growing up is difficult. They begin listening to different forms of music and become fond of various forms of lite beer. Some will dress as if they are in a classic rock band from the seventies, while others will dress as if they spend their days filing insurance papers (because, well, that's in fact what they do). As they get older, emo fans have many paths to

choose from—whether it is parenthood or an unexpected new career—but the natural reaction most of them will have to adulthood is fear and, inevitably, rejection.

But it doesn't have to be that way. Here, in our last chapter, we look at the many different experiences—both good and bad—that emo fans go through once they step onto the *other* side of their twenties.

I GUESS THIS IS GROWING UP

Not sure if you're an aging emo type? Then ask yourself the following ten questions.

1. When you're at a show, do you:

A. Hang out in the back, mostly by the bar, nursing a Stella while asking your plus-one or anyone within earshot, "Jeez, why does it have to be so *loud* in here? Do you have a spare pair of earplugs?"

B. Worry about staying out too late because you have an early squash game in the morning

C. Usually end up walking out of the club barefoot because you lost your flip-flops somewhere in the pit

2. Your hairstyle of choice is the emo combover because:

A. Your job at Progressive Insurance won't allow any 'do to hit below the ears

B. You're trying to compensate for male pattern baldness

C. If it's good enough for Conor Oberst, it's good enough for you

3. While you're channel surfing, you come across an episode of *Law & Order: Special Victims Unit*. Do you:
 A. Change the channel because you've already seen this episode
 B. Put down the remote, get comfortable, and wonder why Olivia Benson and Elliot Stabler haven't built a life together yet
 C. Turn off the TV and go check your MySpace page

4. How long do you go without checking your MySpace account or updating your LiveJournal?
 A. Two days
 B. Two weeks
 C. Two minutes

5. When you're hanging out with friends, you usually initiate conversations about:
 A. Gas prices, 401(k) plans, equity lines, and/or how much your insurance co-pay is
 B. The fact that interest rates are so low that this might be a good time to consolidate your mortgage
 C. The latest crop of naked pictures of emo frontmen to make it onto Oh No They Didn't!

6. Do you think your jeans might be *too* tight?
 A. Yes
 B. I wear Dockers
 C. Never

7. The first time you saw Lifetime play was:
 A. Back in 1995 when they were supporting the release of *Hello Bastards*
 B. "Lifetime? Isn't that a television network for women? Me confused."

ADULTHOOD

C. During the summer of 2006, when they toured with the Bronx, and Pete Wentz said they were cool

8. When you apply eyeliner, is it:

A. Hard to tell where your eyeliner ends and the bags underneath your eyes begin

B. "Eyeliner? Are you kidding me? Now help Nana find her slippers . . ."

C. Difficult for you and your guy friends to decide which shade to apply

9. You wear horn-rimmed glasses because:

A. You only need them when you're reading and, like, you might as well look good

B. They're prescription and that's the only way you can see your own hand in front of your face

C. Some dude sold them to you outside of a Weezer concert and you think Rivers Cuomo would be proud

10. Do you feel comfortable around the opposite sex?

A. Always

B. Let me check with my wife

C. Never

RESULTS

MOSTLY A's: Okay, you might not be a spring chicken, but you're not ready to check into the emo old-folks home *yet*. However, be careful of how many times you happen to land on Fox News or ask to move tables at a restaurant because you think you feel a draft.

MOSTLY B's: You, on the other hand, might as well apply for your AARP card. Face it: You probably own property, go to bed by ten, and actually *like* listening to the radio (NPR, of course), but your faded star and sparrow tattoos are the only reminders of your past emo life.

MOSTLY C's: Breathe easy. You're in the clear. You are an emo youth and are nowhere near emo retirement. Wear your plugs with pride, raise your fist, and exclaim, "I'm not okay, I promise!" Or just be thankful that you still get carded to buy smokes and can't get into R-rated movies yet.

EXPIRATION DATES

For most emo types, there are surefire signals—as proven above—that you are indeed getting on in years. But this isn't a realization that comes merely out of the blue. As the following timeline displays, there are a lot of milestones that you will face as you age.

TWENTY YEARS OLD: This is the age you will realize that 90 percent of all pop-punk singers sound like they *really* need an antihistamine.

This is the first step emo fans take toward having more mature musical tastes. It's only a matter of time before you starting listening to adult alt-rock bands like Wilco.

ADULTHOOD

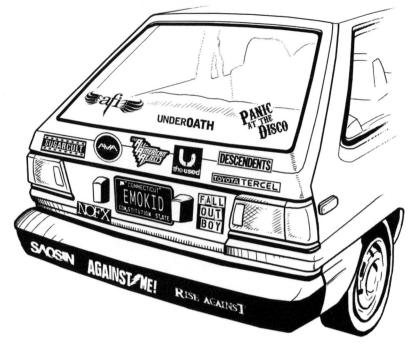

TWENTY-ONE YEARS OLD: This is the age when your car will most likely get towed from your apartment complex because the attendant can't make out the parking-permit tag among the dozens of band stickers on the bumper.

Overaccessorizing—whether we are talking cars or fashion—is a fairly common problem among teenage emo types. But as you make your way into your twenties, nothing makes your friends say, "Dude, we're not in high school anymore," more than a Toyota Tercel that looks like it got vandalized by someone who works at Hot Topic.

TWENTY-TWO YEARS OLD: This is the age when you'll start reading "serious" music magazines like *Mojo* more than you do PunkNews.org.

Sadly, there will come a point when reading "in-depth" articles in *Mojo* about dead rock stars from the seventies will seem more interesting to emo fans than quippy reviews of the new mewithoutYou record and DIY specials about how to get your band signed to an indie label. For most emo fans, this will probably happen around the age of twenty-two, which is also when most emo types

start asking their friends, "Dudes, have you guys ever *really* listened to *Pet Sounds?*"

TWENTY-THREE YEARS OLD: This is the age when you will begin spending a lot of your time in overcrowded, "hip" bars.

Drinking is a rite of passage for most emo fans. But the real shift for emo types comes a few years into their drinking careers when rational thinking goes out the window and it suddenly seems totally acceptable to pay nine dollars for a vodka tonic at some party where professional hipster Steve Aoki is DJing.

TWENTY-FOUR YEARS OLD: This is the age when you realize that the songs on the first few Dashboard Confessional albums aren't about you as much as they were when you were in high school.

Often emo songwriters write with such over-the-top sensitivity that you can only relate to their songs when you're just discovering your emotional side. (Like when you're fifteen years old.) But when you reach twenty-four, the only thing you'll probably be "discovering" is what time *Trading Spaces* reruns air on the Learning Channel and where you can buy massive quantities of lite beer.

ADULTHOOD

TWENTY-FIVE YEARS OLD: This is the age when you realize that standing in a parking lot during a heat wave and paying nine dollars for a basket of chicken fingers is no longer for you.

Not at all coincidentally, this is around the same age when you start thinking that wearing white tube socks with Nike sandals might be socially acceptable. Yes, indeed, aging is a cruel, cruel process.

TWENTY-SIX YEARS OLD: Thanks to your slowing metabolism—and your nightly ritual of eating a Burrito Supreme from Taco Bell at two in the morning—this is the age when things go *terribly* wrong.

Yes, even emo types get fat. For some, this will get even worse with age. If you're a guy, it might be time to kiss those girls' jeans good-bye and, if you're a girl, well, we hear that vertical stripes are supposed to be slimming.

TWENTY-SEVEN YEARS OLD: This is the age when wearing home-made T-shirts with "clever" slogans on them—for example, DO YOU LIKE MY SCENE HAIR?—will result in people laughing *at* you instead of *with* you.

Remember when all your friends thought making shirts like this was funny? Yeah, well, that was probably a long time ago. Now you just look like the character that Matthew McConaughey plays in *Dazed and Confused*—the one who hits on high school girls even though he graduated a *really* long time ago.

TWENTY-EIGHT YEARS OLD: This is the age when you stock up on hoodies and Castro hats more because of "hair issues" and less because of the latest emo fashion trends.

Now, granted, hoodies are an essential part of any emo fan's wardrobe. But for most emo types who are getting on in years yet are still involved in the scene, pretty much the only reason you would choose to look like a Jawa from *Star Wars* is that you're going gray and/or suffering from male pattern baldness.

TWENTY-NINE YEARS OLD: This is the age when you will realize that you are too old for "e-mail wars," considering that your current e-mail address is Jane.Doe@CorporateAmericanHQ.com.

Typically, "e-mail wars" erupt among emo fans when someone publicly disrespects someone else on a message board. What happens from here is usually a debate so pointless that no one can understand what the original argument was about. That said, it seems safe to assume that getting caught doing this at your new corporate job would probably be only a tad less embarrassing than getting caught stealing a stapler.

FIVE PATENTED EMO LOOKS THAT WON'T WORK WHEN YOU GET OLDER

1. THE LIBRARIAN EMO LOOK: For young female emo types in their teens this is adorable. A young girl with platinum-blond hair wearing a top-buttoned cardigan sweater and knee-high socks is definitely cute. But once you begin getting older, this may accidentally make you look like your eighty-year-old nana.

2. THE EMO HAIR-METAL LOOK: Looking like you're an original member of Skid Row for a few years might work if you are a member of the hair-metal-loving emo throwback band Halifax. (Well, *kind of.*) But if you rock this look past the age of twenty-five, you will simply look like a biker cruising for jailbait.

3. THE EMO GOTH LOOK: Goths look weird enough as is. So do old people. There is no need to combine the two. If you are nearing your

thirties and have put on a little weight since the last My Chemical Romance record, applying foundation might make you look like that crazy fat lady on *The Drew Carey Show*. And that's not a good look for *anybody*.

4. THE EMO COLLEGE PROFESSOR LOOK: Often sported by indie-emo types who have actually read John Fante novels, this particular emo fashion aesthetic walks a fine line. Wearing corduroy blazers with suede elbow patches and clunky glasses is fine when you're a fresh-faced sixteen-year-old, but as you get a bit older there is a very good chance that this look will make you seem like a college professor trying to get tenure.

5. THE EMO GUTTER PUNK LOOK: This fashion statement runs a lot of the same risks as the emo goth look. It requires a lot of black and a lot of slim-fitting clothing, primarily the kind of unbelievably tight black jeans that challenge your aging metabolism. However, this look *can* be pulled off post-twenty-five if you are Mikey Way. Or anorexic.

ADULT DRINKING 101

For a lot of younger emo types, drinking isn't a given. Just like the evolution of emo itself, the fans of this music often come up first within the straight-edge hardcore scene, where drinking and eating animals is seen as not so cool. But as time goes by, drinking will mark yet another expiration date. Maybe they'll start with a can of Sparks* and will move on to a steady stream of rum and Coke, but if any of the five scenarios below begins to occur on a fairly regular basis, there is pretty much no denying that you have become an adult drinker.

* *n* A preferred alcholic beverage among younger emo types that tastes like Windex, Mountain Dew, and the stuff that you have to lick to seal an envelope.

- You order a whiskey on the rocks and immediately ask your wife or girlfriend, "Do we have any Excedrin at home?"
- You order a glass of Merlot and notice that your much younger friends are laughing at you.
- You say to the bartender, "I'll have . . . oh, that yummy walnut microbrew!" and immediately start talking about a show you watched last night on the Food Network.
- You order a vodka tonic and notice that most of your friends are slowly drifting away from you as you continue to ramble on and on about the pointless low-carb diet you're on.
- You order a pint of Stella and begin talking about . . . ugh, whatever it is that yuppies in Brooklyn or San Francisco generally talk about.

TRADING SPACES

So, other than having a couple bottles of wine laying about, what does a typical emo domicile look like? That often depends on how old you are. Generally, interior design is a concept that most emo types fail to embrace until they reach their mid-twenties, which is why their first home away from home (often obtained around the age of nineteen) will include the following:

BAND POSTERS: Obviously, band posters on the wall are essential, but they can often be supplemented with two-page spreads ripped out of an old issue of *Alternative Press*.

DIY BOOKSHELVES: There is no way that any self-respecting emo type would not have at least one bookshelf made of milk crates in his or her home. Inside such bookshelves there will probably be very few books, but likely lots of CDs. Unless said bookshelf is owned by the kind of emo audiophiles we outlined in the chapter on Music, in which case it will be filled with lots of vinyl, and its owner will obnoxiously point this out to everyone who comes over.

THE "DUDE, WHAT'S UP WITH YOUR FUTON?" FUTON: Another must in your first emo home is a futon. These are usually found on the street or donated by friends, and they always seem to have at least one or two stains that, if you think about their origins too much, will suddenly make your skin crawl. (It's actually amazing how many people do this without contracting scabies.)

Now, by the time that most emo types reach adulthood, feelings for interior design will begin to change. Your average adult emo home will be heavily outfitted by Ikea, West Elm, or Pottery Barn and will probably look identical to all of your friends' homes. Generally, these homes will include the following.

A REAL COUCH: One of the first, notable differences that occurs in the adult emo home is that you will actually purchase a couch. It will probably be from Ikea and, hopefully, will signify the end of owning any kind of furniture that some bum has pissed on.

A SLIGHTLY BETTER BOOKSHELF: Another staple of the adult emo home is a real bookshelf with real books in it. This bookshelf will probably cost somewhere in the neighborhood of $150 and will still only have the stability of a stack of milk crates. Also, it will probably break a lot sooner.

PHOTOGRAPHS AND ART, BUT NOT TOO MUCH: Yet another design element that most emo types will embrace at this stage is

emo-shui.* Accordingly, sparse bits of art will line the walls but will usually consist of either cartoon-looking concert posters or (in the case of many married emo couples) nauseating photographs of themselves.

LIFE AFTER THE VAN

Getting older for emo types doesn't necessarily mean getting out. But occasionally people who have spent their formative years in the emo scene do get the itch to do something different with their lives once they begin to age. For some, this means settling down, starting a family, and enjoying endless hours of sifting through TPS reports at their crummy office jobs while thinking *way* too much about what they are going to eat for lunch at Outback Steakhouse.

But what other options do emo types have for work once they grow old? Are they really destined to live the rest of their profes-

sional lives inside a cubicle? Sometimes it seems impossible for emo types to get a cool and interesting job once they decide it's time to become a grown-up. Many emo musicians, however, have shattered this preconceived notion.

BLAKE SCHWARZENBACH
WHO: Former lead singer and guitarist for Jawbreaker and Jets to Brazil
PROFESSION: Teacher, New York City

Becoming a teacher seems like a dream for many emo types. For one,

* *n* Derived from the Chinese ritual of feng shui, which is an ancient technique that relies on a well organized home with only a minimal amount of furniture. Many emo types have adopted this technique as their own because it allows them to constantly rearrange their record collections. It also gives them a new excuse for having no furniture other than "Dude, I'm broke."

you're automatically the center of attention, and if some punk-ass kid tries to step to you, you can send him to detention. But more important, you don't have to change the way you dress all that much. This is true for Schwarzenbach, who is probably the only schoolteacher in New York City who shows up to class wearing pegged pants and slip-on Vans.

CHUCK RAGAN

WHO: Former singer and guitarist for the band Hot Water Music
PROFESSION: Freelance carpenter, Los Angeles

In California, when you refers to yourself as a "freelance carpenter" it's easy to imagine those weird beach people who sell their driftwood sculptures on the Venice boardwalk for five dollars apiece. But, as it turns out, carpentry is really hard. It's also, like, spiritually rewarding, which is one reason Ragan has begun a new career hand-carving wood furnishings in between writing songs as a solo artist.

DAN YEMIN

WHO: Guitarist for Lifetime and Paint It Black
PROFESSION: Psychologist, Philadelphia

Now, admittedly, being a psychologist is hard. You have to go to school for something like thirty-two semesters and then spend the rest of your life listening to a bunch of babies complaining about their "issues." But as Yemin probably knows, the best part of being a psychologist is that the next time that annoying friend of yours calls you an ass clown, you can totally respond by saying, "That's *Dr.* Ass Clown to *you.*"

MIKEY WELSH

WHO: Former bass player for Weezer
PROFESSION: Abstract painter, Burlington, Vermont

Welsh played bass in Weezer for only one album, but it was during a period in the group's history when Rivers Cuomo was fining

his bandmates whenever they played out of tune. No wonder he changed careers! Welsh's job now as an "abstract" painter probably seems enviable to most emo types. After all, how hard could it be to spill a bunch of paint on a canvas, call it art, and then sell it to a bunch a clueless rich people for thousands of dollars at your next opening?

STEPHEN PEDERSEN
WHO: Former guitarist for Cursive, current frontman for Criteria
PROFESSION: Lawyer, Omaha, Nebraska

Pedersen played guitar in the long-running Omaha band Cursive before quitting music in the late nineties to become a corporate litigator. We're not sure what these people do with their time, but we are certain that they make a lot of money. For example, during his time in corporate law, Pedersen was the only person in Omaha with a yacht and a diamond-encrusted Escalade and thirty-seven man-servants and . . . ummm, actually, we're making all of this up. But Pedersen did make some money, most of which went into his home studio. He currently plays in the band Criteria and still handles contract work for his friends' bands on the side.

UH-OH, THE ADULT RECORD

It isn't just emo fans who struggle with growing up. Many of the bands throughout emo's history have had to deal with what happens when their lives get bigger than mere melodic punk songs about unrequited high-school crushes. Maturity is a foreign concept for emo types, which is why emo bands often react to this in rather confusing ways.

ALL USED CD'S ON SALE

ADULTHOOD

That being said, you know your favorite band is getting old when . . .

THEY HIRE A BIG-TIME PRODUCER. Hiring a big-time producer for an emo band is always the kiss of death. When the Promise Ring hired former Smiths producer Stephen Street in 2002 for their fourth album *Wood/Water*, it was only a matter of time before they called it a day. Ditto for the Get Up Kids when they worked with onetime R.E.M. knob-twiddler Scott Litt. So what's the lesson to be learned here? Well, the next time your current favorite emo band begins talking about how they *really* want to work on their next CD with the guy who did Radiohead's *OK Computer*, kiss their asses good-bye.

THEY START TAKING FOREVER BETWEEN RECORDS. You can't say that you didn't see this one coming. Old people do move slowly and get easily distracted. Whether a band's members decide to pursue other interests or the lead songwriter isn't inspired to do anything in the studio except order takeout, a long break between records is never good for an emo band.

THEY GET FAT. See above.

THEY START RIPPING OFF CLASSIC-ROCK BANDS FROM THE SIXTIES AND SEVENTIES. Bands like Pink Floyd and Fleetwood Mac are popular influences, but stealing from the Beatles is absolutely mandatory, seeing that every emo band will be guilty of writing at least one Beatles rip-off in their career. Bad idea. There will never be a band as good as the Beatles, and borrowing from them—unless you are Oasis and it's 1994—will likely make most emo bands appear lame by comparison.

THEY START LOOKING LIKE EXTRAS FROM THE MOVIE *ALMOST FAMOUS.* To all emo bands out there, beware of: This doesn't make

you look younger, it only makes you look like some douchebag who followed the Doobie Brothers in the seventies.

THEIR SONGS START GETTING REALLY L-O-N-G. When emo musicians get older, they give in to certain impulses. One such impulse is to write eight-minute-long "epics" in the vein of Mogwai, Godspeed You Black Emperor!, or any other pretentious indie band you might read about on Pitchfork. Often this is seen as "maturing." These songs, however, are rarely "epic" or "mature." Try boring. Or unoriginal.

THEY WRITE SONGS ABOUT PARENTHOOD. It's bad enough when you come to terms with the fact that your parents had sex at least once in order to create you. But when you realize that a member of your favorite emo band has decided to procreate—*and* write a song about it—that's flat-out traumatizing. Once some dude in a ringer T-shirt begins writing songs about cutting an umbilical cord, you might as well be listening to James Blunt.

Now, understandably, you might be a good couple years—or decades—away from having kids or becoming an "adult." But now you know what to expect: bad records, less hair, and a sad distance between you and your favorite pair of black tapered jeans. Growing up, as they say, is also about letting go. But relax, no one expects that to happen anytime soon. At the moment, you're probably still the underage center of your universe, and no one would have it any other way.

However, there will come a time when all of these "adult" things will creep into your life and—just like Gerard Way's decision to cut his hair and dye it so that he looks the guy with the Caesar 'do from 98 Degrees—it'll be the last thing in the world you'd ever expect to occur. But growing up is an essential part of the emo experience. It's another link in the chain. First you identify with the ideology. You realize that the kids on the lacrosse team are not

like you. You come to the conclusion that, just like all the other kids camped out in front of HMV waiting for Panic! at the Disco tickets, you are different!

And then you begin to look and act the part. You start straightening your hair, duct-taping your Chucks, and sitting in front of the mirror for hours to make sure your eyeliner is perfectly smudged. These are the things that all emo kids at one point come around to. They will all write MySpace blogs about how Brand New were better before they thought they were Radiohead, and they will all find a way to communicate through catchphrases from Will Ferrell movies. That's what being emo is about.

Well, that and a bunch of gushy emotional stuff. Cue the strings: Being a part of the emo scene is about an emotional attachment that you can't really buy. It's about something you are born with, which means that no matter what you do (and no matter how many annoying little kids you eventually have and push on your friends), your time in emo will never really end. Sure, maybe you will get really into microbrews and Bravo programming, but that core feeling that has always made you emo will remain intact. In the end, emo isn't a trend; it isn't a marketing tool; it isn't even a passing phase. It's you. And you don't choose emo. Emo chooses you.

So if you've made it through this Stuart Smalley–style speech and you still haven't gotten any closer to the emo inside, we're sorry. A life of boredom—and really bad music—obviously awaits you.

ACKNOWLEDGMENTS

First and foremost, we would like to thank Casey Kait and Jeremy Cesarec at HarperCollins for their guidance and patience. We would also like to thank Jim Fitzgerald and Anne Garrett at the James Fitzgerald Agency for all of their help in the process of making this thing happen. Then there is our small innercircle of coconspirators: Rob Dobi, Andy Greenwald, and Pete Wentz. You are talented beyond words and will obviously make way more money in this life than we will.

As for those who listened, talked shop, helped us sell this thing, or generally put up with the few months of irregularity that came with this project, we heart you. This means you the Simon family, the Kelley family, the Spanier family, Angie St. Louis, Linsey Molloy, Lesley Federman, Matthew Bowne, John Millin, and Bridget Gibbons; Heidi Anne-Noel, Sara Newens, Phil Huffman, T. Cole Rachel, Mark McInerney, Angel Mendoza, and Robert Herrera; Alex Brahl, Jen George, Riley Breckenridge, Ezra Ace Caraeff, Jonah Bayer, Aaron Burgess, Sarah Lewitinn, and Gurj Bassi; Jenna Kimbell, Bonnie Dillard, Lycia Shrum, Bryan Sheffield, Teeter, Amy and Heather Sperber; Brian Bumbery, Kate Cafaro, and JT and Niki Woodruff; Josh Cain, Jesse Johnson, and everyone in Motion City Soundtrack; Dan Suh, Steve Looker, Sue Marcus, Mike Kennerty, and Chris Gaylor; Max Bemis, Tim McIlrath, Matt Galle, Stevie Helm, Billy Gorelesky, and Shannon Maclaughlin at Ordinary Clothing; Heather West, wiL Francis, Greg Krelenstein, and everyone at MisShapes; Jason Tate at AbsolutePunk.net, Nick Bogardus, Jessica Weeks, Annie Shapiro, Bruce McDonald, Steven Smith, and everyone at Fuse; Bob McLynn, Jonathan Daniel, Scott Nagelberg, Alex Sarti, and everyone at Crush; Debbie Wunder and Rusty Pistachio; Jim Bell, the Curtiss family, Catherine Sims, Donald Messinger, and Tom Szich.

We would also like to thank Mike Shea, Norman Wonderly, Aaron Wilson, Katherine Poecze, and Jason Pettigrew at *Alternative Press* for giving us our professional start.

From: Pete Wentz <not.petes.real.address@tmail.com>
To: Leslie Simon <my.hips.don't.lie@gmobile.com>
CC: Trevor Kelley <needsabodyguard@mac.net>
Date: August 5, 2006
Subject: Everybody Hurts

Dear Leslie and Trevor,

Last night I had this dream where I was driving a motorcycle in the desert and this wolf was jumping next to me super high. My dad told me the wolf was bad news, so I picked up one of those desks. You know, where the chair is connected to the desk part? They're the ones from when you were younger, or from, like, *Little House on the Prairie*? And I said, "You want to die?" He said, "Yes." Then I threw the desk at his head and before he died, he said, "No." Then I woke up and brushed my teeth, except my toothpaste tasted like it had gone bad. Then I woke up for real and realized that was part of the dream, too.

I'm not really sure what the whole thing meant, but it made me think about when I watch those kids in spelling bees and get super jealous that they have some real talent. Sometimes this whole scene feels just like Disneyland—only with Lego hair and carefully smudged black eye makeup. Maybe I'll go blog and cry about it so someone can write a blog making fun of how I blog about it and so on. I think at age 27, maybe I'm ready to shed the term "emo." As an adult, I think I'd like to be called "sentimentally pessimistic."

Good luck with your book. I can't wait to read it! By the way, Lil Wayne's *Tha Carter, Vol. 2* was the best emo record to come out, like, *ever*. Be sure to include that.

Back to watching *The Notebook* and painting my nails . . .

—Peteywentz